Painting Still Life in Oils

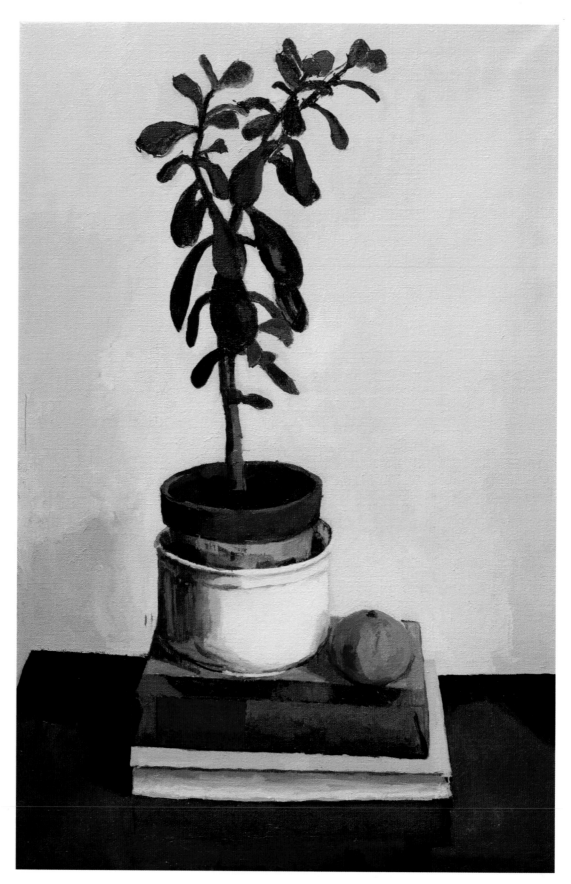

Still Life with Books.

Painting Still Life in Oils

Adele Wagstaff

THE CROWOOD PRESS

First published in 2012 by
The Crowood Press Ltd
Ramsbury, Marlborough
Wiltshire SN8 2HR

www.crowood.com

British Library Cataloguing-in-Publication Data
A catalogue record for this book is available from the British Library.

ISBN 978 1 84797 313 9

Typeset by Simon Loxley
Printed and bound in Singapore by Craft Print International

CONTENTS

ACKNOWLEDGEMENTS

I would like to thank Beth Hopkins, Michael de Jacquier, Jonathan Smith, Susan Wilton, and Jean and Derek Wagstaff for all their help, support and encouragement throughout the writing of this book. I would also like to thank Paul Coleman for all his patience and good humour during his taking of many, many photographs.

This book is dedicated to all those wonderful still life painters, past and present, without whose inspiration this book would not have been possible.

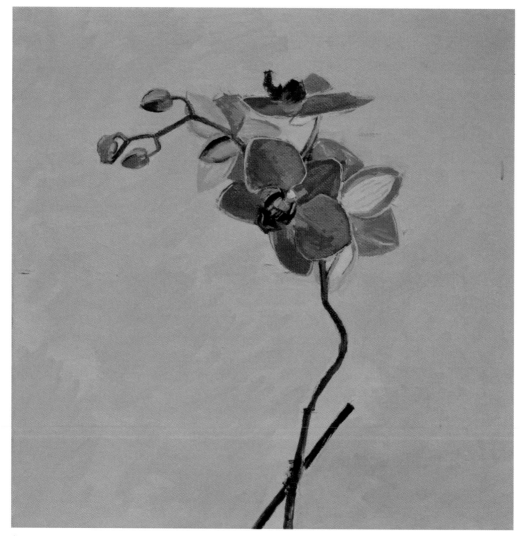

Red Orchid.

INTRODUCTION

Throughout this book we will look at how artists have responded to the genre of still life in oil painting, and how these artists and influences can help us in our own journey and exploration of still life drawing and painting. The huge variety of subjects and objects on offer to us when embarking on a still life work makes this an exciting, yet very personal practice. Still life as a subject may be used in many ways: perhaps as an exploration of colour, studying colour and tonal relationships; or in experimental approaches, from expressive and painterly to carefully measured and observed.

The objects we select to paint may be many, as seen in the crowded tabletops of Paul Cezanne, or just a few, perhaps a more intimate still life of one or two objects as seen in the work of William Nicholson, Euan Uglow and Craigie Aitchison. Our still life painting might be a joyous celebration of colour, as in the still life works of Vincent Van Gogh, or the calm and more muted palette of Gwen John. Over time our selection of objects will become more personal to us and we can begin to develop a greater narrative and personal meaning within our work.

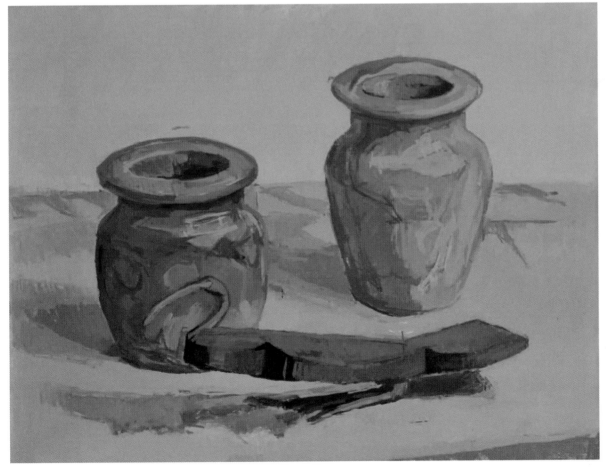

Jar with Ibis.

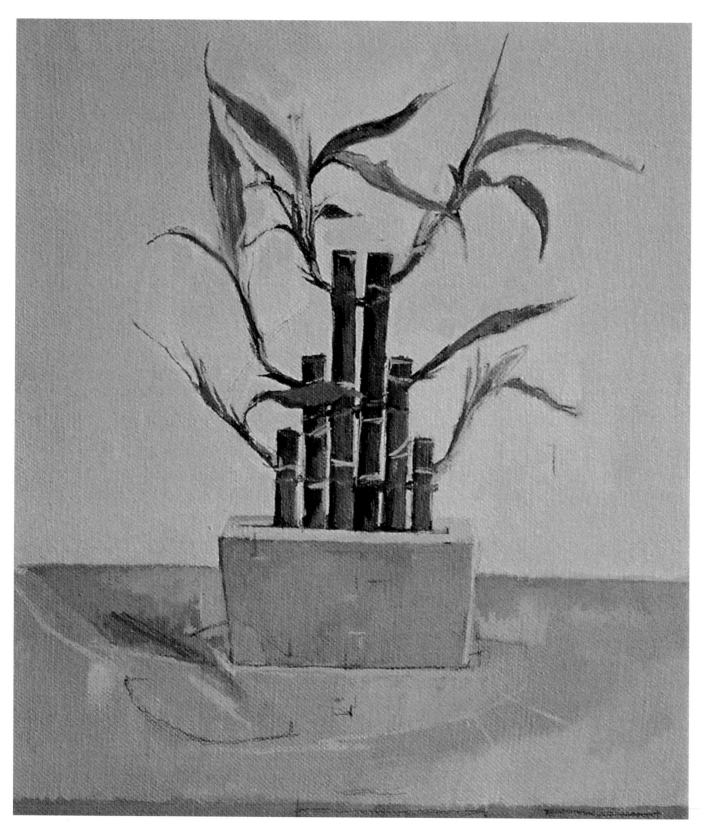

Lucky Bamboo.

THE INDEPENDENT STILL LIFE

In this chapter we will examine how the genre of independent still life painting, as we know it today, evolved from the art of the ancient world to the variety of still life works, both traditional and not so traditional, in contemporary painting.

In my own still life painting I am constantly looking to the work of other artists, both ancient and modern, as a source of inspiration. How did they place their objects? How did they respond to the sort of subject matter I am currently working with? How did they use brushwork to describe form and texture, how have they shown reflections and different surfaces? Have they laid down opaque paint or thin glazes? Studying the work of other artists, whether they are the Old Masters or contemporary painters, is an important element of our own learning and personal study.

Looking at paintings in reproduction is of great help, and in your studio you will probably display postcards of paintings that are inspirational or helpful to you. Try to look at a wide range of contrasting artists, from all periods, to get a feel for how a subject has been depicted. Whenever you can, try to visit galleries to look at paintings 'in the flesh'. Standing in front of a painting – getting as close as gallery security will allow – enables you to see how the painter has used brushwork to draw and describe, how paint is applied, and how rich and saturated, or subtly the colour has been used. Even though observing work in reproduction may be helpful, it never allows us to get a true feel for the palette and how the colour has been used.

Seeing paintings in a gallery setting also gives us the opportunity to appreciate the scale of a piece. In reproduction, whether a postcard or a slide in a lecture, the artwork is always the same size. When we see a painting for the first time its size is often a surprise to us!

The images selected throughout this chapter are my own still life paintings. With each example I have referenced the work of other artists who have influenced me in some way, either in subject matter, approach, simplicity of composition or maybe the palette being used. Some biographical information is given, with a description of each artist's work and how their still life/s have been of influence to me, and particular aspects and approaches in their painting identified in the hope that this will be useful in your own personal study of the subject.

Further reading on the artists and their work discussed during this chapter can be found at the end of the book, along with suggested galleries and collections where you will be able to find each painter's work.

Still Life Painting and the Ancient World

A decisive moment in the interest in still life painting came with the Renaissance, and its revival of the art of antiquity. During the Renaissance itself there were few known examples of ancient still life, although many have been excavated since, found in both mosaic and fresco. In the art of the ancient world, the imagery of still life can be found in the wall paintings of the villas of Pompeii and deep within the tombs of the Valley of the Nobles and Valley of the Artisans at Thebes. The Ancient Egyptians painted sumptuous still life arrangements in figure compositions showing preparation for, or journeying on to the afterlife.

In these early examples of painting, the laying down of colour would be used to enliven objects of daily life, or to elevate objects that were to accompany a man to the afterlife. Applying colour to a wall relief would be used to adorn something thought to be quite drab. At this time most painting would take the form of adding colour to sculpture and wall reliefs; it was only when relief wasn't possible that painting directly on to the wall surface would suffice.

Examples of such wall paintings can be found deep within the tombs of the Valley of the Nobles, most notably the tombs of Sennefer and Nakht. In these tombs of Theban nobles the walls were mostly painted, as the poor quality of the limestone precluded any carving of reliefs. The brightly coloured paintings show offerings made to the gods, and scenes of everyday life. A

superb example of Egyptian wall painting showing an array of still life objects can be seen in the tomb of the nobleman Nebamun in the Temple of Amun at Thebes c.1350 BC. These paintings can now be found in the British Museum, London. The chapel of his tomb is decorated with beautiful paintings showing how the wealthy wanted to live their lives in the afterlife.

The most important scene in this tomb chapel is the painting showing the offerings made for Nebamun. In the centre is a lavish scene showing a huge pile of food with wine and ornate perfume jars, and on the left a tall bouquet of papyrus and flowers. The food offerings include loaves of bread, grapes, figs, meat and roast duck. At the base of the composition three large jars of wine are garlanded with grapes and vines, while at the top is a row of further offerings decorated with lotus blossoms.

The colours of these paintings remain vivid, the earth colours being the most vibrant of all: yellows, ochres, browns and oranges are still bright, while the rougher pigments of the blues and greens have fallen away.

The compositions seen in these wall paintings follow a structured and formal arrangement. Objects are set out in registers or rows, or within a geometric framework that runs throughout the whole composition. Vases and other objects stacked on shelves not only serve a descriptive and decorative purpose, but you also have the feeling that these arrangements have been closely observed from life.

Similar 'still life' arrangements can be seen on the ancient papyrus scrolls of the *Book of the Dead*, showing scenes of mummification and of journeys to the afterlife, except here the jars being used are the canopic jars used in the mummification process.

The Roman wall paintings found at Pompeii and Herculaneum bear 'unique witness' to the production of the Roman school, thanks both to their number and also to their excellent state of preservation.

In the room of garden paintings (*oecus*) in Pompeii there are beautifully observed and naturalistic portrayals of birds, plants and flowers. A bird perches on the top of a cane: its markings and lighting make it not only three-dimensional but also remarkable in the attention to detail of light, form and colour. Within the painted wall scenes of gardens different types of mark, and scale of mark are used to describe different surfaces and foliage.

One of many still life arrangements on the frescoed walls in a single room of a house in Pompeii depicts a bird sitting next to two beautifully painted apples on a shelf. This room of garden paintings (*oecus con pitture di giardano*) is situated in the 'Insula Occidentalis' and was rediscovered in 1979. What is striking about this particular example is its contemporary feel in composition. The attention to detail and the naturalistically painted fruits on a narrow shelf against a striking dark background, seem to be a forerunner of the still life compositions of the

Spanish painters Juan Sanchez Cotan (1560–1627) and Zurbaran (1598–1664). These painters of the early mid-seventeenth century, painting highly naturalistic fruits, used the motif of the shelf for a seemingly 'modern' composition. They also placed their objects against a very dark background, an arrangement which always serves to enhance the colour, light and three-dimensional form of the fruits against the darkness.

Many still life paintings were found at Herculaneum (before AD 79). An example particularly worthy of a mention is *Glass Bowl of Fruit and Vases* now found in Naples National Archaeological Museum, Naples, Italy. This painting, originally from the house of Julia Felix at Pompeii, shows an elaborate glass bowl of fruit – apples, pomegranates and grapes alongside amphora. This is an interesting use of composition, as the objects are placed in a stepped arrangement, the fruit and the shadows created around the objects leading the eye around the pictorial space.

In another fresco there is a silver goblet painted in a highly naturalistic way. The attention to detail, the closely observed light falling and the reflection on its surface, all are depicted in a way that is ahead of its time.

Ancient texts tell us of the high value the ancients gave to pictorial realism; the most notable example often quoted is Pliny the Elder's *History of Nature*. Here the painter Zeuxis is praised for painting such realistic grapes that it was said that birds would attempt to pick at them believing them to be genuine fruit. The painting *Fabula* (*An Allegory*) in the 1580s by El Greco (1541–1614) recreates this scene interpreted by Pliny the Elder.

Such realistic painting – an optical illusion known as *trompe l'oeil* – became popular as early as the fourteenth century in European painting.

Illusionism

The genre of still life painting grew out of ancient and medieval artists using illusionistic effects or *trompe l'oeil* to show off their prowess and skills in painting. From the earliest still life works, whether in Roman wall paintings or on a seventeenth-century canvas, the use of illusionism by the painter to depict as realistic a representation of the objects as possible has been the foremost artistic principle of this genre.

Two very interesting and unique examples of illusionism can be seen in *Trompe l'oeil* (*Pinboard*), 1666–78 by Samuel van Hoogstraten, which shows a collection of objects seemingly wedged behind a strap which is pinned to a board, and *Reverse Side of a Painting* (1670) by Cornelius Norbertus Gijsbrechts, in which we seem to be looking at the back of a framed painting. A scrap of paper with a sale number adds to the illusion. Both paintings are cleverly executed to make the viewer believe they are looking at something else.

The First Known Independent Still Life

Still Life with Partridge, Iron Gloves and Crossbow by the Venetian painter Jacopo de' Barbari (about 1460/70–1517) is the first independent still life painting to be found in European art. It was painted in 1504 on panel: it depicts a dead grey partridge hanging on a wall along with gauntlets and a crossbow, and the way the subject is handled demonstrates a highly realistic illusionism. A watercolour study for this work dating from the same year can be found in the British Museum.

The realistic depiction of the objects in this still life is further heightened by the carefully observed textures of the wall on which they hang. The depth of the shadow created by the hanging objects and the *trompe l'oeil* effect of the note pinned underneath the gauntlet further highlight the artist's mastery in painting.

At the time of its execution this was a radically new concept in painting, and the objects in this work would be perceived as real objects hanging in space. This highly detailed and observed study from nature suggests that Barbari knew of the work of the contemporary German artists Albrecht Durer (1471–1528) and Lucas Cranach the Elder (1472–1553), and that their extremely precise studies from nature influenced the Venetian artist.

The Origins of Modern Still Life Painting

Until the early seventeenth century still life arrangements were present in paintings, used as allegory or seen as part of an interior, most commonly a kitchen scene. Still life was also used in figure compositions laden with symbolic associations, often a sumptuous arrangement as part of a religious painting, for example the Last Supper. Rarely was still life portrayed as an independent subject, a genre in its own right, as we are so used to seeing in galleries today.

The genre of still life easel painting as a tradition in its own right came into being during the early part of the seventeenth century. Only then was still life as a subject painted for its own sake rather than as allegory or decoration within painting.

Post-medieval still life painting evolved as a result of the significant changes that were taking place in agriculture during this time. The beginning of the sixteenth century saw many changes in agricultural conditions. The medieval farming system of three-field rotation gave way to crop rotation; ground was therefore used more systematically and intensively, resulting in a surplus of crops. This increase in food production led to improved economic conditions. This period was shaped by economic revolutions and, most importantly, the beginning of the dissolution of the feudal structure.

Following years of inadequate supplies, these changes during the late sixteenth and early seventeenth centuries resulted in a surplus of agricultural goods now being produced. This surplus began to be expressed in paintings of market scenes and kitchen interiors, therefore becoming a common motif of artists in Flanders and Brabant.

The towns within these regions – Brussels, Ghent and Bruges amongst them – had been major centres in the guild trade during the thirteenth century, and the first factories were then to follow in the fourteenth century. Most significantly, during the sixteenth century Antwerp (being Brabant's largest port) became the most prominent trade and banking centre in northern Europe. Each day in Antwerp huge cargoes were unloaded from overseas, goods that would be used in the extensive cottage industry of this region; this included the processing of cloth from England, and the production of many other goods including fine glassware, soap and sugar[1]. As market scenes became more prevalent they began to influence the painting of kitchen scenes or *bodegones*. Artists such as Velazquez (1599–1660) painted such scenes, and these would be amongst the finest examples of still life painting to be seen.

The Still Life Painting of Caravaggio

The religious scenes painted by Michelangelo Merisi da Caravaggio (1571–1610) contain some of the most sumptuous and exquisitely painted still life arrangements in the history of the genre. Caravaggio's *Supper at Emmaus* (1601) in the National Gallery, London, shows a table bursting with an elaborate still life. This still life builds on the tradition of symbolism, in that many of the objects included are identifying some other meaning.

This table arrangement shows a growing interest in the everyday objects around us. Everything is beautifully observed, each detail captured: notice how the fruit basket at the front of the painting is about to tip over the edge of the table; also how the shadows and reflections have been painted.

Caravaggio is said to have claimed that it was as much work to paint a good still life as it was to paint a human figure[2]. Wise words indeed, as still life painting was deemed to be the lowest of any genre. At this time still life painting was considered to be inferior to figure painting and '...only those artists who lacked the skill and ambition to work in the more demanding genre, and who sought easy success by painting an appealing but insignificant subject, devoted their energies to still life'[3].

In 1595, the most famous of early Italian still life paintings, Caravaggio's 'Basket of Fruit', shows how inanimate objects could be placed in composition and exhibit the same curiosity and attention to detail and all the other elements usually involved in figure painting. Caravaggio is not interested in the perfection of the fruits, but in their transience, so it is significant that he shows the leaves beginning to shrivel and scars on the surface of the fruits. The basket protrudes slightly over the edge of the table, enhancing its three-dimensional effect. In contrast his painting *Young Man with Basket of Fruit*, in the Galleria Borghese, Rome (c. 1593–94), shows a beautiful young man holding a basket bursting with perfect fruit – grapes, plums, peaches amongst others – where the fruits are obviously attributes supporting an erotic motif[4].

The Golden Age in Spanish Painting

This new genre of painting known as the 'independent still life' that began to emerge in parts of Europe towards the end of the sixteenth century, was particularly striking in the art that emerged from Spain. In the years following Caravaggio's death, a young painter in Seville began to combine still life elements in his figure paintings: the young Diego Velasquez began to paint still life objects of great beauty, carefully observed and often revisiting and painting the same objects in different compositions.

A biblical scene of *Christ in the House of Martha and Mary* in the National Gallery, London (1618) shows how the main subject or 'main action' of the painting has been relegated to the background, while in the foreground two figures are shown preparing a meal. The vessels – brass pot, ceramic jar and eggs and fish – all show the artist's virtuosity; it seems that his intention is for these objects in the foreground to be the focus of our attention, rather than the figures in the background. The foreground figures are finely observed, being modern models placed in a set-up within the studio.

The quality and exquisite paint handling shown in such still life arrangements begins to transcend all other elements within the composition.

The exquisitely painted *The Water Seller of Seville* in the Wellington Museum, London (1623) shows the effects of reflection and refraction on the side of the ceramic jars. The rendering of the splash of water on the terracotta vessel is a superb demonstration of the artist's skill.

The painter Juan Sanchez Cotan (1560–1627) began to paint still life works as a way of supplementing his income. Along with his early religious figure paintings he sought to revive the practice of still life of the ancients, and created a series of strikingly modern still life pieces. His remarkable still life of c. 1602

Quince, Cabbage, Melon and Cucumber shows humble fruits and vegetables that are life size set within a window frame. The composition has a distinctive gravity and austerity, being characteristically Spanish. The fruits and vegetables are set against a velvety black void of background, in harsh contrast with the illuminated subjects set within the frame. This contrast serves to accentuate the three-dimensional form of the objects. The clarity of the surface textures and the realism of the forms within the abstract geometric shape are captivating in their beauty and harmony.

The painter made a number of other still life paintings using a similar pictorial structure and a variety of fruits, vegetables and game. These were busier in composition but with the same format, namely brightly illuminated objects set within a window frame against a dark background, almost as if modelled in relief.

The painter Francisco de Zurbaran (1598–1664) is one of the greatest artists of the Spanish Baroque; he is renowned as a painter of devotional works of saints, monks and holy figures. Independent still life played a relatively minor role in Zurbaran's art, but the few remarkable still life paintings that he produced are amongst the greatest in the genre. His bold use of colour – exaggerated against a dark background in many works, along with his flat surfaces and an unconventional approach to perspective – was to have a profound influence on other artists, for example the French painter Chardin.

In his still life paintings Zurbaran achieved a powerful devotional element, which I feel is akin to his religious pieces. They are devotional and contemplative in mood – humble everyday objects elevated to a higher 'plane of reality'. There doesn't seem to be any obvious symbolism, but the way in which the objects were painted could be interpreted as a religious piece with a meditative quality.

It is this particular meditative and contemplative quality that has the greatest influence upon my own still life work; furthermore it is not only in Zurbaran's still life works that it is found, but also in the works of other artists, as I will discuss in relation to specific still life paintings of my own.

Influences and Inspirations

I have always devoted some time to painting small-scale still life works in the studio. In these paintings I try to express the quintessence of the subject by reducing the number of objects or elements in the composition to a minimum. Quite often the initial spark of an idea will be of one colour vibrating against another, or the relationship of one object to another in colour, texture, shape or form.

I work on many of the still life paintings over a period of

weeks, sometimes months, demonstrating the intensity of observation involved. All the compositions are set up directly in front of me in the studio, and each painting develops over a sustained period that allows for the close study of each element in the picture. I will work on a painting over a similar period of each day or time of the week so that the lighting conditions may be as constant as possible. Inevitably small changes will arise, as some days are brighter than others, but it is these small revisions in a sustained piece that give it its carefully considered quality.

In selecting particular objects I am analysing many elements, including colour relationships, shape, form, design and pictorial structure. Some subjects may be more biographical, introducing narrative – for example, some objects may remind you of people and places, or of a particular situation in time.

Looking through an exhibition catalogue of the British painter Patrick George (1923–) I saw the following quote, which I thought summed up that initial excitement of seeing that something you wanted to capture:

> If I see something I like, I wish to tell someone else.
> This, then, is why I paint.
> Patrick George 2007

The painters I have always found inspirational – and particularly their still lifes, which are very intimate in feel – are William Nicholson, Euan Uglow, Craigie Aitchison and Giorgio Morandi. I will observe each painter further, in this chapter, discussing particular paintings and how the artist has had an influence on my own work. Through these paintings I will show how the work of one or more artists has influenced some aspect of my work.

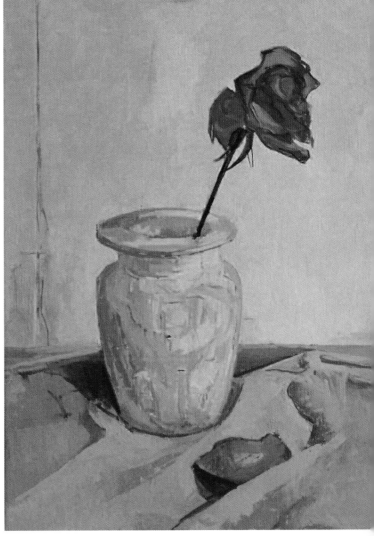

Memories.

Memories

This small painting (18 × 24cm) I feel shows the influence of three of the aforementioned painters: Morandi, Uglow and Aitchison all worked with the motif of flower/s in a vase, placed quite centrally in the canvas with a lot of space surrounding the subject. These quiet paintings have a wonderful serenity and calm about them. The subject of flowers in a vase is one that has been revisited many times throughout the history of 'modern' still life painting.

What I feel separates these particular paintings and artists from the abundant 'others' is the way the subject has been placed in the rectangle of the canvas. For me it is the amount of space around the arrangement that lets the painting 'speak', and gives each its air of quietness and solitude.

The small alabaster jar is a motif that has been repeated in many of my recent still life works. The particular shape of the jar

– a slightly warm cream colour, along with the dark burnt orange of the slowly dying rose – was placed in a set-up with similar light, colours and tones purposely to enhance the subtlety and delicacy of the objects. The fine veins in the alabaster, and the delicate stem of the flower, give a linear, drawn detail to the arrangement.

Craigie Aitchison's *Vase with Lily Still Life* (1982) depicts a beautifully delicate, white lily, a single stem in a white pot decorated with a bird. The arrangement is placed quite centrally in the canvas and is particularly striking as the background colour selected is an incredible bright yellow, so vivid that it seems to vibrate as you look at it. The vase stands on a black surface that stands in stark contrast to the subtle colours of vase and flower.

Aitchison's *Grey Vase: Still Life* (1965) shows an even more sensitively conceived flower in a vase. A yellow flower stem emerges from a long slim pot, and again the subject is placed centrally with a lot of space around it. This whole composition

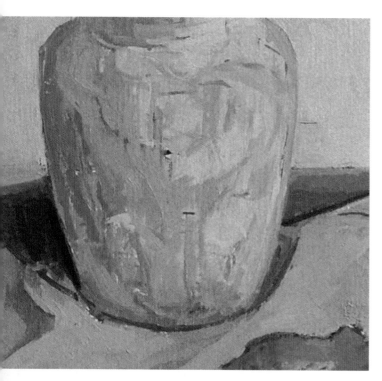

Detail of alabaster jar in *Memories*.

shows a subtle delicacy in the quietly reduced palette of light blues and greys and the harmony of the composition. Of this painting Aitchison commented:

> I think with this one I might have been influenced by Morandi. I was crazy about him at one time.[5]

Morandi's painting *Flowers* (1950) shows a beautifully harmonious and simple composition. The flowers in a white vase are once again placed centrally in the composition, depicted with a palette of subtle 'greys' with much space around the vase.

The motif of a flower in a vase was one that Euan Uglow often returned to, and it is difficult to select any one individual still life piece as an influence, they have all been so greatly admired. Notable still life paintings to look up are *Mimosa* (1971), *White Flowers on Yellow* (1971) and *Camellia* (1981).

Craigie Aitchison (1927–2009)

This artist painted many still life works in the course of his career. These are paintings of a poetic economy and rare beauty. The subjects he chose to paint came from the collection of assorted bric-à-brac in his studio. A flower in a vase was a recurrent theme, and lilies became a favourite flower, being painted many times. The two still lifes discussed above bear all the essential elements of a Craigie Aitchison painting: greatly simplified yet immensely evocative, becoming the 'quintessential still life'.

Euan Uglow (1932–2000)

Of his painting Euan Uglow said:

> I am not a still life painter. I am not a portrait painter. I am not a painter of nudes. I am just a painter.[6]

No particular genre was considered to be more important in its hierarchy. However, in many ways it is Uglow's still life paintings that best define his preoccupations and ideas in painting. His early still life paintings reveal an academic origin, the colour being more sombre than in the later paintings. Each work shows a painstaking act of measurement, resulting in his finished paintings faithfully recording the entire process of each piece. His ruthless eye for detail in translating each nuance, contour or tonal shift, is characteristic of his entire oeuvre, whether still life, portrait or nude.

Still Life with Silver Pot

This painting, the earliest of my still life works used in this book, was inspired by the intimate and quiet still life paintings of William Nicholson. As are many starting points for my still life works, the silver pot was a gift and my intention was to place it

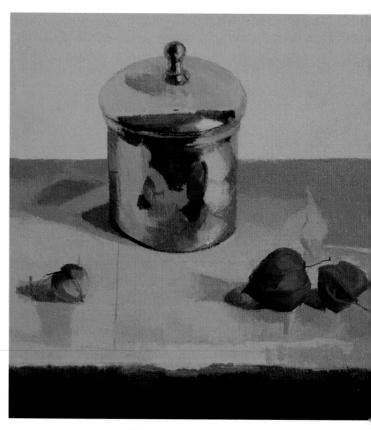

Still life with Silver Pot.

in a small painting, just adding the Chinese lanterns to add a dramatic note of colour, which would be reflected in the pot's surface.

William Nicholson's *The Silver Casket* (1919) was a painting that I had recently seen in a retrospective of the artist's work. This was the first time I had seen a large number of his works together, and the still life paintings selected were exquisite. The harmony and 'quietness' of the works are almost meditative in nature and I greatly admire the mood and quality of these wonderful still life paintings.

Along with Chardin, Nicholson painted some of the most beautiful reflective surfaces within the history of still life painting. Nicholson's use of composition is of particular interest to me. The amount of negative space around the objects and the placing of the subject within the rectangle is an inspiration to me; it also made me begin to think of reducing the number of objects within a painting.

In *The Silver Casket*, the subject is placed centrally upon the horizontal within a rectangular space, almost halfway on the vertical. A dark umber tone hints at the edge of the tabletop, and also gives an added weight to the overall composition. The palette of muted greys is reflected in the silver surface. It is the pale blue gloves lying at the base of the casket, and the bright red beads in the bottom right of the composition that give the painting its note of colour, which is then reflected.

In the same way I used the vivid colour of the Chinese lanterns in *Still Life with Silver Pot* to create a greater depth within the painting, the warm and bright colour being at the front of the picture space. Looking at the reflection of the orange forms in the silver pot creates a pictorial depth and a heightened feeling of space.

The overall palette used was purposely kept to rather muted, almost coloured greys to enhance the oranges further. This is something that has continued in a more recent collection of paintings.

The Lustre Bowl (1911), also by William Nicholson (in the Scottish Gallery of Modern Art, Edinburgh), shows a similar compositional motif. The bowl is placed almost centrally in a nearly square canvas, the dark sombre tones of the pewter reflecting the white cloth and pea pods placed to the right of the bowl. The flat and rich dark of the background adds an abstract quality to the overall composition. The brushwork is fluid, and the paint surface quite thin and very simply executed when viewed close up.

Jean Baptiste Simeon Chardin (1699–1779)

The French painter Chardin is considered to be one of the greatest still life painters in the history of art. The artist was greatly influenced by the subject matter and realism of the sev-

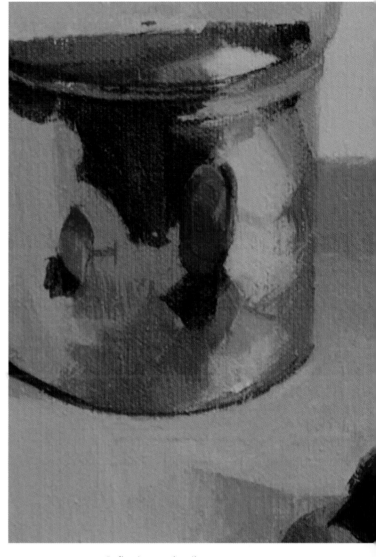

Reflection on the silver pot.

enteenth-century Dutch masters. Chardin's paintings contrast with the highly decorated Rococo period that dominated eighteenth-century French painting.

His still lifes are simple, yet beautifully textured. Close attention is paid to the contrasting surfaces, which are finely observed.

The painter uses the strategy of placing each still life arrangement on a shelf against a dark background. His reflective surfaces, brass pans, carafes and pewter vessels are of particular interest. His *Goblet and Pewter Jug with Peaches* show beautifully reflected fruit in the reflective surfaces. In particular his paintings *The Copper Water Urn* and *Copper Cauldron with Three Eggs*, both c. 1734 and found in the Musée du Louvre in Paris, show his mastery of painting reflective surfaces.

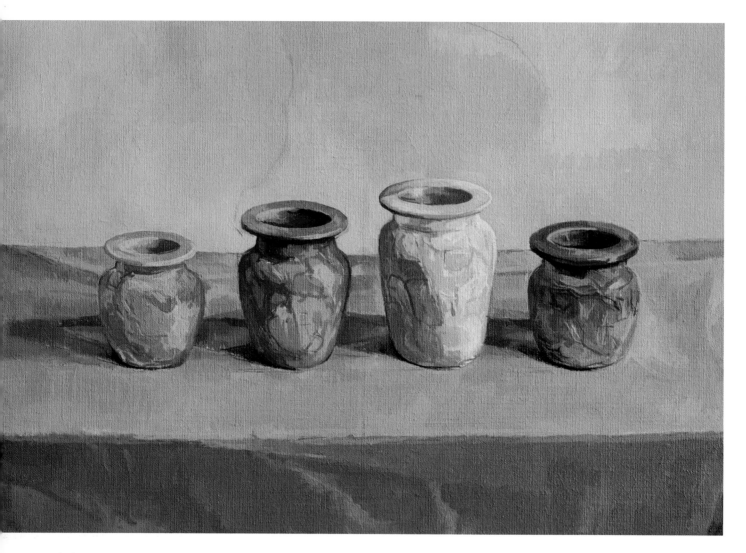

Alabaster Jars

A small group of Egyptian alabaster jars have been the inspiration for a number of still life pieces. Some of the paintings show the jars standing alone, while in others a jar is shown with other objects, for example a rose or a carving. Throughout my work the most obvious influence for the subject matter of pots and jars alone would be the Italian Giorgio Morandi's paintings and etchings.

Giorgio Morandi (1890–1964)

Throughout his career Morandi constantly returned to the subject of jars, pots and jugs. Many of the same jars are used in a number of different paintings, in a variety of arrangements and compositions, the placing of each one carefully considered, its relationship with the other pots and also the way the negative spaces around the objects are used. (The negative spaces are the shapes and spaces around the objects and between

them.) Often Morandi would paint the same group of objects in the same placing, creating a number of works from them in either different lighting or palette.

The reduced palette and harmony of the still life works of Morandi is the most immediate reference to my work, but another painter who has been of great influence on my ideas and still life work is the Spanish painter Francisco de Zurbaran.

Zurbaran's *Still Life with Jars* (c. 1635, found in The Prado, Madrid) bears the same structured formality as *Alabaster Jars*. Although very different in palette and tone, the elegance and simplicity, along with the tranquillity and calm of the Morandis, set 'the mood' for the alabaster still lifes. Alabaster itself is a wonderful subject, the range of subtle colours and the translucence of the stone giving a wonderful sense of light, and the natural veins allowing for a linear and drawn approach, seen alongside areas of colour and tone.

The starting point for this particular composition – the formal arrangement of the four jars in a row – came from an idea of the four canopic jars used in Egyptian funerary customs. Each of the jars had already been painted in other still life works and so each

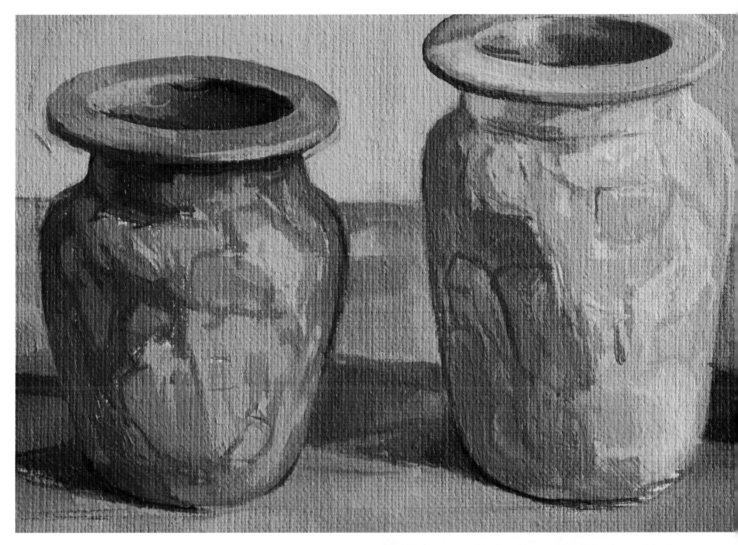

Opposite: Alabaster Jars.
Above: Detail of the drawing on the surfaces of the alabaster jars.

had taken on a particular 'identity'. (Zurbaran's four jars stand like four women standing chatting with hands on hips!) The relationship between the four alabaster jars, despite their asymmetry, reminded me of their Ancient Egyptian origins.

Still Life with Quince

Over the years I have painted many still lifes of a single fruit. To simplify a painting to only one object is to study its very essence and every detail, and has always been of great interest to me. In the same way that Euan Uglow and Craigie Aitchison made paintings of one object, whether a skull, pear, cast or onion, I placed the quince on its own in the centre of the canvas.

The quince is positioned on a crinkled white cloth against a pale, warm orange background. A dark triangle hinting at the table is seen in the bottom right corner of the painting, adding

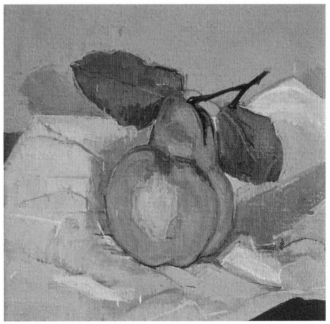

Still Life with Quince.

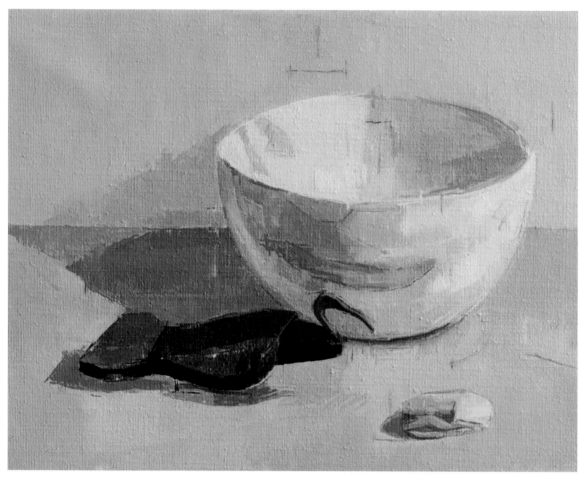

Left: *Egyptian Gifts I.*

Below: Detail showing the planes of tone moving over the ibis figure and the bowl.

Opposite: *Egyptian Gifts II.*

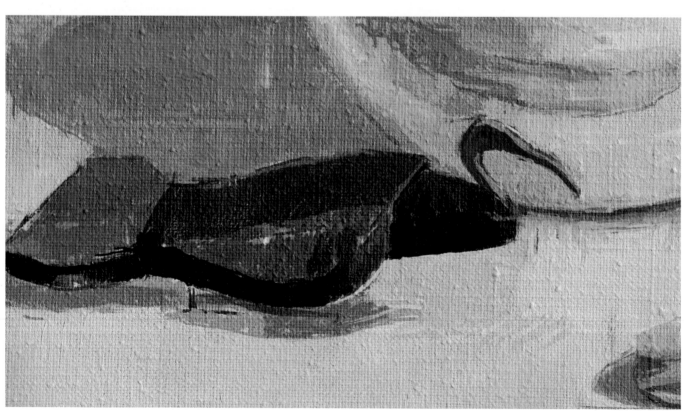

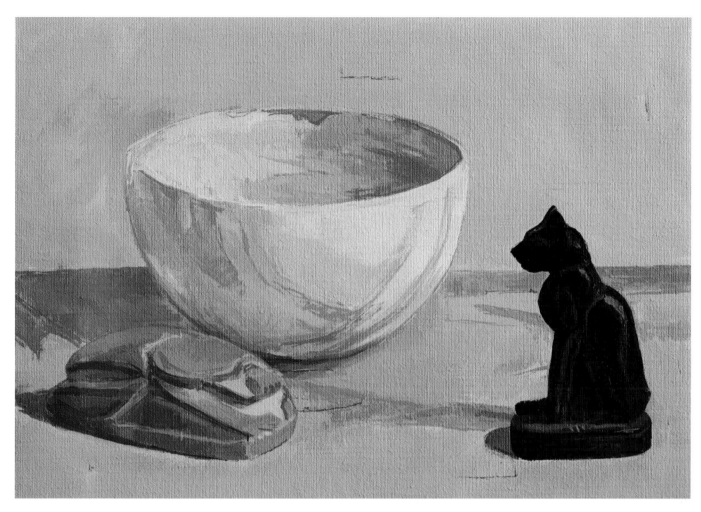

weight to the overall composition. The leaves and stem of the quince give a linear quality that contrasts with the weight and solidity of the fruit while also giving small negative shapes within the composition.

Egyptian Gifts I

The three objects in this painting are an alabaster bowl, a carving of an ibis and a small scarab. All these objects were gifts, and I wanted to make a small still life of the three things together. The composition is inspired by the harmony of Uglow, while the reduced and 'quiet' palette and light are reminiscent of Gwen John.

The starting point was the small ibis figure. I particularly liked the fine linear quality of the head, neck and feet against the bulk of the body, described by the flat planes of tone moving over the body. The lines running through the alabaster bowl give it a drawn quality alongside the sharp edges of colour planes. The texture of the bowl is quite bone-like and reminds me of a skull in an earlier painting.

The British painter Gwen John (1876–1939), known for her introspective and contemplative subjects, painted a number of beautiful still life and objects in interiors. Two still life paintings to look up are *Still Life with Straw Hat* (c. 1920–5) and *The Japanese Doll* (c. 1925). Both show still life objects set on the same table in the lower part of the canvas, the light falling on the objects from the small window at the upper right in the picture. The quality of the light and palette, along with the painterly quality of the brushwork, make this artist's work so inspirational to me.

Birthday Orchid

Orchids have inspired a number of my paintings, either the flower heads alone or, as in this case, a single orchid plant. The paintings of both Uglow and Nicholson have always been an inspiration to me, in particular their paintings of plants and flower stems.

The 'birthday orchid' is placed on the left side of the canvas. The top right edge of the yellow pot is positioned exactly on the halfway point of the vertical. The flowers and stems all lean to the right side in the top of the picture so that the overall weight

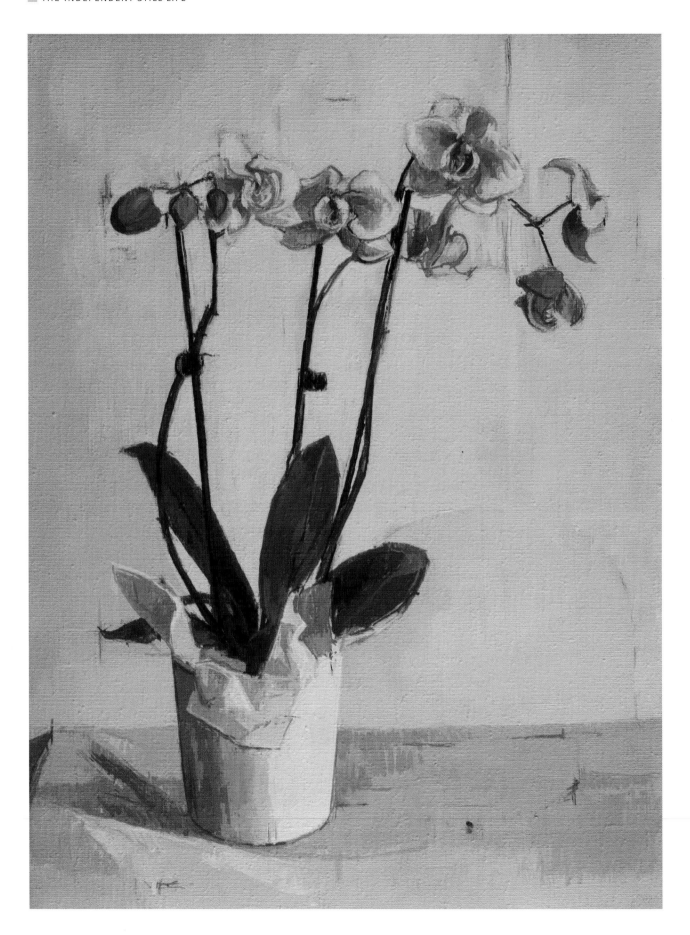

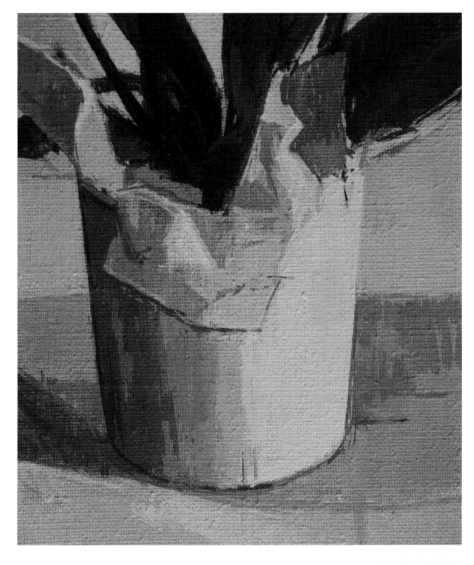

Opposite: *Birthday Orchid*.

Left: Detail of *Birthday Orchid*, showing the drawing and the patches of colour on the pot and surface.

of them makes the plant appear more centrally placed within the rectangle. It doesn't feel as if the plant is placed too much on the left.

There are many drawn lines throughout the canvas, giving information about the area around the subject. Over the surface on which the orchid stands the areas of colour, edges of tones and the use of line describe the folds and markings, while the patches of colour moving around the ceramic pot create form. On the background wall faint lines can be seen, showing markings where earlier still life arrangements have been placed.

Nicholson's painting *Cyclamen* of c.1937 in the Courtauld Institute of Art, London, shows a number of red flowers in a beautifully painted ceramic jug. The focal point of the painting is the jug, its design painted in a fluid and 'painterly' fashion, the red flowers almost falling out of the top of the jug. The handle has broken away and there is a very deep shadow running from left to right behind the jug. The size and weight of the shadow to the right of the jug acts as a counterbalance to the weight of the red flowers to the left.

FINDING YOUR OWN INSPIRATIONS

You may already know of a number of artists whose work inspires you. Before you begin to set up your own still life arrangements it is a useful reference to find a selection of paintings or artists that you find interesting or which excite you and make you want to paint.

Try to find a number of contrasting examples of still life paintings: they can be by artists from any period – they may even be painters known to you. Is it their subject matter, palette or use of composition that inspires you? Display the images in your workspace, or keep a sketchbook with images that you can dip into as you need.

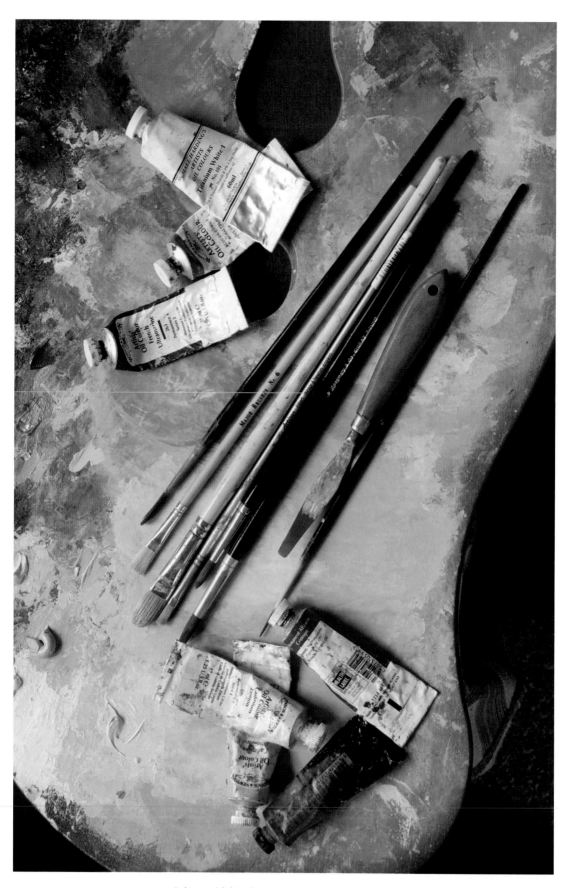

Palette with brushes, palette knife and paint.

METHODS AND MATERIALS

In this chapter we will look at the methods and materials used specifically when painting in oils. There is a wide variety of materials available to the artist, and it can be difficult to know which are the best in order to get started.

Oil Paint

Why oil paint? Oil paint is a wonderful medium to use. Its colours are rich and luscious, and the paint itself has a consistency that is quite unique and distinct from any other medium. Students are often fearful of using oil paints for the first time, reluctant to make that final step towards using them. Oil paints are thought to be messy, and time-consuming when clearing up after using them; and their greatest challenge is that they stay wet for a long time. This shouldn't be off-putting, however: there are techniques for laying down paint 'wet over wet', and there are many advantages to working with a medium that remains wet and movable for a longer time.

Oil paints offer so many possibilities in ways of application: applying the paint thickly (impasto/opaquely) using a brush or palette knife, laying it down in one go and in one layer, or building up the surface of a painting in layers of glazes. Students are often fearful of the transition from water-based paints to oil paints, but many become total converts after trying them for the first time, wondering why they had waited so long! Yes, the paint does feel very different to begin with, and it responds in a very different way from anything else, so do persevere – it is well worth the challenge!

What is Oil Paint?

Oil paint is made when pigment is mixed with oil, most commonly linseed oil. Sometimes other ingredients may be added during the manufacturing process, but the higher the quality of pigment, the better quality the paint. Historically artists (or their assistants!) would make their own oil paints from dry pigment and medium, and some artists today still prefer this more traditional method of working. But for those of us who don't have time to mix our own paints before we begin work, fortunately modern colours are available in tubes of various sizes – indeed all colours of the spectrum are available for the artist today in tube form.

What are the Characteristics of Oils?

There are many different brands of oil paint on the market, and students are often unsure which to buy. So how do the various makes differ: are the colours the same, and can different brands be used and mixed together?

It is important to try more than one brand of oil paint – don't stay with one particular make just because that's the only one you've ever bought. Try to compare and contrast different makes of paint until you find one that works for you – it may be the vibrancy of the colour or the paint consistency that attracts you. Many artists work with a number of different brands within the same palette, perhaps preferring a colour in one brand and a different colour from another range. So don't worry about having more than one paint brand on your palette at the same time: it is fine to intermix them.

When selecting oil colours, bear in mind that colours can vary from brand to brand. This is because there are variations in the manufacturing process of different brands of oil paint. Each brand has its own individual 'recipe', which is kept strictly under wraps, and as a result there are many differences between each brand. Some paints tend to be stiffer in consistency, other brands will feel buttery; some may be glossy, while others can feel quite grainy. Also, although between makes, some colours on the colour chart will have the same name, you may find that there is a slight difference in colour.

When selecting colours, try to get hold of colour charts from different paint manufacturers, and if possible try to get colour charts that are hand-painted rather than the mass-produced,

Interior of a paintbox.

commercially printed variety, as you will find that the colours will be closer to what you find in the tube. And when buying paint, it is advisable to try more than one brand so that you can begin to compare and contrast them. You will notice that some brands will have quite a different consistency, and brushing quality and drying time will also vary between different makes and different pigments.

Colour charts will give you information on each colour, such as whether they are opaque or transparent, the permanence of the pigment and the colour's undertone.

It is also advisable to try different whites, and to avoid buying cheap white paint as the cheaper brands tend to darken or

appear to become yellow. If you have tubes with the same colour name but of different brands the strength of a colour in one make can be tested against another by mixing it with white: you can then compare how the colour mixes.

Artist Quality Colours versus Student Quality Colours

All colours are available as student quality and artist quality. So how do these differ? The artist quality colours are sold in series, from series 1 to series 6 in some makes, and the higher the number in the series the rarer or more expensive the pigment – so they are priced accordingly. Thus earth colours will be found in series 1, and cadmiums and cobalts in series 4. Series 1s are cheaper than series 5s.

In artist quality colour you will find a higher proportion of pigment, which tends to be of a better quality when compared with student oil colour. Student paints tend to use less pigment and a lot more fillers with the paint, so the colour seems to be more dilute and unsaturated.

Brushes

There is a vast array of brushes to select from, and when starting out it can be quite a challenge to know what to buy for the best. You may find quite quickly a type of brush or a particular shape of brush that works well for you. But if not, don't worry:

Different brush shapes.

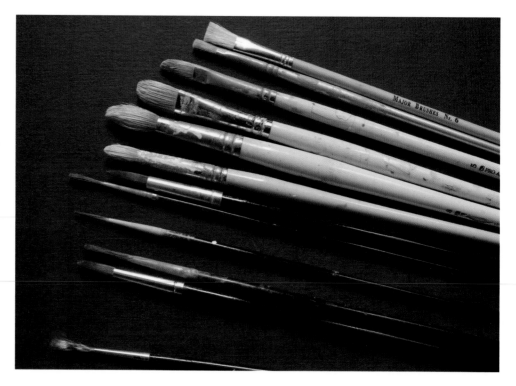

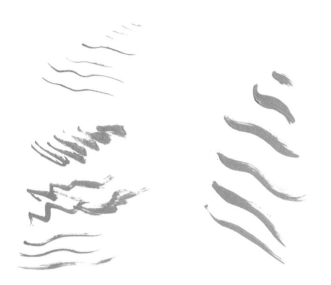

Strokes using rounds and rigger brushes.

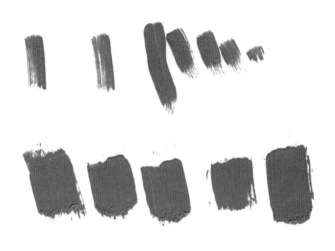

Strokes using flat brushes.

just select a couple of different types and see which works best for you.

The choice of brush is very personal. They respond very differently, with so many 'influences' coming to bear on the brushstroke: the consistency of the paint, the pressure and delicacy of the painter's touch, and the speed of application will all give a different type of mark. The surfaces that we choose to paint on will also make quite a difference to the feel of a particular type of brush; thus a smooth surface will allow the brushstroke to glide, whereas a heavy, coarse canvas will require a stiffer brush to lay down paint.

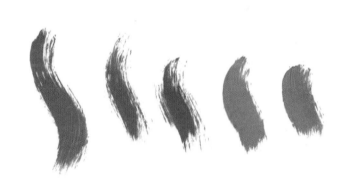

Strokes using filbert brushes.

Brush Shape

Brushes suitable for oil painting are most commonly found in three main shapes: rounds, flats and filberts. Within each range there are many sizes and also many bristle types to choose from. Brushes are made with either a natural bristle or with synthetic bristle.

ROUND BRUSHES
Rounds are a popular choice and useful for everything from the initial sketching out of a composition to layering and more detailed work later on. They can be found as both natural and synthetic and in sizes from 0 to 20. A round brush will usually be pointed (although it is possible to find round brushes which are flat and 'dome'-ended). Rigger brushes are round in shape but with a longer bristle; these are very useful for drawing with paint, and also for those finer details later on.

FLAT BRUSHES
Flat bristles are square-headed in shape. A brush of this shape allows the painter to achieve a precise stroke, and is useful for blocking in when using a larger size brush. The chisel-shaped bristle gives a sharp edge to the paint stroke; think of the shape and angles in Cezanne's paintings.

FILBERT BRUSHES
Filberts are flat in shape but with a tapered, rounded shape that gives a softer, less angular paint stroke when compared to the more traditional square flat.

All bristle types and shapes can be found in both short and longer lengths. You will find that some bristle shapes and lengths work better for certain strokes or areas in a painting. Experiment with different-shaped brushes until you find the ones that work best for you.

Brush Fibre

Brushes made from natural fibres are best for oil painting, and in particular hogs' hair. Chungking hog bristle is considered to be the best quality when oil painting (these bristles are from hogs in the Chinese region of Chungking).

The quality of brushes can vary greatly, so look out for a good quality brush – it is money well spent. Cheaper brushes can be a false economy, tending to shed bristles on to the painted surface. With good care your brushes will last a long time. Better quality brushes will keep their shape for longer and are less likely to 'splay'.

Sable brushes are mostly associated with watercolour painting. When used with oils a sable brush will allow a flexible and soft stroke. Kolinsky sable is expensive and should be considered an investment, nevertheless it is one of the best brushes you can buy.

Mongoose-hair brushes are beautiful to use. The bristles are fairly firm, yet the tip is velvety soft to touch; this makes the brush very responsive and firm in stroke, but allows a delicate touch. The bristles of a mongoose brush are quite distinctive as the hairs are patterned.

Synthetic bristles can be used for both oil and acrylic paints; they are firm enough to use with a stiffer paint mix but the bristle is softer than a more traditional hog-hair brush. Synthetic brushes tend to be nylon, or nylon mix, which gives a soft but firm stroke. This holds the oil paint well and the brushes retain their shape during use.

Care of Brushes

To ensure a long life to your brushes, look after them and take time to wash them thoroughly after use. Wipe as much paint off the bristles as possible with a rag, then using your usual thinners – turps, white spirit or zest-it – to rinse your brushes, removing as much paint residue as possible. Using liquid soap (washing-up liquid), work a small amount of soap into the bristles in the palm of your hand; then thoroughly rinse the brush using hot water, and dry carefully.

If any brushes go hard as a result of forgetting to wash them or because of old residue build-up, soak them overnight in thinners, then wash them with hot soapy water. If old brushes have lost their shape because they have been stored incorrectly, wash them and then work a small amount of Vaseline into the bristles to gently reshape the hairs; wash this out before using the brush again.

Painting Surfaces – Boards, Canvases and 'Homemade'

Go into any art shop or open any art supplier's catalogue, and you will be faced with a whole assortment of prepared surfaces suitable for use with oil paint. There will be a wide selection of prepared canvases, linens, canvas boards and gesso panels.

A selection of painting surfaces.

Each surface can feel quite different when applying paint: a canvas support is flexible, while a canvas board or panel will be rigid; some surfaces will be smoother than others, while canvas textures can vary from fine to very rough. As with selecting brushes, experiment with different surfaces until you find the ones that you most enjoy working on.

Canvases

There are many reasonably priced stretched canvases available to buy today, found in a variety of retailers, shops and mail order; it is therefore possible to experiment with different surfaces and sizes before you consider stretching your own canvases. Both primed and stretched linen and 'cotton duck' are available.

Bought canvases will have been primed with one or more coats of rabbit-skin glue or gesso or acrylic primers; this allows you to paint on the surface straight away with no further preparation. Most prepared canvases have been treated with an acrylic primer, recognizable by the white surface. Boards or canvases with a natural linen colour have been prepared with rabbit-skin glue; this is transparent when applied to the surface.

Better quality linen canvases are often prepared with an oil-based primer that is not as absorbent as a gesso primer. The packaging should state clearly which primer has been used, but if in doubt ask someone in the shop.

Canvas indicates a flexible painting support, stretched tightly over a wooden stretcher. Most commonly a canvas is made from cotton, known as 'cotton duck', but it can also mean a fabric made of other natural fibres such as linen or flax. The majority of prepared and stretched canvases available will be cotton duck. The quality of a cotton duck canvas depends on the weight and closeness of weave. Unprimed cotton duck will shrink a little when primed, particularly if it is a looser weave and lighter weight. Cotton duck is more closely woven, and a heavier weight fabric will be better quality and more satisfactory to work on.

Linen has been used as a support for oil painting for many centuries; most linen is woven in Belgium. It is considered to be superior in quality to cotton duck, and as a surface it is more durable, stronger and more stable. Linen fibres are closely woven and are less likely to shrink once primed. Linen can be bought in coarse, medium or fine (sometimes referred to as 'portrait') weave; this refers to the texture and weight of the canvas. Fine, 'portrait'-quality linen is often chosen by artists wishing to work in a more detailed manner.

PRIMING

It is possible to find a variety of primers; most canvases are prepared with size followed with a couple of white coatings of a gesso acrylic primer. Others are primed with size (rabbit-skin glue), which leaves the natural linen colour of the canvas and is a lovely surface to work on. It is worth trying both tones as a starting point to see which you prefer.

Try to buy a support that has had at least two or three coats of primer otherwise paint will be absorbed, resulting in a 'lifeless' surface.

Canvas Boards

Some may prefer to work on a more rigid support, either a canvas board or wooden panel. It is possible to find many different shapes and proportions; when working on a smaller scale, in particular, boards are ideal. Canvas boards can be found already prepared and ready to work on: they are either sized with white acrylic gesso, or rabbit-skin glue can be used, which retains the natural linen appearance.

Those who like a very smooth surface to work on might try a gesso panel. The surface is beautifully smooth, rather glass-like. The paint will be readily absorbed into the surface to begin with, but as the paint surface builds, this will lessen. Gesso panels are particularly good if your work has a highly detailed finish.

Homemade Surfaces

It is possible to make you own surfaces to work on – pieces of card, mount board, or bits of plywood are all good to try. Prepare your surface with two or three coats of acrylic primer, evenly applied; let each coat dry thoroughly before proceeding with the next. It is always useful to have some small boards prepared with you so if you wish to try a second painting, or to make a quick study, you can do so without being precious about a more expensive, bought surface.

Stretching Your Own Canvas

Being able to stretch your own canvas is a useful skill to have, as this will give you much greater freedom when selecting the

EQUIPMENT NEEDED

To stretch your own canvases the following equipment will be needed:

● canvas
● four stretcher bars
● hammer
● tape measure
● canvas pliers
● staple gun
● wood wedges

(See *List of Suppliers* on page 151 for a suggested list of art suppliers.)

scale, proportion and surface you prefer to work on. So often we find that the sizes and proportions of canvas available for sale in shops are limiting, and are never able to find quite the size and shape we want when we need it most.

Knowing how to stretch your own canvas is also particularly helpful if you find a canvas or linen that you really like: you can then buy it on a roll, and by keeping a supply of stretcher bars of different lengths in the studio, you will be able to prepare a canvas of any size or proportion as you need it.

Those wishing to work on a much larger scale will find it useful to be able to stretch their own canvases. Many art suppliers will make up a canvas on request, but of course at a price,

so it will be much cheaper to make up your own canvas, particularly in larger sizes.

Before laying out your equipment, cover the tabletop with a cloth. Keep the surface as clean as possible. If you are using pre-primed canvas it is particularly important to cover the surface so that nothing can dirty or scratch the primed canvas; if pre-primed canvas is damaged it can lead to problems later once paint has sunk into the fabric, through the primer.

STEP 1: ASSEMBLING THE STRETCHER BARS

Once you have decided on the size of your canvas, you will need to assemble the stretcher bars. Wooden stretcher bars vary greatly in quality. They are usually made from seasoned pine or woods that are fairly resistant to warping, but make sure that the bars you buy are warp-free. The front edge of the stretcher bar will be raised: this is the side that will touch the canvas, and its purpose is to keep the canvas away from the frame once it is stretched. If the edge of the frame is too close to the canvas a line or edge will appear on the front of the canvas as you begin to paint, and pressure when applying paint will result in this edge being imprinted on to the front surface.

Stretcher bars come with mitred corners so they can be slotted together. The joints can be knocked together using a hammer (preferably with a softer head, either rubber or wooden) to make a square or rectangle; the piece of canvas will be stretched over this frame. If the frame is longer than 90cm (36in) in either direction it is wise to use a crossbar that will help to maintain the canvas shape over time.

The wooden wedges supplied with shop-bought canvases will be inserted into the corners once the canvas has been fully attached to tighten the fabric if necessary.

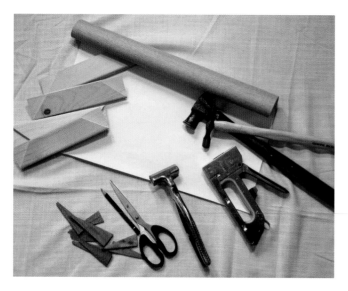

Equipment needed for stretching a canvas.

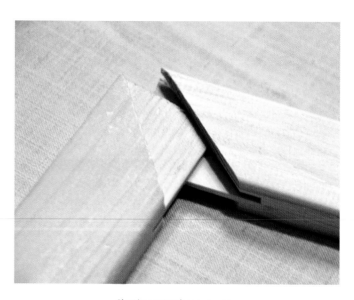

Slotting together a corner.

Assembling the stretcher bars.

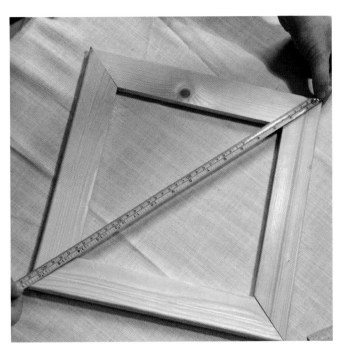

Measuring from corner to corner.

STEP 2: CHECKING THE ASSEMBLED FRAME

To double check that the assembled frame is 'square', measure the diagonals from corner to corner. Then do this in the opposite direction. Both diagonals should be the same length; if they are not, reassemble the frame and check again.

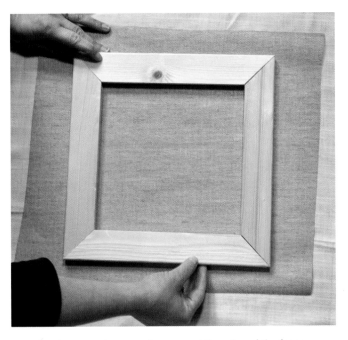

Leaving enough canvas free around the edge of the frame.

STEP 3: PREPARING THE CANVAS

Make sure that the piece of canvas is at least 5cm (2in) bigger than the outer edge of the frame. Until you become more practised at stretching canvases it is advisable to have more than this.

Once the canvas is cut to shape and the frame assembled, lay the piece of canvas on the table; if it is pre-primed make sure that the primed side is face down. Then lay the stretcher over the top. Remember that the side with the raised edge also faces down on the back of the piece of canvas. Make sure to have at least 5cm (2in) of material spare on either side of the rectangle; this will make the process of stretching the canvas easier.

There is one final thing that needs to be checked before attaching the piece of canvas: the weave of the material runs horizontally and vertically, so line up the edges of the frame with the horizontals and verticals of the weave. Like this, everything is square: there is nothing worse than rushing a canvas to find that, once finished, the threads run diagonally when compared to the frame.

STEP 4: ATTACHING THE CANVAS

Once you are sure that all the canvas is protected by cloth on the table or floor, begin to attach the fabric. The easiest tool to use for this is a staple gun, although tacks can also be used to do this.

As you begin to stretch the canvas, make sure that enough pressure is used. However, it is important not to over-pull or you may risk cracking the primer by putting it under too much stress.

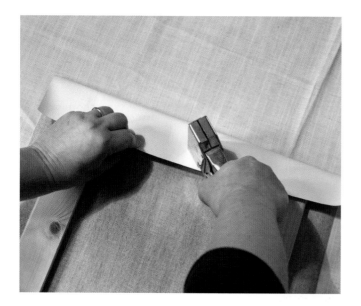

Attaching the canvas in the centre.

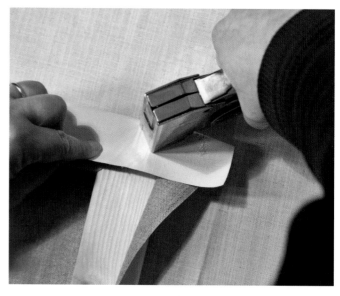

Fastening the corners.

Stretching a piece of unprimed canvas is much easier than stretching a primed one, but be careful not to over-pull and create too much tension across the canvas surface. You will get a feel for the process. When stretching a piece of primed linen it always seems that you need to use more pressure, and it is important to be careful not to scratch the primer.

Using the staple gun, attach the canvas in the centre of each side of the frame. Work in opposite each time: attach the canvas at the top in the centre, then at the bottom. Then rotate it 90 degrees and do the same. Pull the canvas towards you using the canvas pliers, using equal pressure each time and carefully pulling the canvas around the back of the stretcher; then secure it with a staple.

Once a staple has been placed in the centre of each side, pull the fabric gently and fasten down the loose fabric in the corners: this will make sure that you don't over-pull the fabric as you are stretching. Place a staple just to one edge before the joint.

The next step is to work from the centre point out to the corners, attaching with staples as you go. Gently pull the fabric slightly away from the centre, securing from the halfway points along each edge as you go.

Continue to fasten down from the centre to the corner along each edge of the frame until the canvas has been secured all the way around. The staples don't need to be too close together: a 4–5cm (1½–2in) gap will be fine.

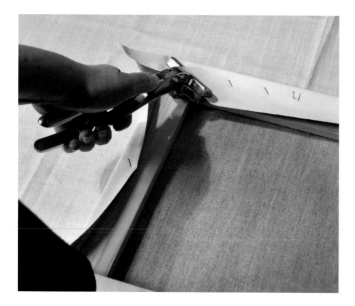

Further attachments.

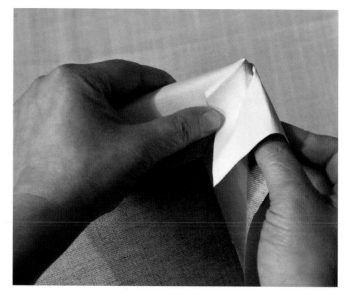

Folding the fabric.

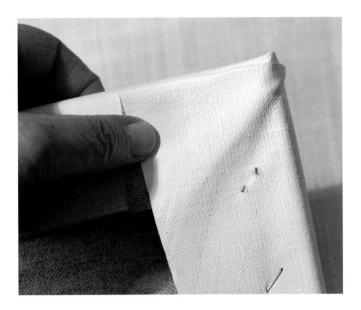

Fastening down the corners.

STEP 5: SECURING THE CORNERS

The final step is securing the corners. Fold over the corner flaps and carefully fasten them down. To begin with this is quite tricky, but don't despair, and keep practising because it will become easier the more you do.

STEP 6: PUTTING IN WEDGES (IF NEEDED)

Once the stretching process is complete, check the tension of the canvas: the surface should be taught, rather like a drumskin.

If it is slightly floppy, wedges will need to be placed into the joints. If the canvas is unprimed, it is wise to prime the surface first before putting in the wedges, as priming will tighten the surface.

With a small hammer, very gently tap one wedge into each corner with a similar amount of pressure; it is important not to hit them too hard. Two wedges are needed in each corner: put in the second wedge in the same manner. This will tighten the fabric a little more.

Even when the wedges have been put in, temperature and humidity changes can affect the tension of the canvas. If the surface becomes somewhat floppy while you are working on your painting, a useful solution is to brush warm water on to the back of the canvas – this will not upset either the primer or the paint surface. Take a large brush and brush a small amount of warm water over the back; this will tighten up the surface once again.

The Palette

Palettes are normally found in two different formats: the wooden palette and the white palette. The more traditional wooden palette is kidney shaped, while the more modern version is rectangular. These palettes were traditionally made out of a wood such as mahogany, although most wooden palettes sold today are more often simply varnished pieces of plywood that have been dyed to imitate the traditional palettes. Some kidney-shaped palettes have a small weight on one side near the hole, and are designed this way so that the palette can be more easily held if you are standing to paint. They also have

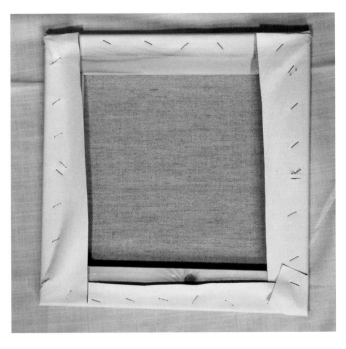

A stretched canvas.

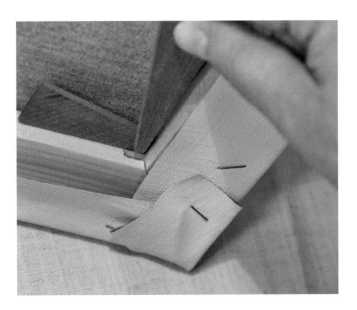

Putting in corner wedges.

Laying out the palette.

a thumbhole so they can be held, supported by the forearm and resting against the body.

A palette made from raw wood will need to be treated with linseed oil, which will seal it. The surface needs to be non-absorbent otherwise any paint mixed on it will rapidly disappear into the wood, and any remaining paint will seem dry. Also if paint is absorbed, cleaning the surface is a much more laborious process.

Linseed oil and a cloth will be needed to treat the palette. Pour the oil on to the palette surface, adding a small amount at a time and rubbing it in, making sure that all of it has been covered. Do this to both the front and the reverse of the palette. Once the oil has been absorbed you will need to do this again a few times, until the surface gradually becomes less absorbent. Once oil stops soaking into the wood, stop and mop up any remaining oil. The palette is now ready to use.

The modern white palettes more commonly found today can be made of anything, ranging from plastic, melamine, Formica™ or tear-off paper palette. Tear-off palettes can be useful if attending a class or when travelling and painting away from home, as no clearing up is involved – you simply tear off the top sheet and throw it away.

Many artists prefer to work on a white surface because they are going to work directly on to the bright white ground of their canvas or board. Colours and tones mixed on a white palette will therefore look the same when they are transferred on to the prepared surface.

The advantage of a wooden palette comes once a painting is underway, and all the white primer has been covered. When the overall tonal relationships have been established it can be very helpful to mix colours and see the tones against a wood, or 'mid-tone' surface. Wooden palettes were more commonly used when the artists of the past worked directly on to darker tone grounds. To have the same tonal relationship of palette and ground would be helpful in establishing the tonal values throughout the painting.

Those who prefer to work on a darker tone ground would find it helpful to start mixing their colours on a wooden palette from the beginning.

Those who prefer to mix on a white palette should bear in mind the comparative tonal range once all the white ground has been covered. Students often have difficulties with tonal values in their work, particularly if the entire tonal key becomes too light. This occurs when comparing the colour being mixed on a white surface: the colour may appear purer against white, but be careful of the effect the white is having on the tone. Everything seen against the white surface will look dark – even light mixes will appear darker. Once a mix is placed on to the painting it becomes all too easy for the overall tonal values of the painting to be too light in key.

Laying out the Palette

The specific colours to put on your palette will be discussed in more detail in the chapter on colour, but for now the illustration

Keeping colour mixes separate on the palette.

opposite shows you the order and how colours are placed on to the palette, light to dark, warm and cool.

Palette Management

The organization of the palette, the surface on which all our mixing is done, is something that is often overlooked. When students complain of colours becoming 'muddy' or 'chalky' the culprit is often found when observing the mixing on the palette itself. Colours that are mixed too hurriedly look bleached or 'chalky'. When too much white is mixed with pigment, or the paint hasn't been mixed thoroughly or for long enough, the resulting colour applied on the canvas will appear dull and washed out.

Try to keep the colours being mixed in separate areas on the palette. If all the mixes tend to blend together as you are mixing, the colours will become rather muddy, and any clarity or saturation of colour will be lost. As each colour becomes mixed with another it will influence the overall mix, and each colour will lose its brightness.

Paint Mixing

For all mixing on the palette a palette knife is recommended rather than mixing with a brush. There are many different shapes of palette knife available; however, try a palette knife that

has a long, tapered blade (10cm/4in). This is one of the best shapes to use for paint mixing. Many palette knives have a much shorter, angular blade, and these knives are ideal for applying paint directly on to the canvas if this is the preferred technique of painting.

Using a palette knife rather than a brush encourages you to mix a greater amount of paint in one go; it also allows better control of the amount of thinner or medium added to the mix, and of the amount of pigment added at any given time.

Try to use both sides of the knife as you mix, mixing, turning over, then mixing again; in doing this, all the pigment is being

Palette knife for mixing paint.

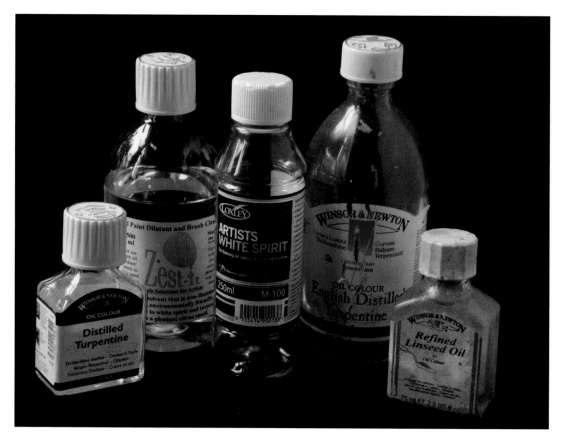

Commonly used oil-painting solvents and mediums.

thoroughly mixed together. There should be no remaining streaks of any pigment added, and the 'pool of colour' should be clean and resonant. Try to spend longer mixing each colour than you would normally, because this ensures that all pigments are really distributed within the mix. There should be no trace of any other colour (or white) on the edges of the mix.

Many students do mix with brushes, but the problem in doing this is not being able to control the exact amount of pigment, thinners or medium that is put into the new mix. It is so easy to dip the brush too far into the jar of thinners or pot of oil; the bristles will then absorb more liquid than is needed, and unless the brush is blotted slightly all the extra liquid will be transferred into the paint mix. This will result in paint that is too thin or 'watery', and colours will be diluted or become too transparent.

Continue to use the palette knife during all the mixing process. When adding to the colour, add a tiny amount of pigment at a time, because in this way the changing colour will be controlled more successfully. Adding too much at once quite often means then having to add too much of the other colours used in order to return to the starting point. It is then often easier to begin the mix again. Although adding a little at a time is slower to do, this does allow you to evaluate the mix and the colour changes as you go.

When adding either more thinners or medium into the mix, just touch the surface of the liquid with the point of the knife:

like this just small amounts of liquid will be picked up, which can be mixed into the paint little by little. In this way you are controlling the thickness, or consistency of the paint, a little at a time. Too much solvent in one go makes the paint mix become too dilute, while too much medium in one go results in the paint surface becoming too 'slippery' and wet when paint is applied.

Thinners and Mediums

Throughout the painting process thinners and mediums will need to be used at some stage. However, there are many products on the market, and the choice can seem overwhelming when we begin to use oil paints. Which one to select? How do they differ? Do they all really do something different?

Some products will seem to have similar results when mixed with paint, but as confidence in using oil paints grows, you may wish to try different substances and see how they compare and contrast. And as we become more experienced in using oil paints and seeing how they respond, it will then be possible to select specific mediums for a particular task – for example, slowing down the drying process or speeding it up as we get a feel for how the paint responds.

Below is a selection of the most commonly used thinners and

mediums, with a description of their main characteristics and what they are best used for.

Thinners/Solvents

Solvents are used to thin oil paint and to clean brushes. However, they are known to dry out the bristles of brushes and make the hair brittle, so when you have cleaned your brushes, also rinse them with hot soapy water. Vaseline can be used to reshape the hair and replace 'moisture'. This must be washed out before the brush is re-used. The illustration opposite shows some of the solvents most commonly used by students.

Care needs to be taken when handling all solvents being used. Make sure that the ventilation in the studio or area in which you are working is good. Use rubber gloves when transferring liquid from one container to another, and develop the good studio practice of using barrier cream, rubbed well into your hands, before you begin work.

Try to get into the habit of covering all solvent jars and dipper pots with lids when they are not in use, and avoid leaving brushes soaking in open jars for hours on end. Remove as much paint as you can, blot your brush and put the lid back on the jar. This will stop solvent fumes building up, particularly if you are working in a warm studio, as a warmer temperature will speed up the evaporation of the thinners. Even in the best ventilated of studios, fumes can build up, particularly in a class environment and working from a life model where heaters are on and draughts won't be appreciated, so encourage your colleagues to do the same for a healthier working environment.

WHITE SPIRIT

White spirit is the cheapest of solvents to buy. It is a petroleum solvent, which is distilled directly from coal. It is very effective in the cleaning of both brushes and palette. It is better to use a low odour spirit if possible. Try to buy artists' white spirit, available in all art suppliers, rather than the white spirit sold in DIY stores as it will be lower in odour and a little kinder to brushes.

TURPENTINE

Turpentine is widely used in oil painting. It is used by artists for thinning paints, and is an essential ingredient in oil-painting mediums and varnishes. It is distilled from pine and has an unmistakable, aromatic sweet smell. All turpentine should be kept in closed metal or glass jars, and kept away from sunlight to prevent thickening and discoloration.

Turpentine is ideal when thinning paint, particularly in the early stages of sketching in a drawing, or when laying down the first patches of tone and colour. However, be careful not

DISPOSAL OF SOLVENTS

It is imperative *never* to pour any solvents either down the sink or the drains. Not only is this illegal, but it is very dangerous to the environment. You will also risk blocking up your sink! Always dispose of any solvents safely. This can be done at the local recycling centre. Many adult education establishments and colleges have jars in which to pour used solvents, and these are then disposed of safely.

Remember that solvents can be used more than once. At the end of a painting session cover all jars and let the paint residue settle. Once this has happened the residue will be at the bottom of the jar, and the liquid above this will be clear. Find a clean jar, and carefully decant the clear liquid into the new jar. Wipe out the old jar with tissue and throw the tissue away, or let the paint residue dry out so that it will crack and become powdery. You can then put this in the bin and re-use the jar!

to over-thin the paint, as this may cause it to lose adhesion to the surface: when this happens the paint breaks up into tiny rivulets.

ZEST-IT ™

Zest-it™ is becoming more widely used as a safer alternative to white spirit and turpentine. Many colleges and art schools now insist on this being used, and no longer allow other solvents as it is thought to be a healthier and more environmentally friendly alternative as it is non-toxic and non-flammable. It can be used for thinning paint and for cleaning both brushes and palette.

Zest-it™ can be used exactly as turpentine would otherwise have been used, to dilute paint, but it does have a slower drying time. It is a natural solvent with a citrus smell, and can be used and mixed with all oil paint mediums.

Oil-Painting Mediums

There are a great number of oil-painting mediums, from oils, resins and waxes. Mediums help to retain the saturation and sheen of the oil colour. While diluting with turpentine can make the paint more fluid and movable, it can also result in the paint surface looking dull and matt, whereas medium mixed with oil paint will not only make the paint more fluid, but once applied

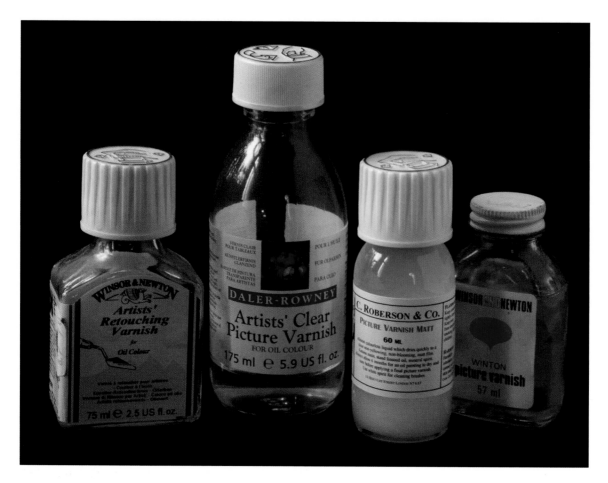

Commonly used varnishes.

to the canvas the vibrancy of colour, depth of tone and sheen will remain. Mediums can be used in opaque mixes and also as glazes.

Some oil paint brands may have more oil than others, while other pigments have different drying rates and may look quite different once dry. It is advisable to use a small amount of medium throughout the painting process to ensure a more unified appearance on the painting's completion.

All mediums will give the paint a more glossy appearance once dry, giving it the appearance of when it was first applied. However, be careful not to add too much medium into a paint mix, as this will make it become quite 'slippery'. Try not to mix in more than a 50/50 proportion of paint and medium. Some artists, however, prefer a high gloss finish and will add a higher proportion of medium into their paint mixes.

LINSEED OIL

Linseed oil comes in many forms, the most common being cold-pressed linseed oil and refined linseed oil. Cold-pressed linseed oil reduces any brushstrokes (self-levelling) so is ideal to use if a smooth finish is preferred. Refined linseed oil mixed with oil paint will show the brushstrokes and allow a more textured finish.

STAND OIL

Stand oil is a form of linseed oil, which has been thickened by heating in a vacuum. Because of this process it is a relatively non-yellowing form of the oil, and doesn't yellow as cold-pressed or refined linseed oil can; hence it is a preferred medium to use with oil colours.

LIQUIN

Liquin medium, when mixed with oil paint, helps to speed up the drying process, which makes it popular as a medium. It is a warm orange-yellow colour rather like linseed oil, and when mixed in paint will give a high gloss. It is particularly useful if glazes are used, since the drying time is quicker, and it also allows each colour to shine through to the final surface of paint. The paint stroke will flatten out as the liquin dries, resulting in a smooth and glossy finish.

Varnishes

Following the completion of an oil painting it can be difficult to decide whether to varnish or not. Many prefer not to varnish their paintings, leaving the surface as it is.

CONTINUE TO EXPERIMENT

When experimenting with new materials, be patient, as it may take some time to discover the best brand of paint or shape of brush to suit your needs and way of working. If you belong to an art society or attend a weekly course, see what your fellow students are using, then try, compare and contrast.

Sometimes the surface may appear to be quite 'patchy' on completion.

Pigments all have different drying times. Perhaps more oil has been mixed into one colour so some areas have a glossy appearance when compared to other areas of the canvas which appear dry or flat. Careful varnishing of a painting can 'bring together' and unify the surface as a whole, making the colours appear richer.

It is essential to wait as long as possible before varnishing a work. The minimum time is at least a year, but the longer you leave the process, the safer it will be. Always test a small area first to see if the colour 'moves'. If the surface is not properly dry, cracking can occur later on.

Varnishes can be bought as matt and glossy, and which you choose will depend on your preferred finish. Some painters prefer a matt finish, others glossy. Always test varnishes on a study or older piece to see which finish you prefer.

RETOUCHING VARNISH

Retouching varnish offers an alternative to other varnishes as it can be diluted slightly so that it doesn't result in a high gloss finish. It is commonly used as a temporary varnish and as a protective surface if paintings are going into an exhibition. Again, make sure that the paint is dry. This type of varnish can also be used to help 'lift' an area that has sunk. As darks, in particular, dry, they can appear sunken, and a thin layer of retouching varnish can help to combat this.

It is also useful to use retouching varnish when continuing work on a painting after a long break, as it helps the new paint to adhere to the older paint.

OILING OUT

Some artists prefer not to use varnish at all and instead use 'oiling-out'. This process helps to replenish the linseed oil in the paint surface, as well as evening out the surface tone. This method does give a little more sheen to a dry surface, but much less than using a glossy varnish.

To try this, mix a solution of 50/50 turpentine and linseed oil. Very carefully, using a lint-free cloth (this avoids any stray strands going on to the surface of your painting), rub a little of the mixture into the paint surface, a small amount at a time. All the time check to see if there is any colour on the cloth. If this happens, stop immediately because it means the paint isn't dry enough. Work your way over the entire surface using a gentle circular motion until there is an equal amount over the whole area. Wipe off any excess mixture. Leave the painting away from dust, and on a flat surface to dry.

Drawing: line, tone and form.

DRAWING: LINE, TONE AND FORM

In this chapter we will look at how a variety of drawing techniques can be used in preparation for painting. Drawing can be used not only as a starting point when making quick visual notes during experimenting with the placing of objects in a composition, but also to gain information in more sustained drawings to explore shape, surface, texture and form. Measured drawing can be used to work out proportion and to gauge positions and scale, while tonal relationships can be explored using reductive drawing before the introduction of colour. Drawing in whichever form develops our hand–eye co-ordination and improves our observation skills.

Drawing Materials

In any art shop, the abundance of drawing materials to choose from can be quite daunting. When it comes to selecting a medium to draw with we are all guilty of sticking with what we know, our favourite, staying safely within our 'comfort zone'. Some of the following exercises will introduce new materials, as well as using some old favourites and looking at new ways of using them.

For the purposes of the exercises in this chapter, materials will be limited to drawing in black and white.

Pencil

Drawing with pencil tends to be the first thing we choose when we want to make a quick study of something. As a medium it is very popular amongst artists because it is such a direct medium to use. A mark is made in a direct and controlled manner, and by combining pencils of varying hardness and softness, a great variety of marks can be achieved. It is versatile and expressive and offers a great number of possibilities in our work.

The grade of the pencil (HB, B–9B) tells us how hard or soft the graphite is, and it is useful to experiment with different grades until you find a selection you prefer. The greater the number next to the 'B' the softer the graphite: thus a B grade gives a lighter and sharper-edged line, while a 6B gives a softer, richer mark which can be made much darker.

Experiment with different grades and see how the marks vary. It won't be necessary to use all grades in a drawing, but you may find it useful to select three, say 2B, 4B and 6B, or B, 3B and 5B (using odds or evens perhaps). Marks with pencil will also vary greatly depending on the surface of the paper used, so experiment with smooth papers as well as those with more texture. Some grades will work better on some surfaces than others.

Pencils come in many forms, including water-soluble and clutch pencils, where the softness of the graphite can be selected and the pencil placed in a holder.

When sharpening pencils either a standard pencil sharpener or a knife can be used. Using a knife will enable you to create a longer point, or a fine or a more chiselled flat point. A very fine, sharp point for detailed work can be made by carefully rolling the pencil on fine grade sandpaper. Depending on the method chosen you will be able to broaden the range of marks.

Graphite

Graphite sticks, like pencils, are available in a range of shapes, sizes and grades. Larger graphite sticks are most commonly found in the form of hexagonal sticks that look like large crayons. They are very useful for making expressive and gestural marks, and offer more mark-making possibilities in your work. They are suitable for both linear work and for tonal work. Used on their edge, a smooth layer of graphite can be laid down very quickly.

Graphite is also available in the form of loose powder, which can then be rubbed into the surface of the paper providing an area of smooth tone. Like the larger graphite sticks, it is useful for reductive drawing when pencil is the preferred medium.

A selection of drawing materials.

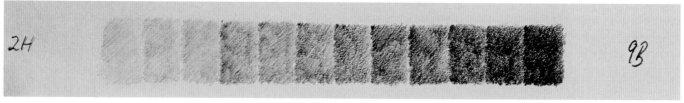

2H 9B

Above: A comparison of marks using pencils of different grades, 2H–9B.

Right: Contrasting marks – odds and evens.

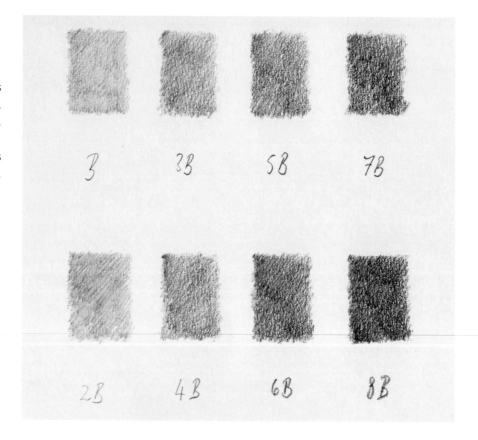

Charcoal

After pencil, the most widely used drawing material is charcoal. It comes in sticks, and is one of the oldest materials used today and is the most basic. It can be bought in many different sizes, and is very immediate in the marks it makes, yet it can be easily erased. The most commonly found form of charcoal is willow charcoal.

Charcoal is made when firing wood at a high temperature in an airtight container. During the firing process air is removed as the wood turns into carbon (without combustion).

Charcoal sticks can be used on their side to lay down a large, dense area or tone, or can be used to produce a light fluid line. The stick can be snapped to produce a sharp edge, which can make a scratchy, sometimes double line. The stick can also be cut at an angle with a sharp knife, which will give another quality of mark. Any edge wears down very quickly due to the softness of the material.

OILED CHARCOAL

Charcoal may be soaked in vegetable oil for a prolonged period, after which it will give an oily, saturated, dense black line when used in drawing. Once a mark has been made it cannot be erased, and it doesn't need to be 'fixed'.

To prepare oil charcoal, put a few sticks in a jar and totally immerse these in linseed, safflower or poppy oil for about twenty-four hours, or until all the oil has been fully absorbed.

After this process the charcoal is less fragile, but it will need to be stored in tinfoil to prevent it from drying out. The resulting marks will be greasier than normal, so it is necessary to consider the paper support used: try using a heavier weight drawing paper which has been sized, or prime a sheet with an acrylic primer.

COMPRESSED CHARCOAL

Compressed charcoal is normally found in the form of cylindrical sticks, and is very effective when used in tonal reductive drawing (discussed in more depth in the following section). It has a wide tonal range and a permanence of mark.

Compressed charcoal is made from the slurry that results when charcoal is mixed with oil. It gives a dense black mark which is easily smudged. The mark is greasier than that made with willow charcoal, but less than that of oiled charcoal. Its range of tone results in dramatic drawings, and areas can be erased with either a putty rubber, which gives subtle tones, or an India rubber (or plastic rubber), which removes more charcoal to give brighter highlights.

Conté, Chalk and Pastels

There are many other materials available to us for drawing. Chalks, pastels and conté crayons all come in a variety of shapes, colours, tones and textures; some of these are sold as

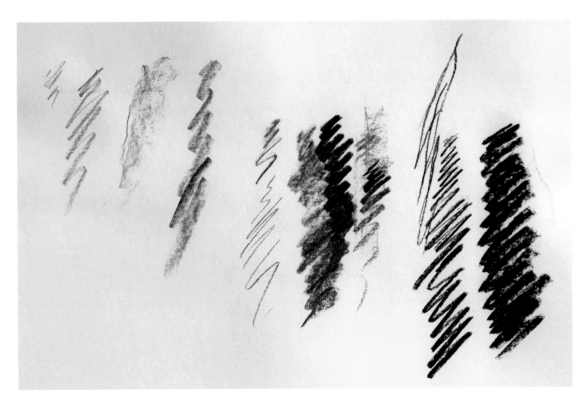

Mark-making with different materials.

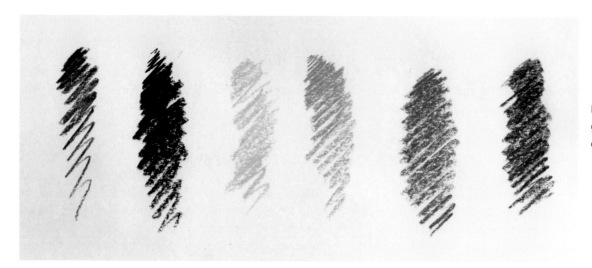

Mark-making with grey shades of compressed charcoal.

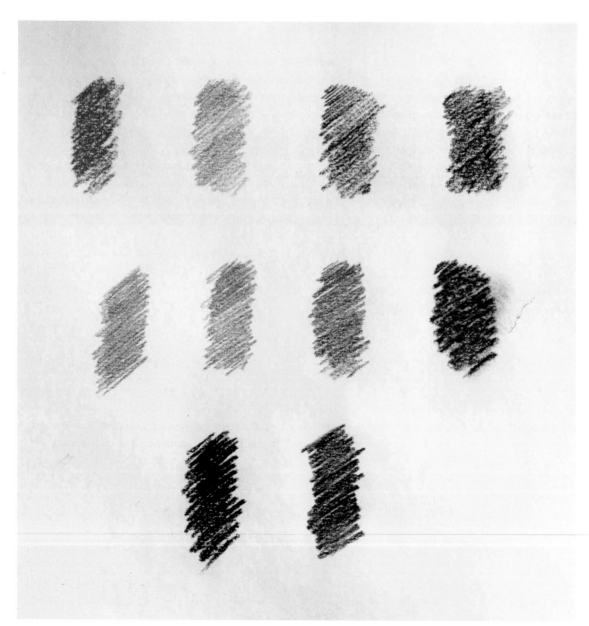

Mark-making with pastel pencils of different grades.

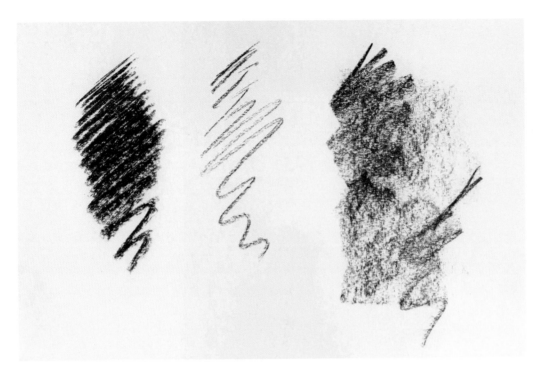

Mark-making with soft sepia pastels.

pencils as well as in stick form. Continue to experiment with different materials in your drawing until you find something that gives you that special quality and that you enjoy working with.

Tone

Before exploring line and other types of mark-making using some of the materials above, a useful starting point to begin drawing would be to study the role of tonal values.

Tonal values are the gradations from light to dark seen on the surface of an object under the play of light. In the following drawing exercise charcoal is used to articulate light and shade; with its wide tonal range charcoal is an ideal medium for this purpose. Concentrating on tone as a starting point will allow you to convey a sense of space and depth when looking at tonal relationships of objects in space, while also focusing on the simplification of form and not becoming too detailed too soon.

Reductive Drawing

Reductive drawing is a very useful way of studying tone and form, and by its very nature becomes excellent preparation for painting. 'Reductive' means reducing or removing tone which has been laid down on the paper, and the whole process of this method of drawing is about removing and then adding charcoal from the beginning to the end of a work. So often in drawing we tend to focus on the 'outline' and only look inwards to other points of interest – structure, junctions, contour – at a later stage. This drawing technique concentrates on manipulating areas of light and dark to create form and volume right from the beginning in order to create a greater sense of three-dimensionality.

The American artist Jim Dine (born in 1935) has explored many subjects using this drawing technique. Most notable are his expressive images of the human body and his striking drawings of Egyptian sculpture. The German-born British painter Frank Auerbach (born in 1931) has made a series of drawings portraying the human head in this way. These works show the head close up and in large scale, and demonstrate how reductive drawing can be used to show each facet and angle moving around the head. The work of these two artists shows how dramatic and exciting this way of tonal drawing can be.

EXERCISE USING WILLOW CHARCOAL
To begin, select a piece of heavyweight cartridge paper of A3 or A2 in size. The paper chosen should be a good thickness: if it is too delicate there is a risk of it tearing. Using a thick piece of willow charcoal on its side, cover the sheet of paper: work quickly so that the entire surface is covered with a dusting of charcoal. Make sure the whole piece is covered so that no white remains, as this will help the overall tonal relationships from the very beginning of the drawing. The layer of charcoal doesn't need to be very dark. You need enough charcoal dust on the surface so that when you begin to remove areas of charcoal with the rubber, the marks can be seen quite clearly. The tone ground will soon become the mid-tone.

Laying down a fine layer of charcoal.

Often the layer of charcoal on the paper will appear to have a texture. This can be the result of the texture from the paper, or from picking up a rough texture from a surface underneath such as a drawing board. To avoid this happening, place an extra piece of paper or two underneath the piece you are working on.

Once the whole surface has been covered, smudge the layer of charcoal using either tissue or rag (your fingers will do the job just as well), so that it remains quite smooth. This will be a good surface to begin to work into.

Do take caution with this medium. Those who are asthmatic or have chest problems should cover their mouth and nose to avoid breathing in any charcoal dust.

A putty rubber will be used when beginning to 'draw'. In these early stages of the drawing try not to use any line, as this way of drawing is all about form and establishing the tonal relationships in preparation for painting. Areas of tone will be put down in the same way that areas of tone will be laid down with paint in the early stages of painting. Try to use only shapes of light and dark, and to use line only in the later stages of the drawing.

Look at the still life, and before beginning to make any marks on the paper, just spend a few moments observing the objects. Concentrate on the lightest and darkest contrasts. These are going to be your starting points. If you are having trouble seeing a strong contrast between the lightest and the darkest tones (particularly if you are working from a selection of objects of bright and saturated colour), it is helpful to half close your eyes so that you are squinting through nearly closed eyes. This

simplifies the number of tones so that you can quickly establish the most contrasting areas. Peering through the eyelashes in this manner also enables you to focus on tone: it allows you to make judgements about the tonal relationships in the composition as the colour is filtered out.

Once you have established the lightest and brightest areas in the still life, note the shape of these areas, then begin to remove the charcoal with the putty rubber, making a number of light shapes throughout the composition. Removing the lights will reveal form. Avoid using the rubber to 'sketch out' an outline. Remember that at any stage it is possible to lay down another layer of charcoal, even over a small part of the paper, and then begin again – so don't worry about anything being in the wrong place at this stage. Resist the urge to blend, but let the 'edge' between two areas of tone remain so that it creates a 'drawn mark': a definite edge between tones becomes a

TIP

After some time you may find that you are not removing charcoal, but rather moving it around the paper. If this happens, rub the putty rubber on either a bit of paper or the side of the drawing board, which will soon 'clean it up' so that when you return to the drawing the marks being made are once again clean and bright.

Establishing the lights with a putty rubber.

structure 'line'. If you begin to blend one area into another, the drawing will very soon lose its dramatic effect and will become rather flat.

It is important to keep reminding yourself to simplify everything: it is very easy to try to put in all the information too soon. Although this way of drawing seems to establish your composition on the page quite quickly, think of focusing on light, mid and dark tones in this early stage. More detailed tonal changes may be addressed later on in the drawing.

If you look at how the light is touching and describing the form and volume of your objects, note the direction of the cross contours and planes. Try not to remove the charcoal so that the marks all seem to be following in the same direction; instead try to follow the direction of the contour in your mark-making, and your drawing will become much more three-dimensional.

The next stage is to address the darkest passages of the composition. In the same way that you placed the lightest shapes and planes, now use more charcoal to establish the dark shapes. Don't become too detailed, and quite soon you will begin to see how the initial charcoal layer becomes your mid-tone.

Throughout the entire drawing process a light is being placed against a dark, and because the whole surface has been addressed at the very start of the drawing, the contrast of one tone against another helps us see how we have to consider the entire page as a 'whole'. Think about how the tone of one object relates to the background tone: if it is the same tone it will not be seen clearly, and there will be no depth or space.

As the drawing continues you will begin to focus on the variety of tones in the light range, the mid-tone range, and again for the darks. Up to now the lines have been created as a result of two

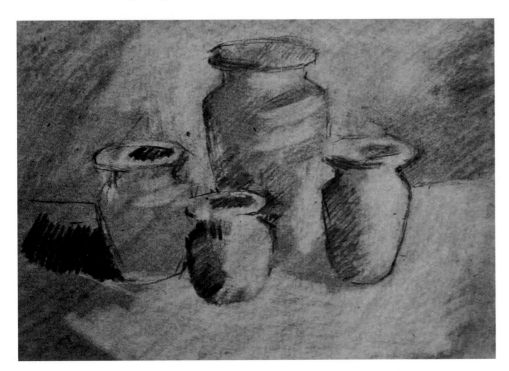

Following the cross contour around the objects.

EXPERIMENT WITH AN INDIA RUBBER

You may also like to try using a plastic rubber, or India rubber. It will give you a different type of mark. You will also be able to remove charcoal so that you are back to the white of the paper more successfully than with a putty rubber. You can chisel and shape the plastic rubber into a particular shape, but a putty rubber can be kneaded into useful shapes and can be used to 'stipple' the surface as well as to erase.

tones meeting, but perhaps now would be a good time to look at the composition and decide if lines should be used to delineate particular structures or 'junctions' within the drawing.

As the drawing progresses continue to focus but in greater detail on the contrasts within each tonal range. How does the lightest tone compare with the darker lights, the same with the mid-tones and again with the darks, light dark to darkest dark?

This method of drawing focuses on the dramatic extremes in the hierarchy of greys, light to dark.

Charcoal is ideal for this exercise, and willow charcoal is good to start with, but compressed charcoal will give an even wider range of tonal values, from the lightest grey to the richest, velvety blacks. Compressed charcoal with its permanence of mark is harder to remove but results in a rather dramatic drawing.

EXERCISE USING OTHER MEDIUMS

When you have completed your first reductive drawing using willow charcoal, try another drawing, this time using compressed charcoal so that the variety of marks and tones in each drawing can be compared. It is also possible to make reductive drawings using large sticks of graphite, which creates beautiful, subtle tones contrasting with dramatic darks in the resulting drawing.

When making a reductive drawing using graphite, cover the paper in the same way as when using charcoal. Use the side of the graphite to cover the paper with a fine layer, then smudge the surface with some rag or tissue so as to give a smooth

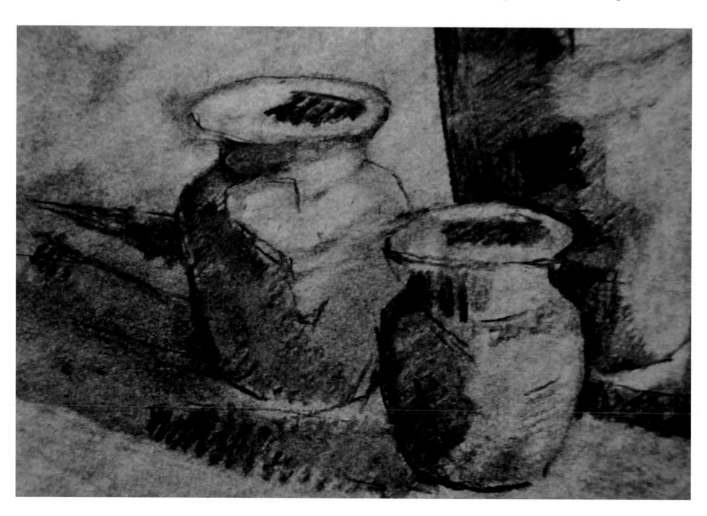

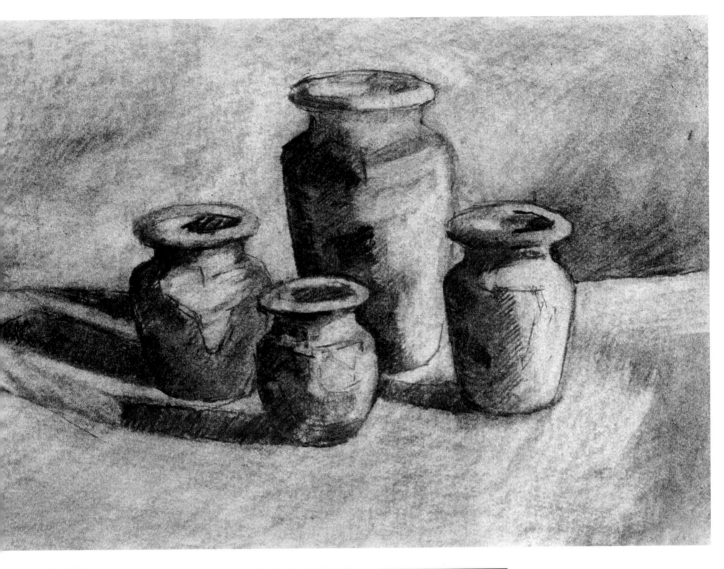

Opposite: Introducing line.

Above: Reductive drawing using willow charcoal.

Left: Removing the lights on a graphite reductive drawing.

covering of tone. Using the putty rubber in the same way, begin to remove the areas of light before continuing the process of further adding and removing.

In the final section 'Form and Contour', the illustration on page 59 shows a reductive drawing made with graphite. This drawing began in the same way as described above – laying down graphite, then the process of removing and adding graphite – but in this exercise that looks at form and contour, lines are added in such a way that line and tone work together.

Line

Line is the most expressive of marks we have when drawing. It is the most natural and descriptive tool we have in mark-making. Line is our first form of language (in drawing) and it becomes our signature, our individual handwriting.

Lines are man-made, they don't really exist in nature. We 'see' a line around a shape, but this is actually a boundary between light and shade, where two tones or colour planes meet. When drawing from observation we naturally begin to draw with an outline to delineate the shapes we are seeing. In the exercises in this chapter each drawing technique will demonstrate how both line and tone can be used to describe structure and form, using lines to pick out internal structures and show the change of direction of each contour over a surface. You will be encouraged to look at objects in a different way, focusing on their underlying form and simplifying the vast amount of information offered by a still life set-up.

Looking at the work of other artists is invaluable to our practice, whether that of fellow students in a class, or when poring over art journals or studying works of art in an exhibition. Before beginning, do some research and compare how different artists used a huge variety of mark-making in their drawings. The following artists all made drawings using very contrasting methods of mark-making, and it would be useful during your study of drawing to look at examples of each artist to see how they used line in their work.

Alberto Giocometti (Swiss, 1901–66): Made drawings of heads, figures in interiors and still life using many lines built up and overlapping each other. They address structure and form, resulting in drawings that are incredibly sculptural and dramatic.

Euan Uglow (British, 1932–2000): Worked in a very structured manner, from the head, figure and still life. In his work it can be seen how he uses measuring to plot each point.

Giorgio Morandi (Italian, 1890–1964): Used bold and heavy cross-hatching in his drawings of bottles and jars, which contrast greatly with his light, fluid, continuous line drawings

depicting negative shapes around the objects he is observing.

Paul Cezanne (French, 1839–1906): Used diagonal marks of varying scales in his work, often following the same direction.

Vincent Van Gogh (Dutch, 1853–90): Made a series of very exciting drawings in pen, brush and ink from the landscape. In these drawings it can be seen how he used a wide vocabulary of marks to describe the varying textures, shapes and depth, changing the scale of marks so they become gradually bigger the closer to the foreground they occur.

Experimental Mark-Making

EXERCISE IN EXPERIMENTAL MARK-MAKING

This first exercise is a great way to experiment with your materials, both the familiar and the unfamiliar. Be as experimental as you can by making as many types of linear mark as you can. Don't worry about what is happening on the paper, but think of the exercise as a way of loosening up your line, as a warm-up, experimenting and having fun!

Think in terms of experimental mark-making – see what happens using the same exercise but with different materials. Try to expand the range of marks used, increasing your 'vocabulary' of mark-making. It's surprising how a wider range of marks can be incorporated into your drawings to describe surfaces and textures without always having to resort to shading or cross-hatching.

Take a sketchbook and make a series of doodles. Don't be precious, and remember that this is a warm-up exercise. Select two or three different grades of pencil – for example B, 4B and 8B – and experiment with how many types of mark or line can be made with each. Use fast lines and compare them with slow ones, compare sharp edges with soft edges, light and dark, heavy and light, thick with thin. How many contrasting types of mark can you make? You can try dots, jabs, anything. Push the boundaries of mark-making with each tool as far as you can before trying the next.

Try the same with graphite sticks, perhaps 2B and 6B, and try the same experimentation with mark-making – it may give an even greater range of marks and lines.

Continuous line drawing can also be tried: it is a very useful warm-up exercise, because not only does it free up the line and build confidence of hand and eye co-ordination, but it immediately introduces the concept of positive and negative shape and space.

Positive and Negative Space

Being aware of the relationship of the negative shapes and spaces in a composition helps when checking overall pro-

How many contrasting types of mark can you make?

portion and scale, but it can also make the composition and placing of a group of objects more dramatic and interesting. Objects are 'positive', which means that all the space around them becomes the 'negative' space. The relationship of a positive and negative shape is very important when deciding how one object should be placed with another – a composition can look dramatically different if the space between them changes.

Think how important the space is between the objects in Giorgio Morandi's paintings of jars and bottles, or imagine how different Michelangelo's *Creation of Adam* would look without that tiny slice of negative space between the pointing fingers of God and Adam, a space which creates the drama and tension of the moment. Look at how Paul Cézanne uses the negative spaces in his tabletop still life paintings of tumbling fruits and flowing drapery to lead the eye around the composition.

When placing objects, try changing the positions between and around them, experimenting with things being close, and then further apart. What effect does the amount of space around the objects have on the composition as a whole? Some objects may be placed so that there is an element of overlap between them, while others may have quite a large area of negative shape between them, increasing the feeling of space and depth in the drawing.

EXERCISE IN POSITIVE AND NEGATIVE SPACE

Select a small number of objects; don't draw more than three or four objects to begin with and overcomplicate things: it is important to concentrate on the quality of line used. When you gain more confidence you can make a simple composition with a greater number of objects and then try another continuous line drawing.

Make two line drawings using a continuous line, the first one focusing on the positive, the objects themselves, and the second on the negative shapes. For these drawings try with pencil first, and then compare how other mediums respond when used in this way.

It may help to think of this way of drawing as 'taking the line for a walk'. It doesn't matter where you begin to draw, but as the eye moves around the still life, let the hand follow. Try to keep the pencil on the paper at all times, letting the line glide

Detail of 'cakes' drawing showing 'internal' lines.

over the surface of the paper continuously: don't pause and let the mark 'stop'. Keep the line very light and very fluid. Having made a start, remember also to consider the shapes and structures within the object, therefore not only concentrating on the outline but also looking for any internal lines. See how these lines can be used to connect with the outer lines as they move around the objects. Internal lines will indicate any internal boundaries or a point where a plane changes direction, and they will give a more structured feel to the drawing. These lines may need to be a different weight to those around them.

Drawing without the hand touching the paper will help to make the drawing more fluid, and the more fluid the line becomes, the more quickly you will be able to sketch. Don't worry about rubbing anything out. Keep the line very light, and if you wish to change the position of something just increase the weight of the mark a little.

How do the two drawings compare and contrast? Do they look quite similar, or is the end result quite unexpected?

The Measured Drawing

In this section the principles of measurement and proportion will be studied. When working from direct observation, measuring is an essential technique to master. Not only will it help in double checking the scale of one object against another when first sketching out a still life, but it is also useful to employ

throughout a more sustained drawing or painting. If something just doesn't seem to work scale-wise, or if an object's position seems incorrect, then the measuring process can be used as a way to check back and see where things may have gone wrong.

In making a sustained drawing of the selection of objects used for the previous exercise, measurement can now be used as a means of gauging proportion and scale, as well as helping to place the composition on the paper.

Taking a measurement.

Above and left: Continuous line drawing focusing on the 'positive' shapes.

Continuous line drawing focusing on the 'negative' shapes.

To begin a measured drawing the arm needs to be fully extended, so make sure to be positioned far enough back from the still life so this can be done without bending the elbow at all. You will need to close one eye (make sure that the same eye is used throughout the whole process).

Hold a pencil vertically in front of the still life and align its top with the uppermost point of the object being measured. Then slide the thumb up or down the length of the pencil to mark the lowest point. Your position relative to the objects should remain constant. Horizontal measurements are taken in exactly the same way, rotating the pencil through 90 degrees.

When using measurement for a more sustained drawing or painting, it is useful to mark your position so that when you return to work you will be in the same space. If seated, mark the position of the stool with some masking tape; if you are standing to work, mark the position of your feet. This will ensure that any further measurements will be consistent with any previous measurements taken.

The principles are the same whether used in drawing or painting. If painting, use the paintbrush in the same way as you would use the pencil to measure, then make a series of marks with paint.

Sight Scale

Sight scale is when the size of the object you are drawing seems to be exactly the same scale as the subject. Hence, if you are a distance away from your object the drawing will be small sized, but if you scan rapidly between your drawing and the objects they will appear to be the same size. As you plot each measurement in turn, the key points will appear as a dot-to-dot drawing.

To work sight scale, measure as described above, and transfer each measurement directly to the paper. This way of drawing/measuring may become rather limited if the resulting drawing is too small in scale as a result of being too far away from the set-up.

Comparative Scale

Alternatively a different scale may be used so that the objects in the drawing can be much larger in scale. Measure in the same way as before, extending the arm fully and aligning a pencil along an object, and then measure between two points, against

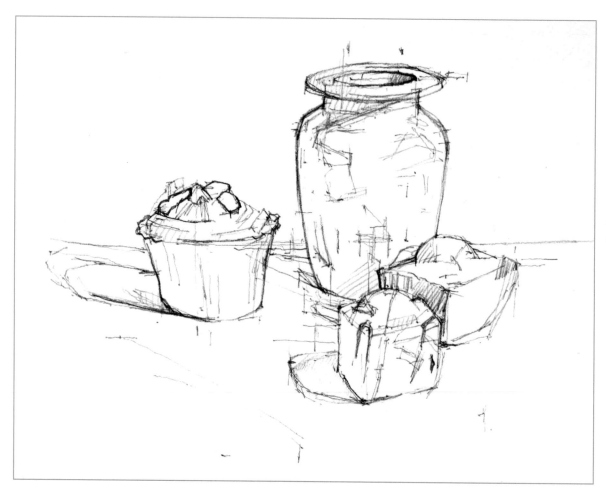

Plotting points in space when using sight scale.

which all other measurements within the set-up will be compared. Using comparative scale will allow you to select the scale of the drawing. If this way of measuring were used with a standing figure, for example, you would measure the length of the head and then see how many times this unit of measurement would fit into the full length of the body.

In drawing a still life, measure in exactly the same way, only select a small fruit or some other object and use this unit to see how many times this would fit into the length and width of the composition.

Make sure that the pencil is carefully realigned each time you measure throughout the set-up. When you have taken a measurement it is always a good idea to check and double check it to make sure that you are getting the same reading each time. If you are getting a slightly different scale, double check that you are still fully extending your arm: if the arm is at all bent it will give a different measurement. Also check that you are in the correct place in front of the objects.

In this measured drawing of 'fruit with vase and jar', small marks are used over the whole surface as a way of double checking the relative positions of objects in space. It may help to make a series of marks, like a grid, both on the vertical and horizontal so as to double check that all the various elements do fit in.

The fruit in the foreground was used as the measuring unit throughout the whole drawing. Thus the height of the fruit measures three times up to the top of the vase, and on the left-hand side you can see how each unit is marked along the edge of the paper. The same unit (the length of the fruit) measures into the width of the composition twice: the marks can be seen at the bottom of the drawing.

The small marks that can be seen over the surface of the vase and jar are made as each measurement is checked, as one is compared against another. When you take a measure and compare, put a mark down as a reference point. This reference point may then be used as a check later on during the drawing.

When making a measured drawing you will need to make comparisons with some areas that will be shorter than the original unit. If drawing a head, for example, the length of the nose could be used as a measurement: this length is smaller than the head as a whole, and you would see how many times it fitted into the head overall. Thus you have found a smaller scale within the overall 'grid'.

So if in your still life you are measuring a part that is smaller than the original unit, measure the part as you normally would, and then compare this against your original unit, the height of the fruit. Place a mark on your drawing to record this measurement. This smaller unit may fit into the length of the fruit two or three times.

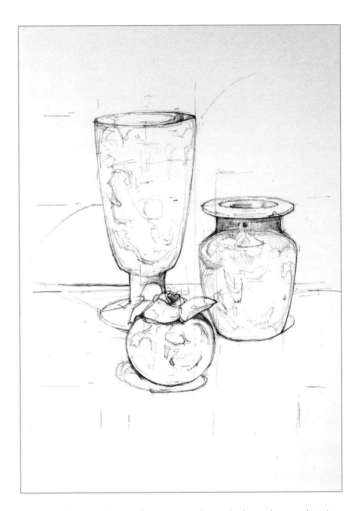

A small object can be used as a measuring unit throughout a drawing when using comparative scale.

Using Horizontals and Verticals

The use of horizontals and verticals is very helpful throughout our drawing practice, and it is also a quick method of checking the relative position of two or more points stacking up along a line. In the same way as the pencil is used to measure, extend your arm and use the pencil to establish horizontals and verticals throughout the composition. As you hold out the pencil along a vertical you will see how the line touches two or more points. Understanding this relationship will be enormously helpful throughout the mapping out of your drawing or painting.

EXERCISE IN MAKING A MEASURED DRAWING
First make a measured drawing using sight scale, practising the act of taking a measurement and transferring that unit on to paper. Every measurement taken will be placed directly on the paper exactly as it is, without changing the scale. Then using

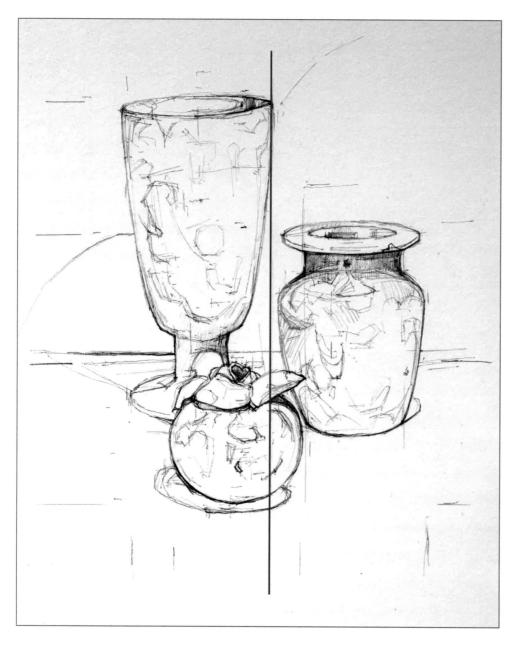

A vertical can be used to check a number of points along a line.

the same still life set-up, make a drawing using comparative measuring, selecting your own scale.

Use a pencil to draw with so that a number of precise marks can be made. Don't use too much pressure, but keep the marks quite light so that as the drawing progresses points can move as decisions are made.

Try not to rub out any marks, but instead use white chalk to soften any point you wish to change. This will create a history of marks as you plot out the drawing – and this in itself can be exciting, showing the development of the drawing and creating a certain tension as the marks build up.

Perspective, and Establishing the Picture Plane

In drawing and painting we are creating pictorial space, a three-dimensional illusion on the two-dimensional surface of paper or canvas. We need to develop an awareness of how we observe to enable us to construct this pictorial space. How do we really see things?

Placing objects within a convincing and believable three-dimensional space can be achieved when using measurement and perspective, and in establishing the picture plane. Being aware of these issues will help us to understand the relationship of the objects to us in space, and then to place them within the pictorial space of our painting.

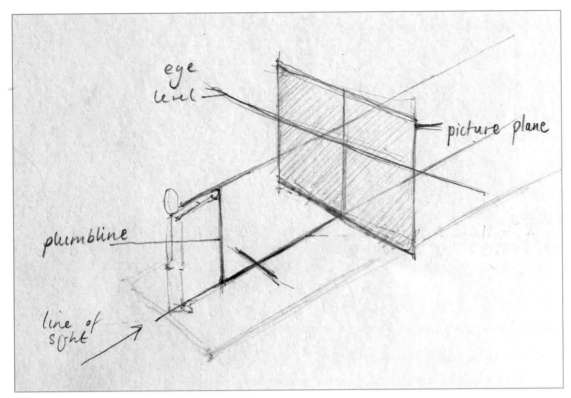

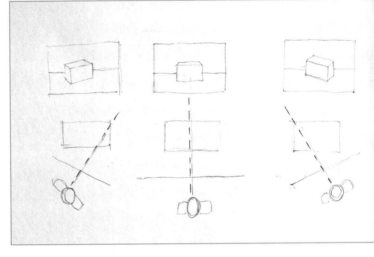

Left: Finding the picture plane.

Below: The relationship of artist and picture plane.

Establishing the Picture Plane

The sheet of paper or canvas represents a void in which you are going to construct space. Using measurement will help you to plot the positions of key elements within the composition, and an awareness of the relationship of the picture plane will help you understand and establish your relationship in space with that of the objects.

The picture plane is a threshold, parallel in space to the surface on which you are drawing or painting. It may be easier to imagine that you are looking at the subject through a pane of glass, or an empty picture frame standing between you and the objects: it is from this plane that you will be measuring and taking angles. The picture plane is at right angles to an imaginary line that connects your eye to the centre of your field of vision. This is known as your 'line of sight'.

To find your picture plane you will need to use a plumb line to establish a vertical that coincides with your line of sight. The plumb line can be a piece of string with a weight at the bottom. With one eye closed and your arm outstretched, hold the plumb line so that the vertical lines up along your line of sight and the end, the bob, is just above the floor. Your line of sight is an invisible line connecting you with your subject as you are facing it.

Once this line is established, and with the help of a friend, place a stick on the floor along this line. In doing this you are projecting your line of sight on to the floor. You can then draw a chalk line along the stick to show its position. Then position the stick on the floor at right angles to the first chalk line. This line is parallel to your picture plane. If you are working in a space where it isn't possible to put any chalk marks on the floor, use two sticks instead.

Once the picture plane has been established we can compare all the angles within the pictorial space in relation to it. It is so easy to assume that a line is on a horizontal rather than being on a diagonal.

As you look at an arrangement on a tabletop, note your position in relation to the table edge. As you face the subject your picture plane is parallel to the edge, but if you turn away slightly you will see how the angles change in relation to the picture plane and the horizontal you just had.

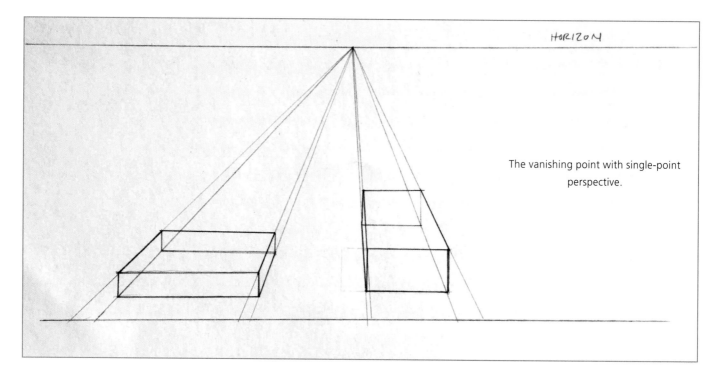

HORIZON

The vanishing point with single-point perspective.

If you have a viewfinder, observe the still life through it. Note how you hold it parallel in space to your picture plane: you don't hold it at an angle towards your still life – it follows that imaginary pane of glass.

Another way of establishing the horizontal, which can then be used to compare all angles in your set-up, is to balance a short ruler on your finger as you point towards the centre of your field of vision.

Perspective

Another means of creating an illusion of depth and space is to observe how perspective works within your 'space'. An understanding of how perspective works will enable you to observe the angles of your objects as they recede in space when compared to your picture plane.

In observing your still life objects on your surface the perspective 'effects' that you will encounter are single-point perspective and two-point perspective.

SINGLE-POINT PERSPECTIVE

Single-point perspective is when an object is viewed straight on, when the front surface is parallel to your picture plane and the angles of the sides stretch away from you and ultimately converge to a single point. This point will be on the horizon and is known as the vanishing point; you will find it is on your eye-level.

It is important to know where your eye-level is in relation to

your objects: it may be helpful to mark your eye-level on either the wall or an object. Look straight across at the wall and place a small mark to establish your eye-level.

DOUBLE-POINT PERSPECTIVE

When an object is angled away from the picture plane, two-point perspective will result: this is when the two sets of lines running from the top and base of the box on each side converge to two separate vanishing points, one on each side of the composition. Both these vanishing points will be at eye-level.

Form and Contour

The drawings made during this chapter so far have focused on using either line or tone quite separately. In this final exercise the drawing techniques used when looking at line and tone will be brought together. Using pencil, graphite sticks, willow or compressed charcoal, a drawing will be made using both line and tone to describe form, volume and depth.

Henry Moore and Picasso created drawings of great power and intensity. Both artists demonstrate an understanding of form and contour in their work using a wide variety of mark-making, and it is possible to sense from looking at their drawings that both artists were sculptors, demonstrating quite a different understanding of form and of objects in space.

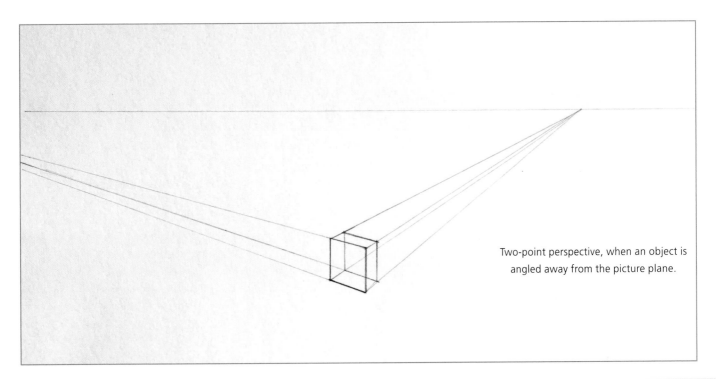

Two-point perspective, when an object is angled away from the picture plane.

Exercise in Expressing Form

In the final drawing of this section we begin to think about how line and tone can be brought together. With each medium used a wide range of marks has been explored. For this drawing select a material that will allow you to express form using the reductive drawing technique and a wide variety of marks. Use a heavyweight cartridge paper so that you don't risk tearing it.

Three alabaster jars were selected for this drawing, as their planes and facets are ideal when studying form. The drawing in the illustration on page 59 was made using graphite sticks of various sizes and grades.

Using a large stick, cover the surface of the paper with a fine covering of graphite. Smudge this to create an even tone over the whole surface. Don't lay down too much graphite at this stage or it will become too shiny.

The lights are then quickly established with a rubber, both on the vases and the lighter areas around them. You may find that a lot of the tone you place on the paper is removed at some stage, however, don't worry about this, as you will find the remaining texture is rather nice to work with, and creates a tension with other marks used.

The illustration right shows the beginning stages of the drawing. Once the paper has been covered with a fine layer of graphite, drawing may begin using a putty rubber to remove areas of light both on the vases and the area around them.

Once the lightest areas have been established, place the darks. Look at the weight of tone in the shadows in particular.

The beginning of a reductive drawing in graphite.

Left: Detail of jars showing the lines delineating planes.

Opposite: Form and contour – line and tone working together to describe form, volume and contour.

After this, lines are introduced to delineate the planes of the vases. You can see in the illustration above how this has been done.

Throughout the entire drawing measurements have been taken. Each position and mark on the jars has been measured and compared to the front vase, which was the unit used to measure throughout. As the lines begin to describe and give more information you will then need to return to building up tone, as the two elements develop side by side.

When describing contour, remember, when removing graphite or charcoal, to use strokes following the direction of the form to create a more three-dimensional feel around the surface. You can see the way the direction of these marks has been used on the surface on which the objects are standing.

In the final stages of this drawing lines were used to describe the tops of the jars and the lightest planes on the front of each jar.

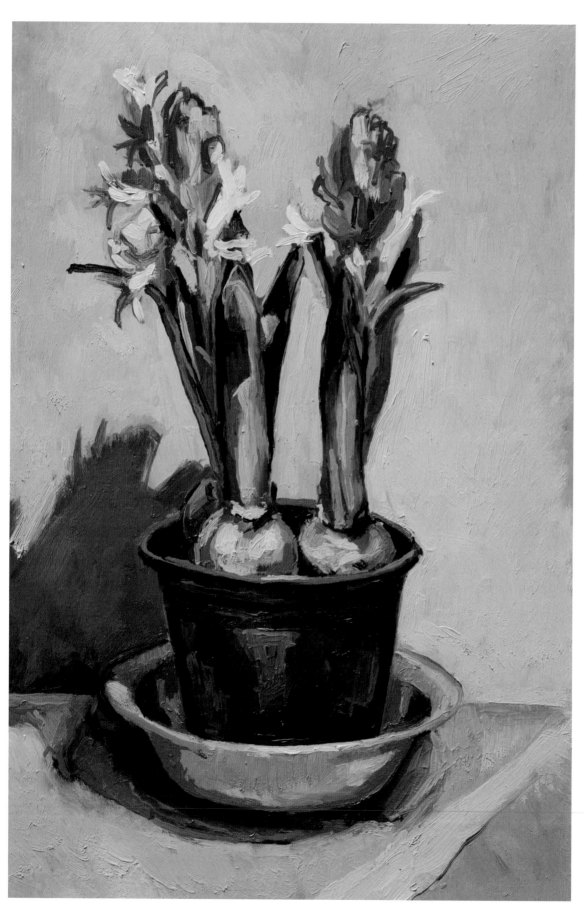

Hyacinth.

DRAWING WITH PAINT AND USING A TONAL PALETTE

This chapter focuses on making the transition from drawing into painting, and sketches will be made with oil paint using a simplified tonal palette to analyse tone and temperature relationships. Drawing with paint, the oils will be used with the brush in a free and fluid manner to make a series of quick, rapid sketches in a direct and immediate way.

The exercises in Chapters 6, 7 and 8 examine the process of painting, from the initial drawing to the laying down of paint stage by stage while working on a piece over a more sustained period. The oil sketches made during this chapter will be rapidly painted and they will be more immediate and spontaneous in approach. When applying paint to the surface the response will be direct, establishing the still life quickly using thick, opaque paint. The paint will not be layered in the same way as it would be during a longer painting, and some of the marks made with paint may be visible at the end.

When making an oil sketch, remember that it is a study, a rapidly executed work. It doesn't have to be a 'finished' piece. You may not cover the entire surface of the canvas or board, and parts may show through the paint surface. Let each mark describe and give as much information as possible, and make sure that the mark-making doesn't become too laboured. Let your brushstrokes move in different directions so as to follow the direction of the form of the observed objects.

Drawing with a brush will help you to create a study with more energy and fluidity. This spontaneous approach allows a more sketchy series of marks and lines to develop with the brush. The technique can then be transferred to any other study made in preparation for a new work, either when deciding on a new composition or when taking a closer look at the tone or temperature relationship in a new set-up.

Studying Tonal Relationships in Paint

When making oil studies, try to experiment with different surfaces. You can use anything, from brown or coloured paper and cardboard to board and canvas. Any scrap found lying around the studio will be fine to use for an oil sketch, and you will be surprised at how you respond to something quite unexpected. Normally a painting would be made on a prepared surface, which prevents paint from being absorbed. However, working on an unprepared heavyweight paper or on cardboard gives great results without the painter becoming precious about using expensive canvas or board.

Studies on paper can give a pleasing result as the paint is readily absorbed and you can achieve a painterly study, quickly adding more paint and readjusting your work as you go.

Using a limited palette is a very helpful exercise for tone work as it enables the painter to study the various tonal values throughout an entire composition before beginning to worry about the introduction of colour. In Chapter 3 a drawing was made using the reductive method to analyse each tone from light through to dark in the still life arrangement. This drawing technique makes you analyse the relationship of contrasting tones over an object, and also of one object against another. As well as looking at the tonal values of the still life objects, reductive drawing also allows you to observe the overall relationship of tones in the whole composition, of objects against the background, surface, drapes and so on.

In the same way that the reductive method allows you to study how light falls across the surface of objects, the following exercises will use a hierarchy of greys from light to dark to make a number of oil studies. Working with only white and black oil paint, a number of tones will be mixed that will allow you to establish tonal relationships quickly. Another combination that could be used is white and raw umber, which will give a warmer, sepia-toned palette, or you may prefer to try white plus another dark tone of your choice.

Later in the chapter a study will be made using the suggested

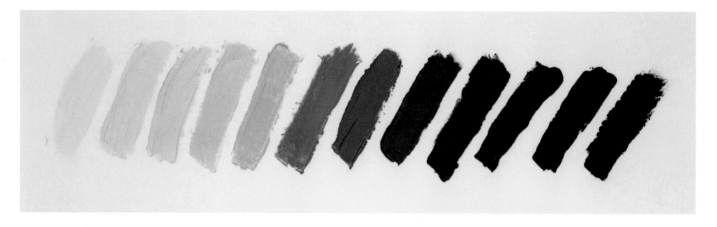

limited palette of black, white and yellow ochre to analyse tone and temperature.

A number of small alabaster jars that have featured in other still life works have been selected for these exercises to demonstrate the contrast of tone in a composition. These objects have many natural markings and lines in the stone they are made of, and are hand chiselled, resulting in a surface which isn't perfectly smooth. These markings help to show each plane and facet moving around the three-dimensional form, and are ideal when drawing quickly with brush and paint.

Making Rapid Painterly Sketches with a Tonal Palette

When sketching with paint, its consistency will need to be buttery yet fluid to allow the paint to flow easily from the brush. The paint will be thicker when compared to that used when working on a painting over a more sustained period. Mix in a small amount of thinners with a palette knife to obtain the right consistency. The surface you work on will influence how the

A series of mixed greys showing the step-by-step transition from white to black.

paint is applied: on paper or on an unprimed surface the paint will need to be mixed so that it will cover opaquely, yet be fluid enough, because it will soak rapidly into any unprepared surface. Sometimes the paint sinks into the surface almost immediately, enabling work over the top, whereas on a smooth, primed surface – for example a fine-grain canvas or a gesso panel – the brush will glide over the surface leaving a clear brushstroke. When making a stroke the paint should transfer easily to the surface: you should be able to apply it without feeling that the brush is dragging or that the paint is sticking to the brush, requiring you to make another stroke. Resist too much dabbing and overworking of the paint.

Whatever surface you select, remember that when painting an oil sketch your intention is to make a series of marks that best describe your subject without any layering of paint as would be required during a longer piece. Try to use as few marks and layers of paint as possible.

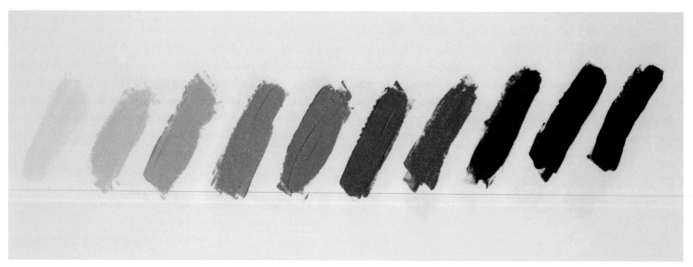

A series of swatches showing the step-by-step transition from white through to raw umber.

Black and White and Mixing a Hierarchy of Greys

When working with a tonal palette, premix a number of tones before beginning work on a sketch; this will allow paint to be applied quickly. The illustration opposite (above) shows a series of swatches demonstrating the step-by-step transition from white to black with a number of mixed greys.

Place white and black on the palette leaving space for the other grey mixes in between. Mix a mid-tone grey with equal proportions of white and black. Try to mix a good quantity of paint as this will save you time in needing to re-mix and match tones later on during the painting. When you have mixed your mid-tone, place this mixture in the centre of the space between the black and white. Using this mix, add small amounts of black to make a number of greys between the mid-tone and black, and do this until you have black.

Then do the same working towards white, beginning with the mid-tone and slowly adding increasing amounts of white. Try to have two or three tones between the white and mid-tone and the same for the mid-tone to black: this will give a good range of tones to begin work.

If you are using raw umber or another pigment and white, mix a series of tones in the same way so as to have a number of gradations of 'grey'. The illustration opposite (below) demonstrates a series of swatches made in a sketchbook showing the transition from white through to raw umber.

Working from a range of tones that have been premixed will enable you to make a direct translation of the tones you see in your still life to those on the palette. Look at the darkest tone and use that mix, the same for the lightest, and then the mid-tones. As you settle into your painting and your eye becomes more sensitive to the subtleties of each tonal range you can begin to compare darks and lights more clearly.

Look back at your reductive drawing. Remember how within each dark, light and mid-tone you found subtle variations: light darks to darkest darks, and light mid-tones to dark mid-tones, and the same for the lights.

In mixing a range of tones from light through to dark on your palette first, you will be able to select the most suitable tone for the one you are observing. Try to work from the number of tones you have premixed without adding more along the way. This will encourage you to make quick decisions when establishing the main relationships in your painting.

Remember to make the consistency of your paint buttery and thick enough so that on the surface the paint is opaque but sufficiently fluid so that with each brushstroke paint will stay on the board or canvas rather than your brush.

The illustration (right) shows a detail of *Hyacinth*. You can see how the sketching of the flower buds has been done rapidly with as few brushstrokes as possible, and the entire study has

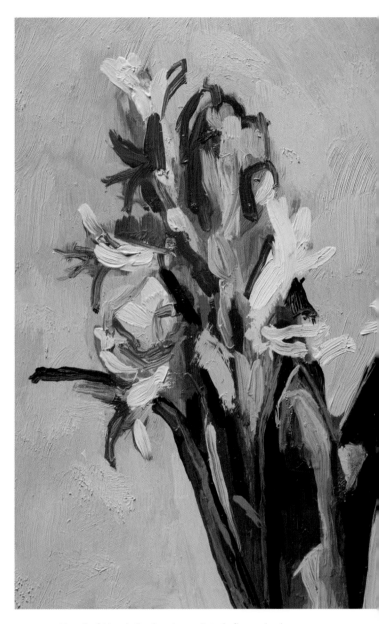

Detail of *Hyacinth*, showing painterly flower buds.

been executed in the same way, simplifying the number of tones while keeping brushwork to a minimum.

Drawing with paint and using a tonal palette is also useful in making oil sketches when setting up a new composition. As well as deciding on the position of things in the new arrangement you also make a tone study at the same time.

The following exercises use a palette of mixed tones as described above. Whatever your subject matter, try to keep your compositions as simple as possible, and mix your palette of tones from light to dark before you begin.

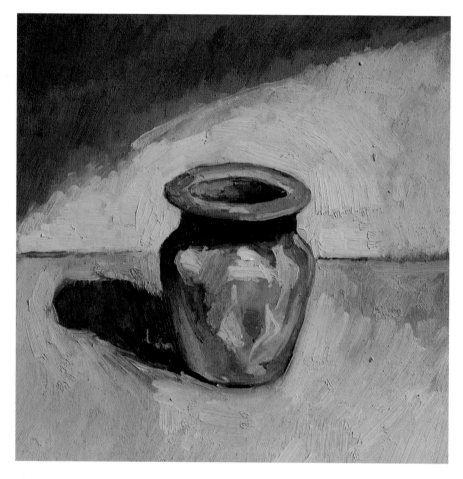

Left: *Alabaster Jar*, using black and white.

Below: Close-up of brushwork on the jar.

Exercises Investigating Tone and Temperature

Exercise: Oil Sketch Using Black and White

This small still life study was painted during a sitting of an hour and a half. A small piece of mountboard was used which had been primed with two thin layers of gesso acrylic primer. A thin wash of tone had been placed over the surface before starting work. Make sure that if a ground is put down it is dry before you begin to work over the top.

After mixing a number of greys, the composition was quickly sketched in using the mid-tone. Once the position had been established, paint areas of tone were then laid down using a medium-sized round brush.

The tone study was painted in artificial light. A daylight bulb was placed high over the object and slightly to one side, creating dramatic and sharp-edged shadows. The curve created by the arc of light behind the pot helps to give depth to the sketch, while the dark area in the top left serves to enclose and to keep the eye in the central part of the composition.

As the paint is being applied over a tone wash, the lightest and darkest areas could therefore be established immediately.

Being mindful of the direction of the contours moving around the small pot, brushstrokes followed this movement of the planes.

The illustration opposite (below) shows a close-up of the brushwork moving over the front of the jar, giving a drawn element whilst also establishing form and shape. When painting a rapid oil sketch the direction of the brushstrokes is important in order to describe form and contour from the beginning.

As other tones were added throughout the painting they were taken directly from the palette, trying to keep the paint in each area clean and fresh. If paint began to mix with that underneath and muddy the clarity of the tone, some would be carefully removed with a palette knife before more was added over the top.

Exercise: Palette Using White and Raw Umber

In the same way that a series of 'greys' was made using black and white, for this exercise mix a range of tones using white and raw umber on the palette before you begin. Start by making a mid-tone using equal amounts of white and raw umber as before. Then working in opposite directions, slowly add more of each tone, white or raw umber, into this mix working progressively towards the lightest and darkest tones. Aim to have two tones between the mid-tone and the white and umber.

The small oil sketch in the illustration above right uses this tonal range, with white and raw umber instead of black and white. This palette works well because it gives the range of tones needed but the overall effect is softer and warmer, like sepia. It was felt that this palette was more suitable for the subject matter because the light range of warms in the stone lent itself to the warmer tone range of this limited palette. The illustration below right is a detail of this oil sketch showing a close-up of the two pots and how the direction of each brushstroke describes the form.

Make two small studies trying both palettes, black and white and white and raw umber, to see which one you prefer.

Exercise: *Hyacinth*

This hyacinth study was made in preparation for a colour work. It was made over three short sittings in artificial light. This time a gesso panel was used, the surface being very smooth and

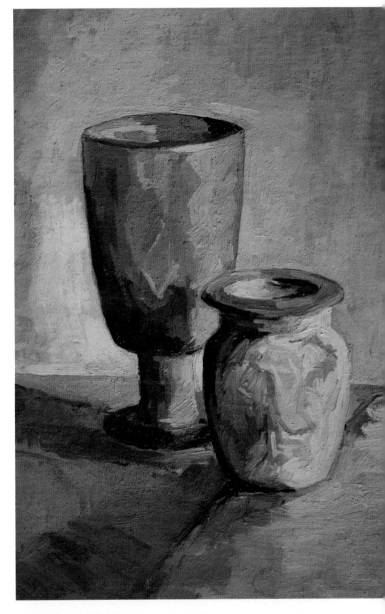

Top: *Alabaster Jar with Vase*, in sepia tones.
Right: Detail of brushwork over the two pots.

Hyacinth.

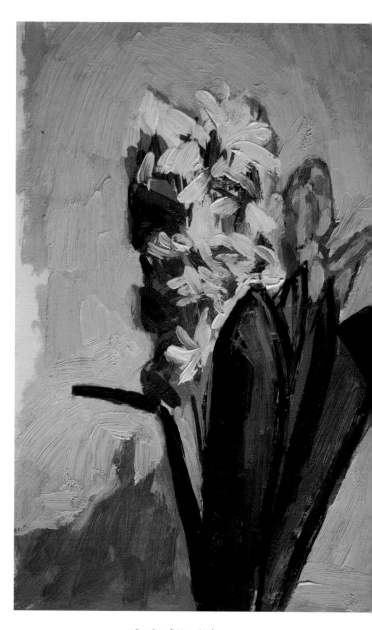

Study of *Hyacinth.*

absorbent. Using a series of tones as before, the composition was sketched in using a mid-tone. All the larger areas of tone were then quickly blocked in. Once these areas were placed, the linear aspects of the flowers, leaves and bulbs were drawn using the most suitable tone.

This sketch of a hyacinth opening was painted on a small piece of board, and the umber wash is still partly visible. It was painted in about fifteen minutes using thick paint, and shows the rapid brushwork, in particular in the direction of the strokes used when describing the contour of the flowers.

Exercise: Limited Palette Using Black, White and Yellow Ochre

This limited palette of black, white and yellow ochre is ideal to introduce the notion of tone and temperature. It is suitable when working in artificial light, as any colour seen under artificial light is leached from objects. Although it is restricted, this palette is excellent in this context as it gives a great number of possibilities when mixing tone and temperature.

All light and reflected light has a temperature. This palette gives us the opportunity to mix a range of tones, but it also allows us to study the temperature relationships of each tone either in light or shadow. As we observe an area in light we may

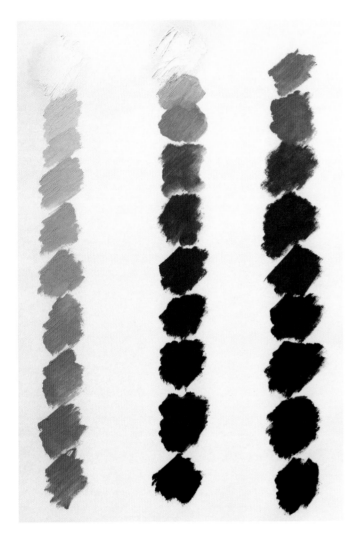

Three columns of swatches mixed using this limited palette.

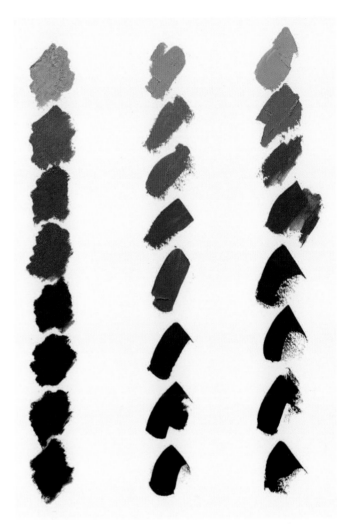

All three colours mixed together in varying proportion.

also see a simultaneous contrast with its shadow. A warm next to cool, and vica versa, will be observed.

The first illustration above shows three columns of swatches mixed using this limited palette. In the left-hand column we see the resulting mixes made from white and yellow ochre, in the centre black and white, and in the right, yellow ochre and black. These columns demonstrate the variety of tones which are produced when mixing these three pigments. Each column is a result of two colours being mixed together, and it is evident how some already appear to be warm or cool. In the next illustration all three colours are mixed together in varying proportions.

The mixes seen here demonstrate the vast range of tones, both warm and cool, that can be mixed with this reduced palette. All three pigments are present in each of the swatches in different proportions.

Exercise in Tone and Temperature Relationships

This exercise is a sustained painting analysing tone and temperature relationships.

Select three or four jars or pots for this painting and find a pleasing composition with them. Perhaps try to find shapes and sizes that are contrasting in scale, tone and shape. However, as with the tonal exercises made earlier, you will need to spend some time mixing a range of tones, both warm and cool, on the palette before you begin to sketch with brush and paint to establish the position of the objects on the canvas.

Begin by mixing black and white together first to create a tonal hierarchy. Then add varying proportions of yellow ochre into these mixes to consider warm and cool relationships. Yellow ochre is an opaque, mid-tone colour, and its qualities can lean equally towards warm or cool when mixed, depending on what it is placed next to. Remember that in this painting you

Arrangement of jars and a bowl under artificial light.

will be using mixtures containing all three pigments of black, white and yellow ochre, so don't just use white for light, black for dark and yellow ochre for the mid-tone.

Once you have decided on the composition, sketch out each object using a mid-tone mix. Use a small to medium round brush to do this. When sketching the composition for *Alabaster Bowl and Jars* the initial blocking in was rapid, as a range of tones from warm to cool had been mixed on the palette before work began. During this first session the main tonal contrasts were established, as were the major warm and cool relationships throughout the composition.

The still life was painted under artificial light, with the lamp overhead to create dark and sharply defined shadows. The shadows create a series of arcs running through the composition, which echo the ellipses of the objects. The depth of tone of the shadows gives a number of rich darks, and these show a simultaneous contrast of warm and cool throughout.

On this occasion very few outlines were used in the initial drawing. Once key edges of objects had been placed within the rectangle of the canvas, large areas were then blocked in, concentrating on passages of light and dark creating form and volume.

Using quick fluid marks, block in large areas of tone over the canvas: don't worry if paint goes over any line – this doesn't matter. Try to take the edge of one tone area up to the edge of the next so that areas are broadly painted and the canvas is quickly covered.

It is clear in the illustration opposite that attention was given to the warm and cool contrasts in the composition straightaway. The top of the central jar is one of the lightest areas, but is also the coolest. The reflected light on the inside of the bowl is much warmer, as is the light drape on the left-hand side of the composition. The warmest area is the small negative shape between the small pot and the bowl. It is important to establish this alongside the coolest element in the painting. Look for contrasting areas of temperature such as these in your own still life, and put them in.

To begin with the notion of temperature when referring to colour or tone can be difficult to grasp. If you are having difficulty seeing this, just let your eye scan rapidly between two areas. One will appear to be warmer than the other. When letting your eye move rapidly between two points you will begin to see a difference in the temperature of the two tones. Try this and see if it helps you to determine temperature contrasts between two or more areas.

During the first session on the painting it is important to

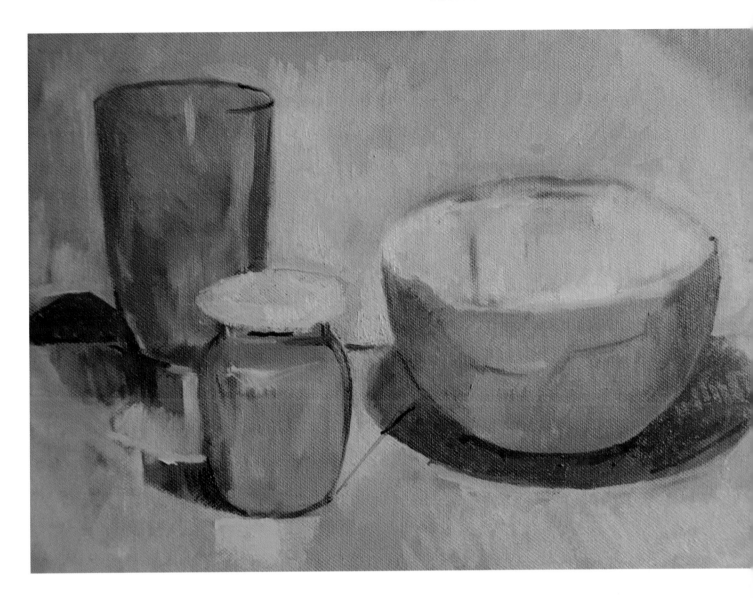

establish the lightest and darkest passages, but with the addition of yellow ochre on the palette you can now begin to introduce the warmest and coolest light and dark. As you lay down patches of paint, continue to simplify the areas to shapes of light, mid and dark tone, warm and cool.

Following the first session on a painting, the first layer of paint may seem to have sunk into the surface. Layering the paint and increasingly thickening its consistency will make the surface tones richer and will reduce any further sinking.

The illustration at the top of page 70 shows the development of the oil study made during the second session. The paint was still being thinned slightly with turps, however it is important that when adding thinners to the paint you don't add too much. The paint surface will build up with increasingly thick and opaque paint, resulting in a more exciting and painterly study.

Still simplifying the shapes of tone that you see and without putting in too much detail, use a rigger brush to establish any

Establishing the composition using a palette of black, white and yellow ochre.

drawn lines or edges of planes. These will help you to understand and describe the rounded contours of each form. Planes and facets can then be blocked in using a larger, round brush.

Now make a closer examination of the warms and cools in each tone, but also begin to look at the smaller transitions of light to dark within each area.

During the final session on this painting continue to look at the dark and light contrasts as well as the warm and cool relationships. The illustration belowon page 70 shows the drawn elements on the bowl. Smaller planes of tone moving around the contour of the bowl help to describe its volume, while in other areas of the canvas the building up of the paint surface continues where the surface appears to have sunk. The warm, dark shadow under the bowl was made stronger, and the planes and markings of the stone of the left-hand pots were

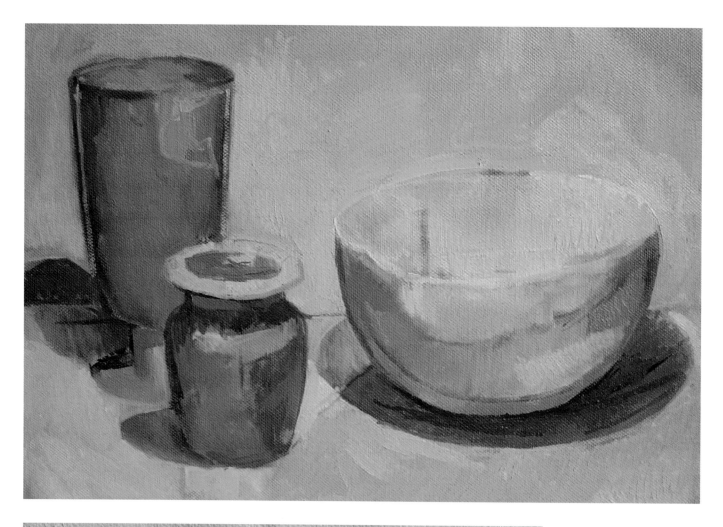

Above: Closer examination during the second session.

Left: Detail of drawn elements on the bowl.

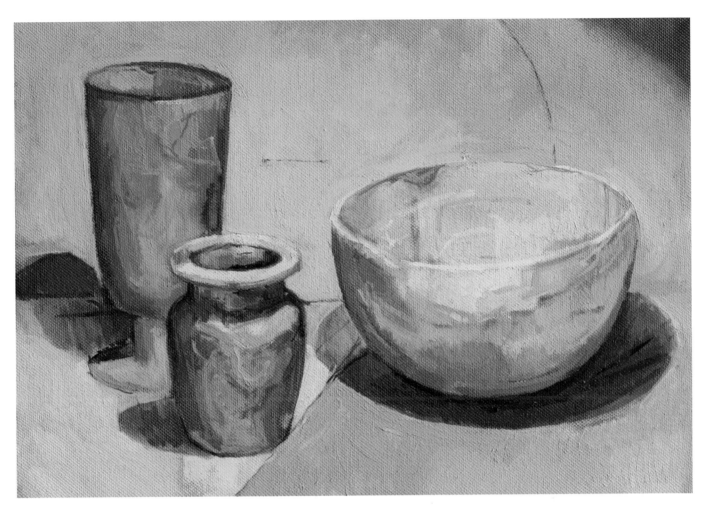

Sustained oil study made in black, white and yellow ochre,
painted in three sessions.

picked out using a rigger brush. While working on the back-
ground the warmth was intensified, as was the tone contrast
over the surface.

When laying down more paint over the background and on
the surface or drape, continue to analyse the tone and temper-
ature relationships of the light and the reflected light and the
tone of the shadows.

Summary

During this chapter a series of rapid painterly sketches has been
made, each one using a reduced palette, to study tone and tem-
perature. Using paint in the same way you can adopt this
approach as you make further oil studies when setting up other
still life arrangements when using colour.

In the following chapter investigating colour, two small
paintings will be made using two different palettes: the first a
limited palette of three primary colours plus white, and the
second the impressionist palette.

As you mix colours and experiment with different palettes, try
to make quick painterly oil sketches as you set up new compo-
sitions and make small changes in the positioning of objects.

Exploring Colour.

AN EXPLORATION OF COLOUR

A History of Colour

Colour gives the painter a vehicle which allows exploration and experimentation. It can express emotion and feeling, create atmosphere and mood, and describe light. Whether artist, scientist or historian, our perception of colour means something quite different to each of us. 'Thus the perception of *colour* is in the mind of the beholder, yet *colours* as we know them are a product of our language and our culture...'[7].

It is easy to forget just how colour was used throughout art history, and we can't imagine its impact on how artworks would then have been seen. In the art of the ancient world, colour was everywhere, and it is now hard to imagine how classical Greek sculpture was painted. Today we marvel at the surface of a marble figure both in its perfection and its worn and damaged state, telling of its passage through time – but can we imagine such statues as those from the Parthenon being realistically coloured, their eyes, lips, hair and clothes rendered as in life?

It is quite a shock to realize how vividly painted sculpture (polychromy) was. Looking at sculpture in museums and galleries today we appreciate the surface, the unique textures and qualities of the materials used. But it wasn't just marble and stone surfaces that were regularly coloured. The ancient terracotta warriors at Qi'an in China, depicting the armies of the first Emperor of China Qin Shi Huang (dating from 210BC), were all originally highly coloured with paint.

The temples of Ancient Egypt were also vividly coloured, each surface painted with bright pigments. The Temple of Medinat Habu of Ramesses III at Thebes is famous for its decoration, showing religious and historical events. It is one of the better preserved monuments, and the large areas of colour, several thousand years old, that have been protected from wind and rain, allow us to see how bright and vivid the colours are, and to imagine how colourful these buildings were in ancient times.

Polychromy of stone sculpture was usual practice right up to the Romanesque and Gothic periods, while in wooden sculpture polychromy continued through the Baroque and beyond. It was during the Renaissance when art works from antiquity were rediscovered, that we became used to seeing the material in its pure form, time having already stripped away any paint from their surfaces.

In painting we admire the stunning colour we find in medieval churches and Renaissance palaces, and we forget how the colours have faded, as pigments will have darkened and changed with age. The richness and saturation of colours when first viewed must have been such a sumptuous and colourful display in the world of art at this time!

The Development of Oil Painting in Northern Europe

During the early fifteenth century the use of oil paint became more widespread throughout northern Europe. Until this time egg tempera had been the more commonly used medium, although egg tempera wasn't abandoned straightaway because it was often used in the first layers of a painting, with oil paint being used over the top in the final stages. The Flemish painters – including Van Eyck, Robert Campin and Rogier van der Weyden – began to use oil paint in a very sophisticated way, using colour so that it looks as refined and fresh now as it did when first painted on to panel. The colours glow with a resonance and luminosity that hadn't been seen before.

Oil paint was widely used by the painters of northern Europe because it could be used in so many different ways. Its consistency could be controlled, so it could be either thick or thin, and used so it was opaque or transparent in layers of glaze. The oils used then were the same as we have now, namely linseed, poppy and walnut: these oils when mixed with pigment result in luscious and richly saturated colours. Oil paint became the preferred medium for these artists because it is slow-drying, viscous, glossy and highly refractive. The consistency of the paint also allowed brushstrokes to remain as individual painterly marks, or to be blended together so that the paint surface became glass-like in appearance.

The Colour Systems and Treatises of Cennini and Alberti

During the fourteenth and fifteenth centuries artists began to understand and use colour in a new way, as two colour methodologies were introduced. The Tuscan painter Cennino Cennini wrote *Il Libro dell'Arte* in about 1390. In this book, Cennini describes specific colour systems used to describe a variety of subject matter, including draperies and how to lay down colour in a particular way to depict flesh. He also gives detailed instructions on the preparation of materials, and painting on panel and in fresco.

The second treatise appeared half a century later. Leon Battista Alberti's *Della Pittura*, written in 1435–6, is most famous for its revolutionary description of perspective, and in particular single-point perspective. This was to change representational painting for ever, as artists could now use a system to create three-dimensional space on a two-dimensional surface.

Alberti also wrote extensively about colour, and although he worked with a different set of primary colours during his time, his writing about using colour with black and white to lighten and darken gave artists further understanding of using colour to describe form. His ideas of colour chords – how colours react when placed next to each other – also anticipated theories about colour contrast and complimentary colours during the nineteenth century.

Colour and the Venetian School

The emergence of the Venetian School during the sixteenth century is considered to be of great importance in the history of colour. Venice, as an important trade centre, at this time became central to the pigment trade in Europe, and it was then inevitable that the city's painters delighted in being able to use all the colours that this availability of pigments offered to them.

Venetian paintings of this time show both the variety and finest pigments available to the artist. It is from this background that Titian emerged, considered to be one of the greatest colourists in the history of colour. In Titian's paintings we see colours which demonstrate the brilliance and saturation of the finest pigments Venice had to offer. In his painting *Bacchus and Ariadne* of 1522–3 in the National Gallery, London, we see colours which are radiant and saturated. This painting includes all the pigments that were available to the painter in Venice at this time. We see the purest ultramarine used at full strength being used in the sky, which makes you stop in your tracks when in front of the painting.

From then on colour began to be used as never before. Titian and the Venetian School were to greatly influence many generations of painters.

Colour and the Impressionists

Today we think of the group of Impressionist painters as being instrumental in their use of complimentary colour theory and simultaneous contrast in their work. The Impressionists observed and recorded the world around them, and were no longer confined to the studio as oil paint could by that time be obtained in lead metal tubes and so be easily transported. These landscape painters now worked *en plein air*, using pure colour.

Monet and Renoir made landscape paintings boldly juxtaposing complimentary colours – red and green, orange and blue and in particular yellow and purple. Chevreul in his *Principles of Harmony and Contrast of Colours*, published in 1839, described how these complimentary pairs mutually enhance each other by simultaneous contrast.[8]

So many of the Impressionist paintings we see show a dominant complimentary pairing. This was pushed to the limit in Monet's *Rouen Cathedral* series, where abstractions of orange and blue portray shimmering light on the stone surface. These painters were the first to note how shadows contained an object's complementary colour. A shadow cast by a red apple, for example, will contain some green, and yellow sunlight casts a mauve shadow – and it is concerning this particular complimentary pair that critics penned the uncomplimentary term 'violettomania'. To them, everything seemed to be portrayed in violet landscapes and woods!

Seurat took his ideas of colour theory even further in his painting style. Using his method of pointillism (applying paint in small dots or strokes), he lay down dots of pure colour next to each other on the canvas. Using this technique he was trying to imitate how light behaves, believing that in observing these dots of pure colour, the eye would mix the colours itself, thereby recreating the colours found in nature but with a greater brilliance and luminosity than could be achieved with any artificially mixed colour.

Colour in the Twentieth Century

The way emotion and mood are expressed when using colour gives individuality and a uniqueness to our painting. This may be in a fluid and 'painterly' fashion, or paint may be applied in a more controlled way. How we use and apply colour in its many combinations allows us to be expressive in our work. Look at the work of the following painters and see how you personally respond to how each artist has used colour.

Compare how Matisse painted large-scale still life canvases filled with vivid, brilliant colour to the intimacy of the smaller-scale works by Craigie Aitchison who used saturated and rich colour fields. William Nicholson selects a palette that is muted and calm, which might be compared to that of Gwen John, who

The order of colours on the palette.

also creates a contemplative and quietly observed atmosphere with her limited palette. A totally different mood is created by the palette used by Picasso during his 'Rose' and 'Blue' periods.

Understanding Colour Relationships

Understanding colour relationships will help greatly during colour mixing. The selection and application of pigment on to canvas is one of the most exciting aspects of using oil paints. Using colour theory, making your own colour wheel, and looking at colour relationships through a number of simple mixing exercises is the starting point in this chapter. When mixing selected pairs of colours you will see how they respond, interact and change once mixed with each other.

For those who would like to make a further detailed exploration of colour following these exercises, the treatise on colour by Johannes Itten (1888–1967) is recommended. Itten taught in Vienna and later at the famous Bauhaus, and was considered to be one of the greatest teachers on the art of colour and colour theory. His profound interest in painting and colour led him to be a highly respected teacher on colour theory. He believed in spontaneity and personal expression when using colour, and he saw relationships between music and colour, in particular the expressive abstract colour seen in the geometric paintings of the period.

In the first exercise a colour circle will be made, then a series of colour notes in a sketchbook – a visual reference which can be dipped into as needed when painting. This will enable you to see colour temperature, the relationship of warm and cool colours.

The last two exercises of this chapter involve painting two still lifes using slightly different palettes, the first a limited palette using the three primary colours plus white, and the second the Impressionist palette of six colours – a warm and a cool of each primary colour – plus white. This second painting will demonstrate how colours can be mixed to produce a very subtle and harmonious range of 'coloured greys'.

Laying Out the Palette

It is important when laying out colours on your palette to try and keep a sense of order and organization. When colours are placed in any old fashion the resulting disarray means that they are often badly mixed, becoming muddy or 'chalky' before the paint even reaches the canvas. When laying out colours, put them along the outer edge, which then gives the optimum mixing space that the palette allows. If pigments are placed anywhere on the palette, plopped right in the middle of another colour for example, each colour will become tinged with everything else.

When laying out your palette, place the colours moving from light to dark along the edge furthest away from you. The illustration in Chapter 2 on page 32 shows a palette with the colours laid out in the following order: from left to right, titanium white, cadmium yellow, cadmium lemon, raw sienna, cadmium red, alizarin crimson, French ultramarine, cobalt blue, raw umber.

The Colour Wheel

As an introduction to this practical section on colour and colour mixing we describe how you might make your own version of the colour wheel, which can then be stored in your paintbox or placed in a sketchbook for future reference. This is just one version, and slightly different versions of the colour wheel or circle can be found: some have the primary and secondary colours in the centre, pointing to their positions on the circle, as found in Itten's treatise; others present a greater number of shades within the tertiary mixes.

Here we describe how to make a twelve-hue colour circle. This will show you the relative positions of the primary colours with each secondary and tertiary mix.

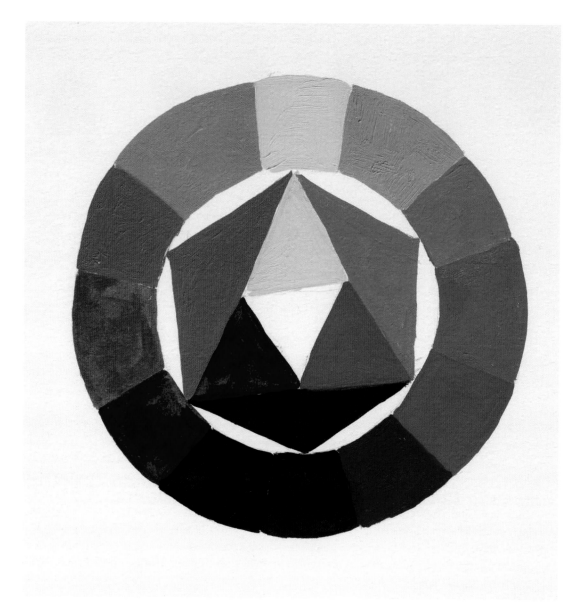

The twelve-hue colour wheel.

Making a Colour Wheel

The primary colours are yellow, red and blue. For this colour wheel cadmium lemon, cadmium red and French ultramarine are used.

To make the wheel, in a sketchbook draw a circle to fill the page. Within this circle draw a smaller inner circle. Now within these two circles make twelve individual segments, of equal size: each primary, secondary and tertiary colour will be placed within these segments. As can be seen in the illustration above, there is an equilateral triangle in the centre of the circle, and each point is touching a segment of the inner part of the wheel. Draw a triangle in the centre making sure that the points are positioned as if they are at twelve, four and eight on a clock face. Make sure that there are three empty segments on each side of each primary colour.

Begin by placing a primary colour into each point of the triangle; then place the same colour into the segment that it touches. The next step is to make three further triangles around the initial one: see how the orange, green and purple shapes connect the inner triangle with the circle. Draw in these triangles so that each point touches the middle segment between each primary: this is where the secondary colour will be placed.

For example, orange is the secondary colour made when mixing red and yellow together. The orange triangle is therefore placed in the centre next to the red and yellow shapes. The secondary colour orange is then placed in the halfway position between its two primaries. This rule will apply to the positioning of the other two secondary mixes, green and purple. Each triangle sits next to the two primaries that make each secondary, and the point gives its position within the colour wheel.

MAKING SECONDARY AND TERTIARY COLOURS

The secondary colours are created when mixing a pair of primary colours: thus red and yellow makes orange, yellow and blue makes green, and red and blue makes purple. The secondary colour needs to be carefully mixed so that it doesn't lean towards either of the primaries used; for instance in mixing a green, it mustn't be either too yellow or too blue. The same applies in the mixing of the other two secondary colours.

Once each secondary colour has been carefully mixed, place it in its correct position in the circle. The orange will fill the central space between the red and yellow, the purple between the blue and red, and the green between the blue and yellow. There will be one space remaining between each colour, for each tertiary colour. A tertiary colour is made from mixing a primary with a secondary colour: thus yellow and orange makes yellow-orange, red and orange makes red-orange, and so on. Place each tertiary in the correct position between its primary and secondary source.

You have now constructed a twelve-hue colour wheel. Note

Mixing secondary colours.

that the sequence of the colours around the wheel is that of a natural spectrum or a rainbow.

It is possible to make a continuous colour circle (Newton) by introducing more tertiary segments between each primary and secondary. To do this, a greater proportion of one hue must be added into each tertiary colour. Thus to extend the number of changes between yellow and orange, add further amounts of orange into the mix so that the colour moves closer towards the orange. Add more yellow in the mix, and step by step it will move towards the yellow. This will give the appearance of a continuous transition from one colour to the next.

All the possible colour combinations that have been mixed while making a colour wheel will be a useful reference when beginning to paint. The Frenchman Delacroix (1798–1863) was said to have had a colour wheel on his studio wall, each colour labelled with all possible combinations. Delacroix was

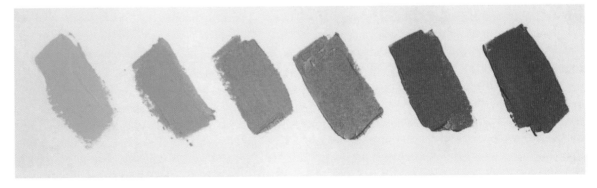

The step-by-step transition of yellow to orange.

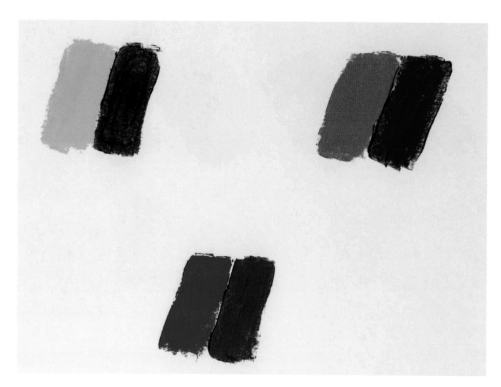

Left: Complementary pairs.

Opposite: The three primary colours, a warm and cool version of each.

esteemed as an eminent colorist and highly regarded by those in the Impressionist circle, including Seurat, Signac, Cézanne and Van Gogh. Cézanne or Seurat are often considered to be the founders of using colour principles in their work, but it was Delacroix who used colour in a way that achieved a heightened degree of order and truth in painting.[9]

Complementary Colours

Two colours are called 'complementary' when they are found opposite each other on the colour wheel; when mixed in the proper proportion they make a neutral 'grey'.

So the complementary of red is green, of blue is orange and of yellow is purple, and it is well to remember these three pairs for those occasions when you don't have a colour wheel to refer to. You may remember the complementary of a colour being the mixture of the two remaining primaries.

When placed next to each other, complementary colours will appear brighter and more intense. Look at how the early twentieth-century group of artists called the Fauves used complementary colours in their work. Matisse's second version of his painting *The Dance* of 1910, and Music of the same year, demonstrate how the painter uses complementary colours next to one another which enhance and vibrate against each other.

When a colour is mixed with its complementary, the colour will become neutralized and appears 'grey'. Within each pair of complimentary colours all three primaries are present.

Once you understand how complementary colours work together you can explore and experiment with them when painting. Matisse and Derain, two of the Fauve painters, made pictures using vivid palettes of primary and secondary colours. The Impressionists used complementary colours to great effect, in their landscapes in particular; when you next look at Impressionist landscapes consider how the yellows and purples, and the other complementary pairs, work together.

When white is mixed with these 'greys' we begin to see how wonderfully subtle and exciting a palette can become – think of the beautiful paintings of Gwen John and Morandi, created using a harmonious and rich variety of greys.

Harmonious Colours

Harmonious colours are found next to each other on the colour wheel. Whereas complimentary colours are about contrast, harmonious colours are subtle and harmonious when placed together. Think of how colours work together in nature: these are harmonious colours – the blue of the sky against green fields and trees, the colours of autumn green turning into yellows and gold, and the rainbow, where the order of the colours follows the order of the colour wheel.

Simultaneous Contrast

Simultaneous contrast happens when a particular colour is observed: the eye will simultaneously require its comple-

mentary. Even if the complementary colour is not already present, the eye will generate it spontaneously. We see the effect of simultaneous contrast as we observe two colours placed side by side: they will interact with one another, and our perception of how we see them will be influenced. When we see a flower border with bright colours sitting one against another, the colours appear to change: this is because we perceive them differently than when we see them in isolation. This contrast is at its most intense when two complementary colours are placed together.

To see the effect of simultaneous contrast at work, try placing a small, neutral grey square into the centre of a larger square of each primary colour: the brilliance of the primary will influence how you see the neutral square. Thus if the grey is seen against blue, the grey will seem to be tinged with orange, against red it will be tinged with green, and against yellow with purple.

It is interesting to refer to Itten's book *The Elements of Colour*, which discusses the effects of simultaneous contrast in depth; a number of the colour images clearly demonstrate how the eye experiences perceived colour.

You may have tried the experiment of staring at a square of red for a short time, and then looking at a white sheet of paper. In its place you will see a square of the same size in its complementary green. Try this with each primary in turn and see what happens.

Colour Temperature – Warm and Cool

When beginning to paint, the idea of colour temperature can be a difficult one to understand. We hear that red is 'warm', a quality that causes it to appear to move forwards in a picture, while blue is 'cool' and recedes. But with each primary colour we have warm and cool variations.

Each primary colour has a leaning towards a secondary colour, and this 'undertone' helps us to understand the notion of 'warm' and 'cool'. Within the range of yellows, reds and blues that can be bought in a tube, it is possible to compare them in terms of temperature: thus some reds will appear to be warmer than others, and the same with the yellows and the blues. When looking at a colour, analyse its undertone. For example, cadmium red has an orange undertone, while alizarin crimson is purple. The undertone of cobalt blue hints at green, while ultramarine is a warmer mauve.

In your sketchbook, lay down a patch of each of these primaries next to each other: you will then be able to establish the undertones of each colour and get a sense of which is 'warmer' and which is 'cooler'. Seeing the colours against the white of the paper will make it easier to compare them, rather than just observing them in the tube. Also, laying the two yellows, two reds and two blues side by side will help you to distinguish which is the warmer and which is the cooler of the two.

The row underneath shows the six colours all mixed with a small amount of white. It is easier to determine a colour's undertone once a little white has been added.

The Impressionist palette.

EXERCISE

On a page of your sketchbook, try this exercise: make a row of primaries warm against cool, and underneath make another row mixed with white. They will look quite different when seen 'in the flesh'. As you are making the patches of colour also try and establish which of the colours are transparent and which are opaque. (Transparent colours will seem quite thin when applied on paper, while opaque colours will have a more solid appearance, and will give a better coverage.)

The Extended Palette or 'Impressionist' Palette

The extended palette will be used during most of the exercises in this book. It consists of six pigments: a warm and cool of each primary colour, plus white. These are titanium white, cadmium lemon, cadmium yellow, alizarin crimson, cadmium red, cobalt blue and French ultramarine. This combination will allow us to mix most of the colour spectrum with the addition of white when needed to mix coloured greys and tonal variation.

You may also have alternative colours to the ones above in your paint-box. Take a look at any other yellows, reds or blues. How do they compare to the colours listed above? Do they appear warmer, or cooler? Can you spot the undertones of these colours?

We all probably have a greater number of tubes of colour, accumulated over the years, than we really need. Some colours we try to use regularly to extend our palette further. This suggested palette reduces the number of colours so that you will gain a greater understanding of colour mixing, from primary colours making secondary and tertiary mixes. The resulting palette will also have a greater unity and harmony when mixed from these limited colours than one that has other colours added.

COLOUR MIXING AND PALETTE MANAGEMENT

Remember when mixing oils always to use a palette knife rather than a brush. This will enable you to mix more paint at a time and also to keep colours cleaner and brighter. Mixing with a brush can muddy the colour mix if there is any residue in the bristles. It is also possible to add too much of thinners or medium if a brush is used rather than a knife.

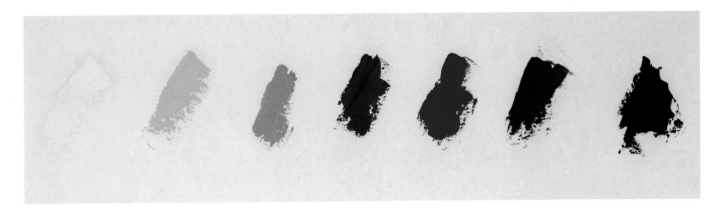

Making Sketchbook Swatches – Colour Mixing

Above: How colours are laid out on the palette.

Spending time mixing colours on your palette will enable you to examine colour relationships further. The following colour-mixing exercises will allow you to experiment with colour as well as getting a feel for mixing with oil paints. If you have previously used other paint mediums you will notice that some pigments will be quite different to a colour of the same name in another type of paint. Characteristics such as transparency, opacity and brushing out qualities, and flow, saturation and staining will all be very different when using oil paints.

EXERCISE: MIXING THREE PRIMARIES WITH WHITE

This exercise demonstrates how each primary colour is slowly desaturated as white is slowly added. White mixed into any pigment lightens the tone of the hue, but also makes it cooler. The illustrations overleaf show how white changes each primary, and demonstrate the transition from pure colour to shades becoming lighter as more white is added.

Some colours stain, or appear to be 'stronger' when mixed with other colours. It is useful to see how each colour reacts when mixed with another, or in this case white. Some pigments disappear quite quickly, whilst others take much longer to dilute with white.

Below: Cadmium lemon and cadmium yellow hues with white slowly added.

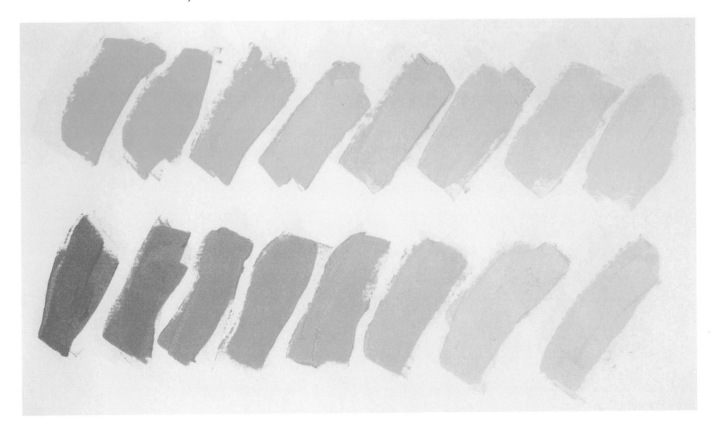

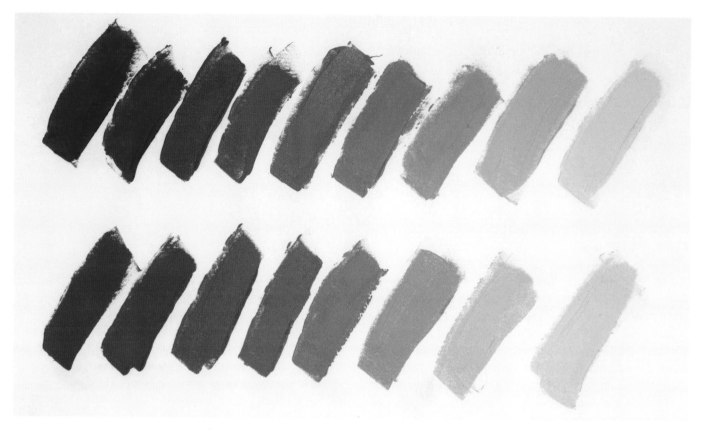

Alizarin crimson and cadmium red hues with white slowly added.

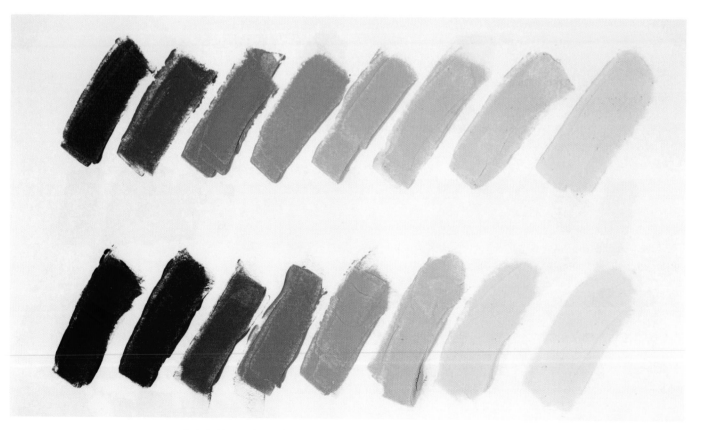

Cobalt blue and French ultramarine with white slowly added.

Ultramarine – cobalt blue.

Cadmium red – alizarin.

Ultramarine – cobalt blue plus white.

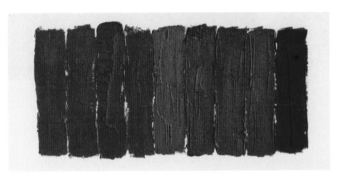

Cadmium red – alizarin plus white.

EXERCISE: MIXING WARM AND COOL PRIMARY PAIRS

In this exercise varying proportions of the two yellows, reds and blues will be mixed together in turn. Mixing the warm and cool of each pair of primary colours will help you to discover more about the colour temperature relationships of each. On a page of your sketchbook make a row of colour notes, beginning with the two blues to show the step-by-step transition from ultramarine to cobalt blue.

Make a mix of 50/50 ultramarine and cobalt blue, and make a swatch of this mix in the centre of the page. Then divide the mix in half on the palette, and into one half slowly add more ultramarine, and into the other half add more cobalt. As you add more of each pigment, make a swatch next to the previous one on the page so that they are touching, then add more pigment, and so on until you place the last swatch which will be pure ultramarine at one end and cobalt at the other.

As you make each shade, separate a small amount and place it underneath the original mix on the palette; then add a small amount of white. After you have added a little white into each mix, make a second row underneath the first. This will help you to see the undertone as each colour changes.

Then try the same exercise with the two yellows – cadmium lemon and cadmium yellow – and the two reds – cadmium red and alizarin crimson. When seen together you will be able to see the transition from one colour to the next, and also the change from warm to cool.

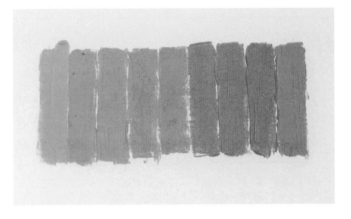

Cadmium yellow – cadmium lemon.

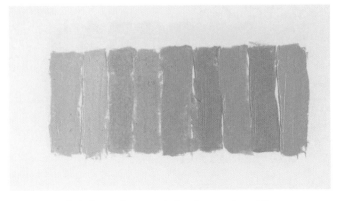

Cadmium yellow – cadmium lemon plus white.

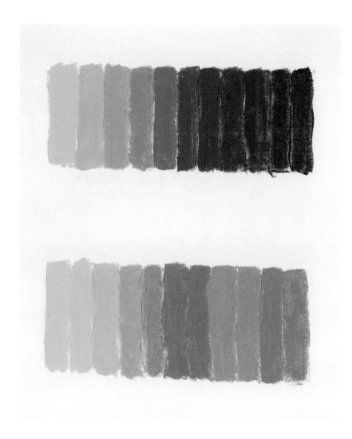

Cadmium lemon – cobalt blue.

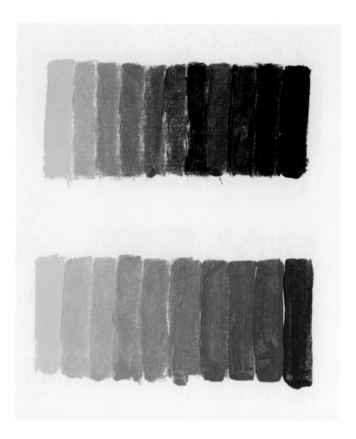

Cadmium lemon – ultramarine.

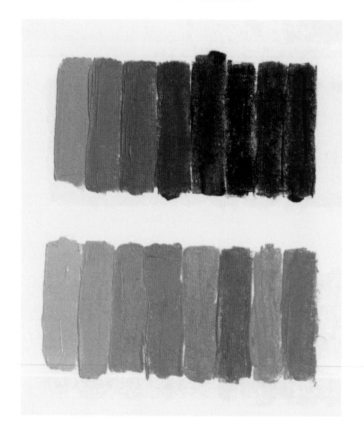

Cadmium yellow – cobalt blue.

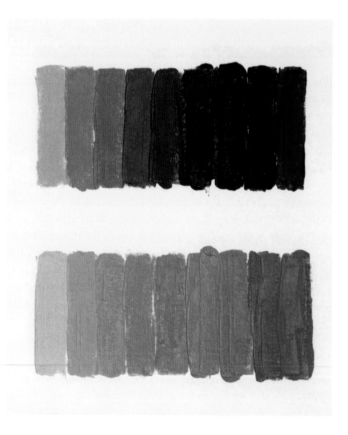

Cadmium yellow – ultramarine.

EXERCISE: MIXING ALL COMBINATIONS OF PRIMARY WITH PRIMARY

So far yellow has been mixed with yellow, red with red and blue with blue. In this exercise each primary colour is mixed with all the others to demonstrate all combinations of 'warm' and 'cool'. This mixing exercise looks at the transitions between one colour and another, intermixing step by step. It is particularly useful when comparing temperature relationships and the contrast of warms and cools. In total there will be twelve rows of mixes which can be compared with the others, and the temperature relationships soon become clear. All the possible combinations of each colour mix are illustrated here, and seen together, the contrast of warms and cools is striking:

Cadmium lemon – cobalt blue
Cadmium lemon – ultramarine
Cadmium yellow – cobalt blue
Cadmium yellow – ultramarine
Cadmium lemon – alizarin crimson
Cadmium lemon – cadmium red
Cadmium yellow – alizarin crimson
Cadmium yellow – cadmium red
Cadmium red – cobalt blue
Cadmium red – ultramarine
Alizarin crimson – cobalt blue
Alizarin crimson – ultramarine

As before, at each stage of colour mixing a small amount was separated to be mixed with white. The swatches of colour are placed below each row of primary mix, and the undertone can be compared.

Mixing 'Coloured Greys' and 'Coloured Blacks'

EXERCISE : MIXING GREYS

Using a palette of mixed coloured greys can produce some wonderfully harmonious and subtle works. A grey is made when a small amount of the complimentary of a colour is added into a mix. When white is added into these mixes it is possible to achieve a very calm and tranquil palette. We see in the work of the painters Hammershoi, Gwen John, Nicholson and Morandi how greys can be used to produce works of great subtlety and beauty.

The illustration on page 88 demonstrates how a grey is mixed. The first mix is a pale orange mixed with white. Into this a small amount of blue was added little by little, and you can see how the orange becomes more neutralized as you move along the row. Ultramarine was added into the top row, and cobalt into the bottom row.

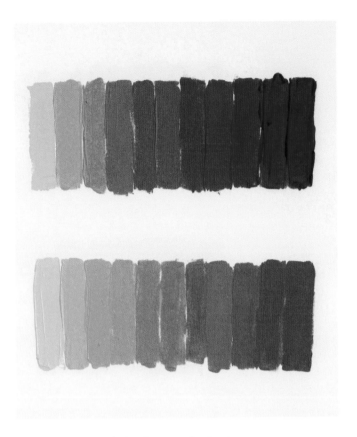

Cadmium lemon – alizarin crimson.

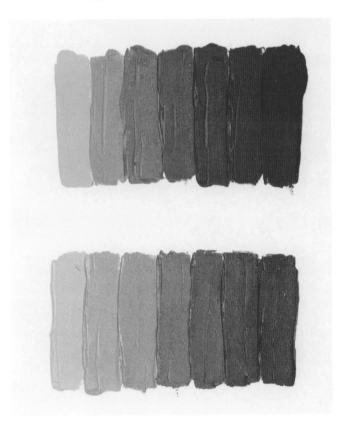

Cadmium lemon – cadmium red.

85

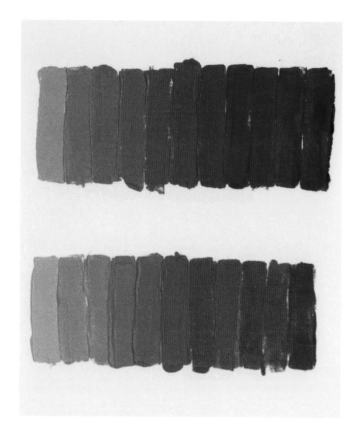

Cadmium yellow – alizarin crimson.

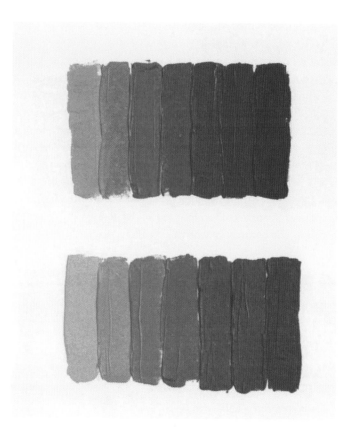

Cadmium yellow – cadmium red.

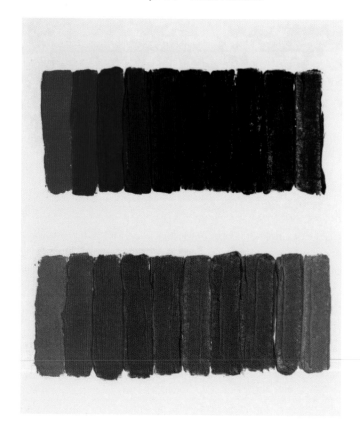

Cadmium red – cobalt blue.

Cadmium red – ultramarine.

Alizarin crimson – cobalt blue.

Alizarin crimson – ultramarine.

EXERCISE: MIXING BLACK

Black is rarely placed on the palette except when using it for a tone study. When black is added into a colour mix to make it darker everything tends to become dark and grey, with no colour. However, a range of beautiful and richly coloured 'blacks' can be made by mixing colours from the extended palette.

Begin by mixing as dark a tone as you can with alizarin and ultramarine: the resulting colour will be a very dark purple. When a small amount of its complementary colour yellow is added, the purple will become more neutral, making a 'coloured black'. Make a note of the mix in your sketchbook.

Try another mix, this time adding another yellow. Make a second swatch in the sketchbook and you will see how the colour and temperature, however subtle, begins to change. You will be able to mix a range of such blacks using other combinations with the extended palette. The illustration overleaf shows a range of mixed 'blacks', with alizarin + ultramarine + cadmium lemon/cadmium yellow, and cadmium red + cobalt blue + cadmium lemon/cadmium yellow. Each black will result from varying proportions of the three primary colours being mixed together.

See how many different blacks you can make. As the subtleties of temperature become apparent you will be able to see how these can be used in your painting to create a more dynamic and exciting colour range, but keeping within the extended palette.

Painting a Still Life Using Two Individual Colour Palettes

Each of the following exercises will focus on the use of a specific palette. The first will use a limited palette of the three primary colours plus white. The subject will be highly coloured and will enable you to focus on complementary colour relationships.

The second exercise will use the extended or Impressionist palette as previously discussed, and the subject this time will be lighter in key. Using objects close in tone and colour will allow you to focus on mixing a subtle palette of 'coloured greys'.

Exercise: *Clementine*

For this exercise a limited palette of the three primaries plus titanium white is used. Place the colours on your palette from left to right: white, lemon yellow or cadmium lemon, cadmium red and ultramarine, from light to dark.

Select a single fruit and drape, and place these on to a surface at or just below eye level. The clementine is placed purposely on the blue cloth to examine the complementary relationship of the two colours, orange and blue.

Identify the direction of the light: how is it falling on the object or wall? Use this to help you establish changes in temperature and tone.

You may feel that this limited palette will be just that, rather limiting, and it won't enable you to mix a wide enough range of warm and cool colours. But with patient mixing this palette will give a surprising number of colours. Try varying the proportions of each pigment as you are mixing, adding a small amount at a time.

'Coloured grey' mixes using the extended palette plus white.

Mixed blacks.

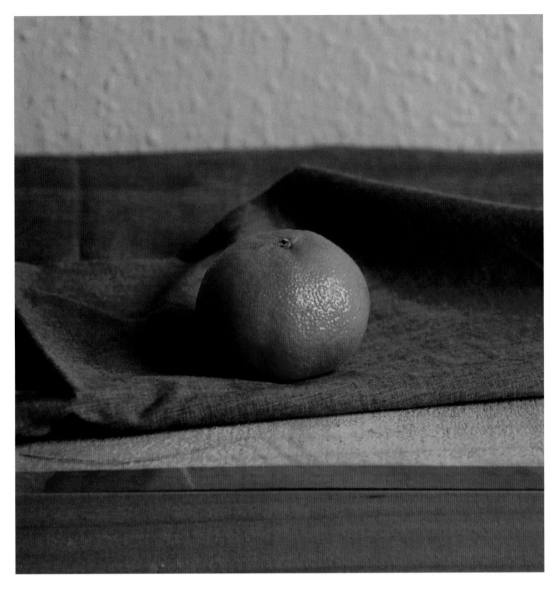

Clementine still life.

Cadmium lemon and white will allow you to make the cooler mixes of the palette, while the cadmium red and ultramarine will give the warmer shades. Adding white to a mix will desaturate the colour but also make it cooler. Thus for a cool red, mix cadmium red with white: as you can see from the sketchbook page, this mixture produces a cooler red that can be used in a mix (a hint of it can be seen in the background colour of the illustration on page 91. The illustration overleaf shows a page of colour notes from a sketchbook made during this oil study to demonstrate the variety of colours that can be mixed using this limited palette.

Make a number of shades of varying proportion with each pigment. As blue and orange dominate this composition, mix a number of oranges with the yellow and red. Different oranges can be achieved by mixing different proportions of red and yellow together. Do the same with the blue, mixing ultramarine with different proportions of white so that you have a range of tones from light to dark. To make the blue a little more subtle, remember that a small amount of its complementary colour, orange, will grey it slightly.

Once you have a number of colours premixed on the palette you can begin to sketch out the composition on your surface. Dilute the paint with thinners and use a fine round brush to draw with. Through drawing, or by looking at the still life through a viewfinder, examine the relationship of the object within the edges of your canvas or board. Think about the amount of space you would like around the fruit. Do you wish to place it in the centre or nearer to one of the edges?

As you begin to draw with paint, work from the colours already mixed. For the fruit itself, select from the oranges, light to dark; do the same for the blue cloth. Blocking in using ready-mixed colour will allow your study to develop quite quickly during this early stage. Use line to establish a number of reference points, and once these have been placed, begin to block

Sketchbook colour notes made during Clementine.

in by placing colour in small areas, or patches, describing the most important planes and structures. When laying down paint over any larger area, begin to experiment with brushes of different sizes. The overall relationships of dark to light, warm and cool, can be established after quite a short time as you lay down one block of colour against another. At the start of each new session, try to premix a number of colours from this limited palette before beginning to paint.

Initially as you block in an area such as the blue cloth, simplify the number of tones, only putting in the essential blocks. As time passes you can focus more closely on the more detailed colour transitions in your composition.

As you can see in the illustration opposite, both the clementine and background soon begin to take shape. The paint is opaque and covers quickly, and the main areas of light and dark are established immediately. This painting was completed over two days.

The triangle of dark above the fruit is important to the composition, creating depth behind the subject but also acting as a

counter balance to the weight of shadow on the left side of the clementine and its cast shadow.

Across the surface of the clementine you can draw with colour to establish form; you can see how blocks of colour have been placed around the contour. Coloured lines in different shades of blue cover the drape to describe the folds and creases.

During the next stage of the study, revisit any areas that may need more paint to be applied. In places the first layer of paint may appear to have sunk, and the surface may look dull and therefore appear lighter than when the paint was fresh. If this has happened, lay down more paint over these areas first.

Because of this 'sinking' the next step is to brighten the background. Initially the background was one flat tone, but now you should begin to look at the areas of colour here. In this particular still life the background did need to be brightened with another layer of paint as the initial light colour now seemed darker and somewhat dull (as the oil had sunk into the surface). It also needed to be a cooler colour, to contrast with the vivid warm tones of the fruit and cloth.

During this stage add a little linseed oil into the paint mix so the paint can be used rather more thickly. It needs to be more

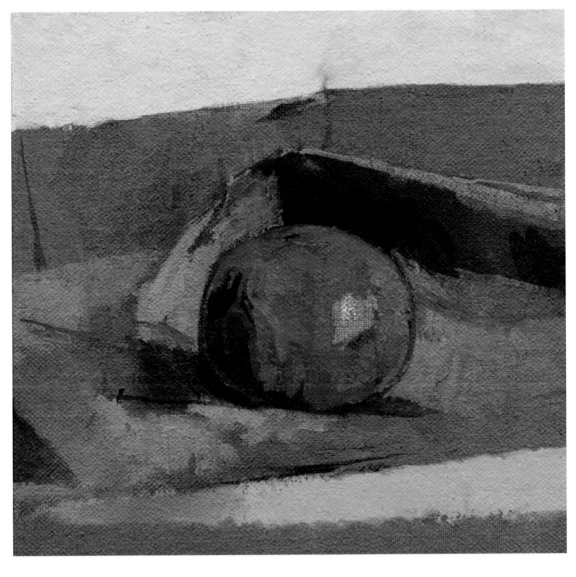

Blocking in the oil sketch of *Clementine*.

buttery in consistency, whilst still able to flow freely from the brush. As the layers of paint build they will help to seal the canvas surface and prevent subsequent layers of paint appearing to sink so much.

During the second day on the painting continue to make the colours rich and saturated, being careful not to use too much white in any of the lighter colour mixes. As the colours become more saturated make sure that the tones are contrasting enough. At this stage of the painting the lights are brightened and the darks made richer – though if the darks are dark enough the lights will appear to be lighter anyway.

In the last session identify the key areas you intend to work on – where the drawing needs to be refined, use line to pick out the contour and to describe the edges of planes or turns on the fruit or drape. Paying closer attention to the fruit, consider how the direction of your brushstrokes may begin to describe the form by following the contour. If brushwork remains fluid and sketchy, this will help to enhance form and volume.

Look at the planes and angles moving around the fruit: the facets of bright orange begin to take on a more structured feel as they move over the surface. Areas of reflected colour on the underside of the fruit are introduced, and the final addition is to make the cool highlight on the skin brighter using a cool blue-green.

A small amount of orange was added into the dark shadow under the fruit to grey the blue slightly. Originally this area on the painting was both too warm and too blue. Orange was added because it is a reflected colour, and because the complementary is also present in the shadow.

The lower part of the canvas hadn't received as much attention, so now look at this area if the same applies to you – the wooden surface that the fruit sits on had been 'left behind' when compared to the other areas of the canvas. The colour temperature needed to be cooler, with the same brightness as the background colour.

The final touch was to put in the thin line of shadow under

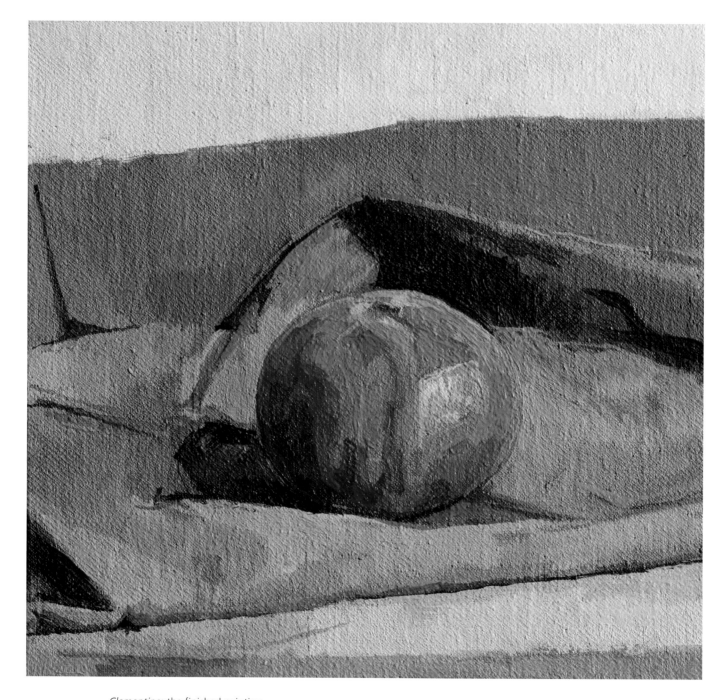

Clementine: the finished painting.

the curve of the drape at the front, and the markings on the wooden box. Only as you reach the end of the painting begin to pick out details, for example any scars or lines on the fruit, and the top of the fruit.

Continue to use paint mixed with oil, but to help to make the colours more luminous, reduce the amount of turps and use more oil.

Listen to your own instinct as to when to stop. Ask yourself what you would achieve by continuing, and if it feels as if it is time to stop, then do so, and don't overwork your painting!

Exercise: *White Pots with Scarab*

This small still life of white pots with a scarab focuses on a palette of 'coloured greys'. On first impression it might look as if a limited palette had been used for this painting, but in fact the extended palette was used, with white. When looking at groups of jars and pots together the work of Morandi always comes to mind, and it is his still life arrangements and palette that influence this work.

It was the contrasting qualities of the surfaces and the different 'whites' – warm and cool, opaque and transparent – that brought the three objects together for this painting. The

Sketchbook swatches showing mixed 'coloured greys'.

ceramic pot feels very solid and opaque, while the polished alabaster bowl is semi-transparent, the range of light colours within it making it glow. The subtle and pale key of this picture demonstrates the number of colours that can be seen in an all-'white' composition.

The colours needed on your palette for this painting are titanium white, cadmium lemon, cadmium yellow, cadmium red, alizarin crimson, cobalt blue and ultramarine; raw sienna is added at a later stage. The illustration above shows a number of colours mixed during the early stages of this painting.

The objects were drawn on to a small linen board using a wash of diluted raw umber and a rigger brush. The board had been sized but not primed with white; it is sometimes more helpful to work on a mid-tone surface rather than on brilliant white. It is beneficial to be able to establish the light to dark tonal values straightaway, and the natural linen allows you to place the most contrasting lights and darks immediately. Perhaps try one painting on this type of surface and another on a white gesso-primed surface, and see which tone you prefer. In

this composition the tones are mostly light, the darkest area of tone being the left-hand side of the taller jar.

Using a fine rigger brush, draw directly on to the board or canvas with paint to establish the positioning of the objects. The three objects were placed so that they filled the composition, with only a small amount of space around them. To check scale and proportion the width of the ellipse of the taller pot on the right was used. This measurement is also equal to the depth of the bowl, from the back rim to the bottom. Carefully checking the proportion of the objects throughout, and the amount of space between the subject and edge, continue to establish the objects using the umber wash.

Once you are satisfied with the overall drawing, begin to look at the tonal relationships throughout the composition. As at the beginning of any painting, simplify what you are seeing and don't try to put in everything at once. Using oil paints allows us to plan ahead, stage by stage. Try to block in the larger areas to begin with, establishing the major tone, colour and temperature relationships throughout the whole painting, laying down patches of colour over the entire canvas surface.

First lay down paint over the largest areas – here the back-

Establishing the composition.

Patching in areas of colour and
simplifying what you see.

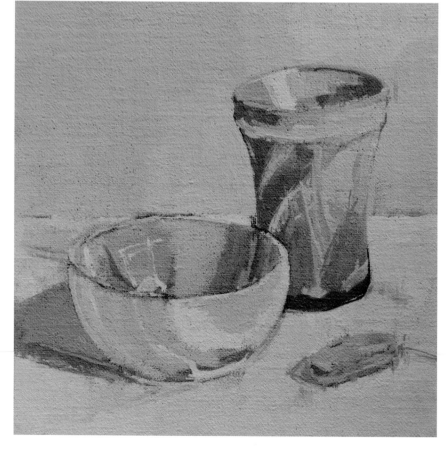

Detail of paintwork on pots.

ground and the cloth. The pots have many changes of tone and colour, but during the early stages only look at the light and dark tone shapes and just paint in patches of tone in these areas.

Use opaque paint for this stage; if the mix is too thin and dilute, use less turpentine or 'Zest-it'. Add this with a palette knife rather than dipping your brush into it, as the bristles can absorb too much liquid and turn the consistency of your paint mix to something more like watercolour than oil paint.

The background shows subtle temperature changes right from the beginning. The light is coming from the right-hand side and makes the warm pale peach colour look cooler, with more blue in the mix. Further to the right the tone is slightly darker and warmer in feel. The same cool light strikes the right side of the cloth by the scarab and the right pot.

Although there is a lot of detail in the texture and colours of the pots, to begin with the overall surface was simplified by placing patches of light and dark, warm and cool sections over the entire canvas. The illustration opposite shows how the surface is described with small patches of colour moving over the surface. Try to establish the contours and form of the pots by laying down areas of paint, one next to the other, without these becoming too detailed or laboured.

To begin with the painting will look rather 'patchwork'-like, but don't worry about this 'patchiness' as the form will develop quite quickly. The triangular shadow on the left side of the bowl shows how the area is painted very simply at first and appears quite flat. This will, of course, be considered in further detail later, as attention to the subtle colour changes and smaller patches of colour will become more focused as the painting progresses.

The colours used until now have been mixed from the extended palette, but at this stage burnt sienna is introduced, as it is useful for the warm dark at the base of the pot. Mixing a palette of 'coloured' greys throughout the painting gives it a wonderful unity and harmony throughout.

White has been mixed with many of the colours. Make sure that any white used is mixed very thoroughly into each individual pigment with a palette knife: this allows for a more through mixing, and keeps the consistency of the paint a little thicker to allow for a more opaque covering. Opaque paint also makes the colour richer and more saturated while the tones appear closer to those observed.

In the illustrationat the end of the chapter you can see how individual colours have been used to draw on the pots and scarab. The lines mark the edges of each colour plane, showing where the next patch of colour will begin. The scarab was initially one block of colour, and other colours within the object were mixed and used to put in structure lines. The same applied for the folds and creases on the cloth and the design on the pots themselves. These drawn lines remain to help to describe the

objects, without standing out or needing to be painted out at a later stage.

As the still life nears completion, begin to focus on the smaller areas of tone and colour in the composition while continuing to make any further revisions to those already established. As the layers of paint build, use less thinner and introduce a little more oil so that the paint becomes slightly thicker in consistency with each layer, particularly if the paint surface has sunk at all and appears dry or dull.

Areas that always seem rather complicated are the shadows cast by the objects. As this still life is so light in key, the shadows appear particularly dark and at first seem too strong, jumping out of the painting. There is a lot of reflected colour within the shadow, but also look out for a suggestion of the complementary colour. The quality that makes the larger shadow on the left is more complex by the the reflected light within it as light shines through the semi-transparent walls of the bowl.

The shadow overall was first simplified, and then the slightly lighter area within the triangular shape was placed, followed by very small shapes of lighter colour to prevent the weight and depth of tone being too dominant. The same approach was used for the small shadow cast by the scarab. As the shadows become more resolved, check the areas of colour around the cloth: do any of the colours or temperature changes need to be enhanced?

Looking closely at your painting, check the surface of paint over the outer areas. It is always tempting to spend time painting the subject so it is easy to overlook the surrounding parts. Does the background need any further work? Do you need to layer more paint, or is the colour saturated enough?

Drying time will slow down considerably the longer you spend on the work. As there is a lot of white and linseed oil mixed into the paint, drying time is now very slow.

As you paint the bowl and jar in more detail at this stage, be very mindful of the direction of the contours of the surfaces. When laying down more paint, think about the direction of the brushstrokes following the same direction as the contour, in the same way that you used directional marks when making a reductive drawing (see the illustration in Chapter 3 on p. 00 [ref=Fig 48]). Use the paint and brushstrokes in exactly the same way.

The final touches are to establish a few lines on the cloth and the scarab, making sure that the drawing doesn't become too detailed or 'tight'. Once this is done, any final areas of colour can be placed.

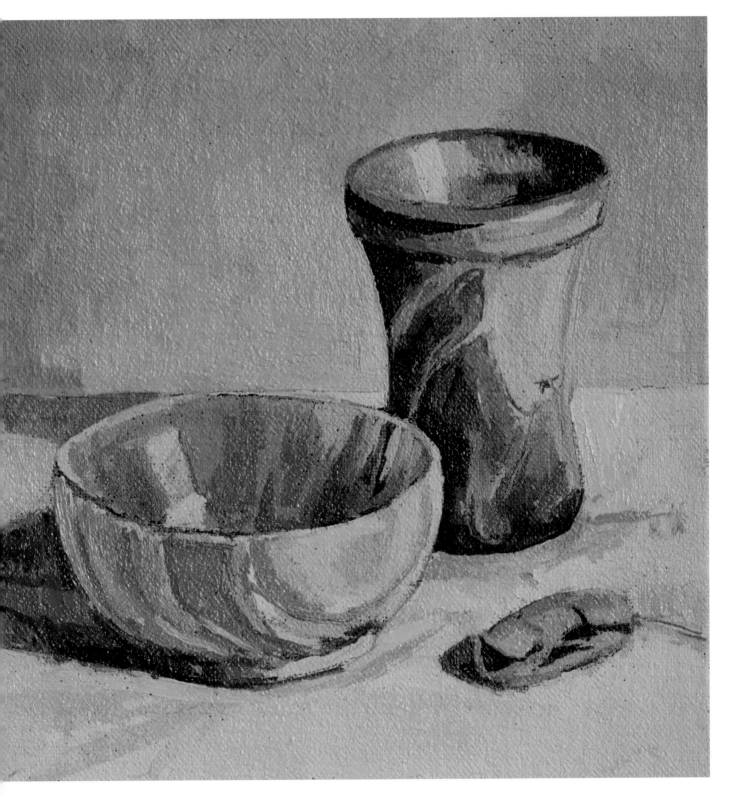

White Pots with Scarab.

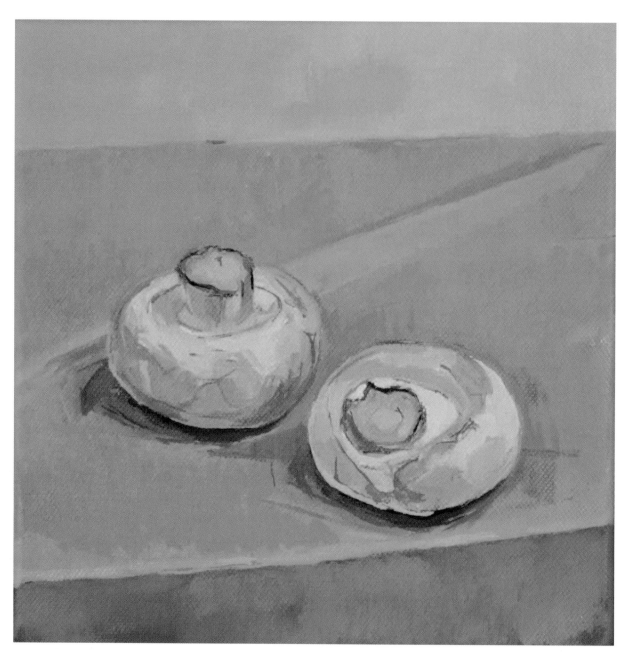

Mushrooms.

STILL LIFE WITH FLOWERS, FRUITS AND VEGETABLES

The natural forms found in nature have inspired artists throughout the history of still life painting. Fruits, vegetables, flowers and shells provide us with a wonderful choice of colours, textures, shapes and forms. Whether they are painted individually or grouped with other objects, we have a continuous supply of subjects to inspire our work.

From the earliest still life paintings discussed in Chapter 1 we have seen how nature has continued to inspire and inform us. From the wall paintings of Pompeii, through the Italian Renaissance, to Dutch painting during the seventeenth century and the twentieth-century paintings of Uglow and Aitchison, we have seen how artists have responded to, and painted natural forms of fruit, flowers and vegetables.

Flowers

Flowers as a subject have been painted by many artists, and artists have returned to them time and time again. The first flower still life pieces were painted on the reverse side of portraits; one example of this is *Still Life* (1490) by Hans Memling. The tradition of decorative flower painting was then to flourish in Madrid. Often we see paintings showing elaborate vases of flowers, such as those of Fantin-Latour, and of course Van Gogh's *Sunflowers* is one of the most famous images following this theme.

The motif of the simple flower composition, using a few or perhaps just one flower stem, became more popular during the twentieth century and was used by artists including Uglow, Aitchison and Nicholson, amongst others.

Whenever I have been inspired to paint flowers, it has been to paint a simple and small-scale composition, capturing the beauty and elegance of one single flower stem. The flower has often been placed against a colourful background, of either a contrasting or a complementary colour.

The following exercise takes as its theme a single flower, its vivid colour enhanced by that of the background drape. This single rose stem is the next in a series of flower paintings, placed against the same colour drape and under the same direction of light in the studio. The illustrations overleaf show two previous flower paintings of this type.

Exercise: *Kate's Rose*

All the exercises in this chapter use the extended palette, with titanium white, cadmium lemon and yellow, cadmium red, alizarin crimson, cobalt blue and French ultramarine. Occasionally raw sienna and *terre verte* have been included on the palette.

This small still life of a single yellow rose is painted on board; it was painted in two sessions. Due to the nature of the ever-changing opening flower it was decided to paint this subject on a small gesso-primed board: because the study would have to be painted very quickly, the paint had to be used opaquely right from the beginning, and slightly thicker in consistency than when beginning a painting which is going to be worked on over a more sustained period.

The vivid, rich yellow of the rose is what excited me about painting this flower, particularly once placed against the drape. This blue drape used as a backdrop moves towards a warm mauve hue, and therefore the complementary colour seen against the yellow bud.

This exercise is designed to make you focus on painting a rapid oil 'sketch', from an object that will soon change and wither. You will have to work quickly to capture its beauty, intensity of colour and shape before it changes, so you will need to think about paint consistency, and drawing with thick and opaque pigment from the outset. The paintings of other subjects in this chapter will be longer and more sustained, so you will be able to draw and to sketch out the composition and to layer the paint in thinner layers, building up the surface slowly. This technique of applying and layering oil paint on to canvas.is different altogether.

Select a single flower stem and place it against a coloured

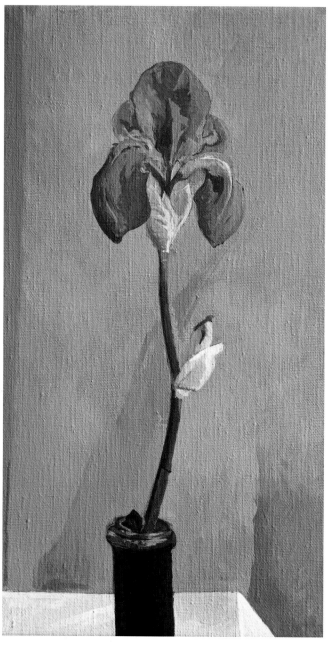

Iris.

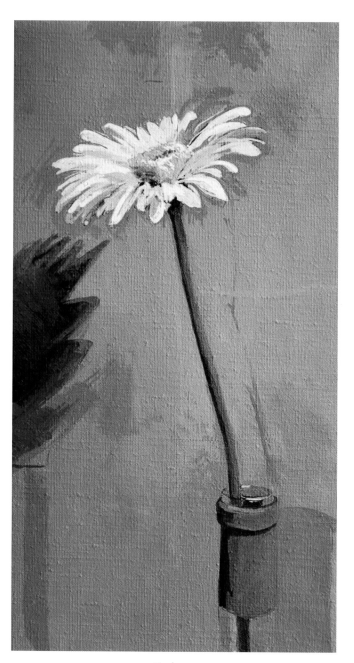

Gerbera.

drape of your choice. You may go for a very colourful and striking combination using complementary colours, such as with this rose, or perhaps a more harmonious and subtle colour relationship, as in the painting *Iris*. Here the mauve shades of the flower against the blue ground are placed next to each other, as we would find them on the colour wheel.

Because the flower will continue to open and so change during the painting time, it is essential to work quickly. You won't have time to layer the paint in a more considered way, starting with thin transparent layers and becoming progressively thicker. Try to mix a number of colours on the palette before you begin.

As you begin to sketch the flower, place each colour as it is seen in the composition. Draw with shades of light, mid and dark tone of each colour for the flower, stem, leaves and drape. As you apply these, establish the drawing and block in with a colour and tone appropriate to the area being observed.

You will be surprised at how quickly the image will begin to 'pull together' and take shape. Concentrating on the lights and darks, you will soon begin to establish the form and three-dimensionality. If the paint is used opaquely, the paint surface will build up quickly and the colours will be clean and resonant from the start.

If you are used to working by layering paint thick over thin, or

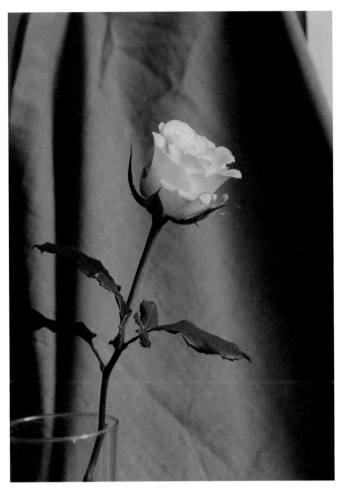

Kate's Rose set-up.

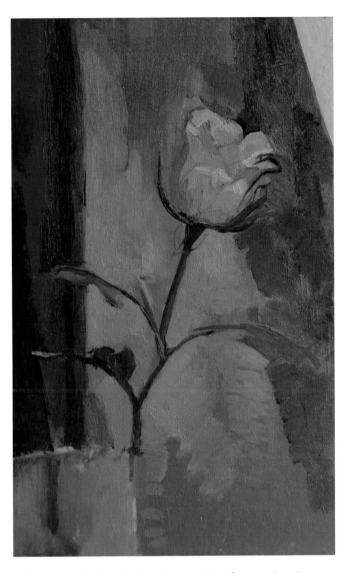

The oil sketch of *Kate's Rose* after a session of two to three hours.

'fat over lean', this will feel to be quite a different way of working the paint. If you wish to work over the top of an area, you may find that the paint mixes too much with the buttery paint underneath. To avoid this, very carefully remove any paint you wish to work over with a palette knife or scalpel blade. Once you become more confident, you will be able to lay down thick paint over the top of other paint with the minimum of brush-strokes. But be careful, as too much 'dabbing' will mix the fresh paint with the older.

During the first session it is important to try and simplify each area of the painting in the composition as a whole. Thus the background drape is simplified to shapes of light, mid and dark tones of blue, and the yellow of the rosebud is simplified in the same way, with blocks of yellow in light and dark.

During the second session use line to establish any 'drawn' elements, for example the edges of the petals, and the edge of the leaves and stem. Use a fine round or rigger brush to do this, and to add any smaller patches of colour on the inside of the flower, and also any darks or reflected colours you can see.

During this last session pay close attention to any detailed colour shifts, for instance the ochre edge around the base of the rose, and the small colour transitions on the leaf. Don't forget to look at light and dark contrasts in each area. In the illustration overleaf the dark on the left-hand side has been deepened with a more saturated colour. However, should an area become too colourful or 'hot' in temperature, remember to mix in a small amount of the complementary colour. Make sure that the colour of the stem seen through the glass is slightly different in tone to the colour seen above the glass. Also, does the stem meet, or is it slightly distorted?

The detail of the light catching the rim of the vase was sim-plified to as few brushstrokes as possible. Try not to overwork such an area or make it too detailed, but decide where you want the focus to be, and keep everything else as simplified as possible.

Don't overwork the surface, but try to keep the brushstrokes as painterly as possible so that the surface is exciting, rather than flat and dull.

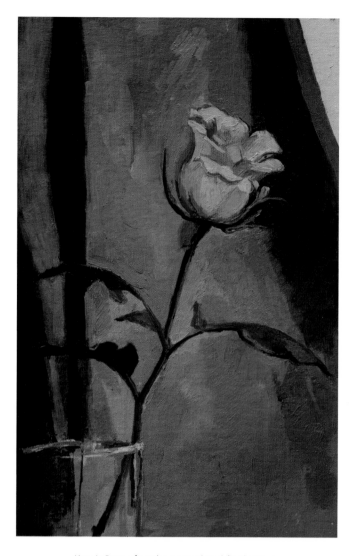

Kate's Rose after the second and final sitting.

Exercise: *Orchid Still Life*

We may find that we return to some subjects and paint them a number of times, perhaps over many years. When looking at the work of any artist it is possible to see the same subject and themes being revisited in their work, and painted in a variety of ways.

The elegance and simplicity of a single potted orchid is one such subject that has become a recurrent theme. What attracts me to this subject again and again is the contrast between the weight of the flowers and the delicacy of the stem, the leaves acting as a counter balance for the flowers, which at first appear to be top heavy. The subtlety of colours of an orchid's flowers against the strong dark greens of the stem and leaves make this a captivating subject. The flowers of an orchid can last quite a long time when compared to other flowers, which makes them an excellent subject for painting.

Before starting to draw on to a canvas using brush and paint,

it is useful to think about the tone of the canvas you will be working on. In this painting, the white of the canvas is helpful to the composition as it is light in tone. Sometimes it is helpful to lay down a wash of a darker tone, but this will need to be done a couple of days before you begin work, so that it is dry before you draw over the top of it. If the surface is wet, any paint you put down will mix with the under-painting and the colours can soon become 'muddy'. A thin wash of raw umber or unbleached titanium is a good choice as it breaks the white, and the surface tone is then similar to the tone of natural linen, before being primed white. If painting a subject in front of a dark or highly coloured background it may be useful to consider laying down a suitable wash before beginning work.

A tone ground is helpful when establishing light to dark relationships at the beginning of your painting. It is rather like the reductive drawing method, when a mid-tone ground helps to establish the overall tonality of the piece, as the lightest and darkest tones are placed during the earliest stages of the work.

A canvas of narrow proportions was selected for the painting of the orchid, in response to the tall, slender shape of the plant. The intention was for this subject to fill the space, so the edges of the canvas would be very close, emphasizing the overall length and narrow shape of the subject. In your own composition think about the amount of space you would like around the subject: would you prefer to have a lot of space around the still life, or will the edges of the canvas be very close so that the object fills the picture space?

To sketch the still life on to the canvas, use a fine round or rigger brush, as this will give a finely drawn line. A thin wash of raw umber is useful for this. You may have a preferred tone for this task, but avoid using a colour that is too vivid and will 'jump out' because as you lay down areas of paint, you don't want any coloured lines of the drawing to affect how you see other colours that are put on the canvas later.

Before beginning to work on the canvas, do some measuring. Select a part of the orchid that can be used to establish a scale. Use a viewfinder to get a feel for how the subject will fit into the shape of the canvas, and then sketch with brush and paint to establish the position of the orchid on the surface. The measurement used throughout this painting was a section of the

TONAL CONTRASTS

When working on a white ground, each area of colour placed on the surface will appear to be darker because it is seen against the white primer. Once other patches of colour are put down and the white disappears, the first tones placed may appear too light.

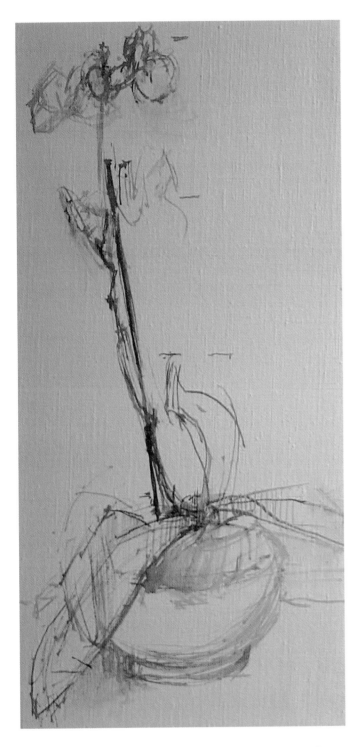

Sketching out the orchid using raw umber and a rigger brush.

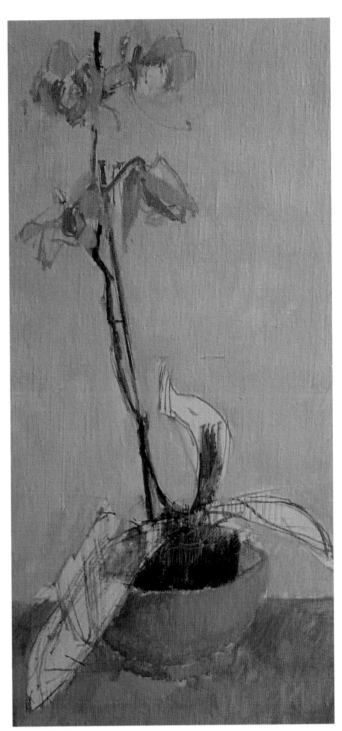

Blocking in the main areas of colour over the background, surface and pot.

stem between two angles; this unit measured four times into the total height of the orchid. After double checking this scale, make sure that the same measurement also fits at least four times into the height of the canvas.

As you begin to sketch the orchid, use fluid brushwork and paint diluted with turpentine. Don't worry if at this stage a part of the drawing needs to be corrected: marks can easily be erased by brushing a small amount of turpentine over the area and carefully wiping away, and it is possible to re-draw over the area straightaway. A ghost of a mark may still be visible, but this doesn't matter, as such marks document the process of a painting and add to the tension and dynamism of a piece.

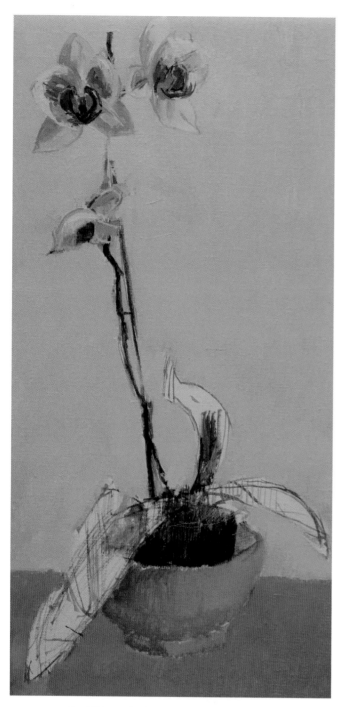

Establishing the flowers before they change!

next stage is to introduce colour as simplified patches over the whole surface. Try to mix your range of colours from the extended palette without introducing other hues, and during the painting process continually simplify what you are seeing. As you observe each area, note how it is made up of shapes of light and dark, and start your painting by describing these shapes in broadly applied colour. As each patch of colour is placed on the canvas and the surface is gradually covered with a thin, opaque layer of paint, it will be possible to analyse each light-to-dark and warm-to-cool relationship more closely.

The illustration on page 103 (right) shows how the background and surface on which the orchid is standing is the first to be patched in. The flower heads, stem, leaves and pot take shape as simplified patches of colour build up, and the light and dark transition around the pot is also suggested. The paint at this stage is thin and diluted slightly with thinners, but be careful not to dilute it too much so the paint layer becomes transparent. Try to use opaque paint as soon as you begin to put down patches of colour. If the paint is too thin and dilute the primed surface will show through the resulting paint layer, and the true colour or tone of the newly added paint will not be apparent.

The illustration (left) shows the third stage of this piece, when another layer is added over the background, and the subtle changes in colour and the warm and cool areas begin to be established. It is also evident that although not all the areas have yet been addressed, work has proceeded quickly on the flower heads before they begin to change and wither too much. The orchid flower has so much information and detail, but it is

USING TURPS AND LINSEED OIL

In the early stages of a painting linseed oil should not be added into the paint mixes, as there is enough oil in the paint itself. For the initial layers thin the paint slightly with thinners (either turpentine or Zest-it). The paint should be fluid enough so that it flows from the brush to the canvas with ease; if it is too thick or dry it won't transfer from the brush to the surface as well, and as a result the paint layer as it builds up can look dry and lifeless.

As the painting develops, each layer progressively becomes thicker. As time passes the amount of thinners being used will decrease and the medium will increase, a stage neatly described by the phrase 'fat over lean'! The paint mix will become buttery and the colour saturation will not be diminished.

The illustration on page 103 (left) shows how the initial placing of the orchid within the rectangle has been made with rapid and fluid brushwork. Four equal units measuring into the length of the drawing can be seen along the centre of the canvas. Try not to allow the drawing to become too tight, and remember that positions can be easily changed. As you revise your work during the following sessions some parts of the drawing will change as part of the painting process.

Once you are happy with the positioning of the subject, the

important that as you translate what you see into paint, you continue to simplify: don't try to put in everything, but keep your focus on the main tone and colour changes.

As you are working, remember to half close your eyes frequently to remind yourself of the tonal relationships throughout the entire painting process. It is easy to forget to do this because we become concerned about colour mixing and forget about the tone of colours. For instance, in a dark palette it is difficult to make colours dark enough, and it is important that any darker tones are placed early on in a painting to help gauge the overall tonal relationship. In the illustration (right) the dark umber of the soil in the pot has been painted, and this tone can then be used to compare any other darks, for example inside the flowers, and the leaves. The leaves will be painted next, and then the whole canvas will be covered with at least one layer of paint.

The focus during the next session on this painting was the lower part of the canvas. Up to this point this area had been left in favour of establishing the flowers before they wilted, so the flowers developed more quickly than the rest of the canvas. Normally when painting a subject you should aim to work over the whole surface of the canvas, giving equal attention to all parts, the subject as well as the background. In doing this, the entire surface will be addressed in equal measure, the layers of paint building up as equally as is possible.

Due to the transparent nature of the greens being used, the leaves were painted by patching areas of tone light to dark in layers, one over another. Working with slightly thicker paint over the top of the previous layer, it is possible to build up an opaque surface. When painting the plant stem, stick or another part, allow the background paint to dry so that when working over the top a sharper and better defined edge will be achieved.

The pot is the next area of focus. As with all the other parts of the canvas, try to simplify what you are seeing. As light falls across the surface of the ceramic pot, try to establish the form by laying down paint in a series of shapes. To identify the planes of light and dark, draw them with a line first if this helps you to pick them out. Although the surface is curved, these areas of tone will create a feeling of volume and form as the surface moves towards you and away again. Avoid blending the edges of any of the patches of paint, because if these edges are 'smoothed out' it will result in a flatter surface rather than a three-dimensional one.

In the final session, work concentrates on the lower section of the canvas – the pot, leaves and the wooden surface. A greater contrast of light to dark was needed, as well as warm–cool colour relationships. Over the surface, the colour needed to be more saturated, particularly the dark greens and dark spaces between the leaves.

As you apply what is going to be the final layer of paint, make sure that you don't blend any areas of colour; it is very easy to

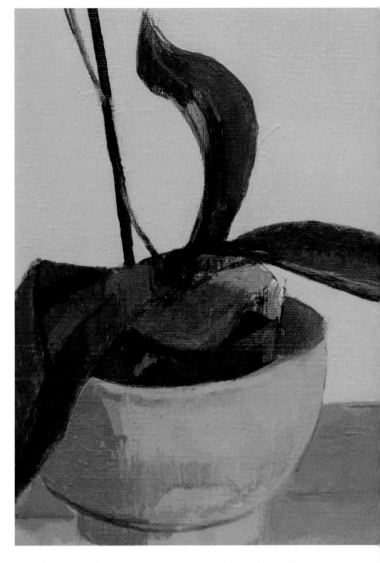

A detail of the pot and leaves, showing how coloured lines are added over areas of tone.

finish by making everything 'smooth'. Continue to lay down small areas of colour, but leaving the edges of each plane and facet; it is these that create a 'drawn' mark, giving definition to the turn of a leaf, the contour of the pot, or areas of warm and cool over the wooden surface.

The temperature key throughout this painting is very cool, as a cool north light falls on the orchid. The temperature of the palette can easily become too 'hot'. As the painting progressed the focus was to make the colours cooler, particularly the wooden surface, which had become too warm. If a colour becomes too bright or vivid, remember that adding a small amount of the complementary colour will grey the hue slightly. Also think about the temperature of the pigment you are adding, use the cool option, and don't just automatically add white to the mix.

As you work from large areas of tone and colour to smaller

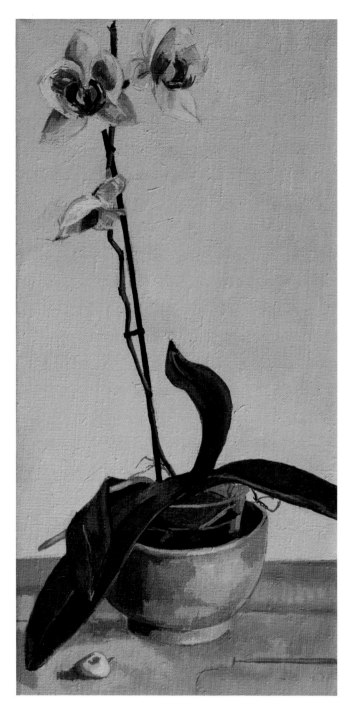

Orchid Still Life.

re-draw an area, mix a colour close to the one you are observing, and use that. It is surprising how using line and tone together creates a much stronger and defined structure, and gives form to your objects.

As the surface of the painting begins to settle, sometimes the paint appears to 'sink' and its sheen when fresh can disappear, resulting in the surface looking rather dry. This can also make darks appear to be much lighter after drying. Add linseed oil (or your preferred medium) as it will make the paint more fluid without diluting the colour and making the surface too 'thin'. At this stage use just oil and don't mix with any thinners, as this can result in the final layers becoming rather flat and dull.

Sometimes one of the most difficult decisions to make is when to stop painting. We have all experienced overworking something and wished we hadn't – so we have then endeavoured to go back a stage or two, overworking even more.

Stop work as soon as you feel that you are beginning to 'fiddle' or to 'fill the time'. Ask yourself, have you done all that you set out to do? If you have, then stop. If you feel that you haven't, then leave the painting for a few days: spend time looking at it, rather than adding more paint. It is surprising how a little time away from your work can make you look at things afresh. Perhaps you don't need to do as much as you thought you did on reflection and after a little distance.

As you sit and evaluate your work, it may be helpful to make a few notes on what to work on next. Doing this does focus the mind and makes you keep to the most pressing aspects, as it is easy to go off on a tangent and work on something else more than is needed, and overwork in that way.

Another useful tip is to take a photograph of the painting. This makes you look at your work in a different way, and quite often things do look more resolved than initially we think they are.

As your painting of the orchid has developed stage by stage, the aim has been to simplify and to paint broad areas of tone and colour. As these have been established, and depth and shape defined, you have then looked at further detailed colour and tonal changes.

It is easy to try and do too much, too soon. If you try to place all the colours and all the tones too early, the resulting effect can become rather like a patchwork. All the information is there, but any sense of form and solidity is broken up rather than consolidated. Painting broad areas of colour early on gives a base and a structure to the objects right from the start. After this, at each stage slowly focus on more detailed passages, but without doing too much all at once.

As this painting reaches its conclusion, look at the work of some other artists who painted a similar subject matter, for example, Uglow and Nicholson. See if you can spot the initial layers of paint, those large areas that would have been laid down first, and then observe how the more detailed passages have taken shape. Select a still life painting and see if you can

and smaller sections, slightly increase the consistency of the paint each time so that the colour becomes more resonant and saturated. With each area, however small, keep the edges of each individual shape or plane crisp and sharp, to describe shape and depth.

Even during the later stages continue to think about drawing within the painting. Over time you will observe more detailed transitions in colour, and see new aspects, so the process of drawing is used to accentuate, re-establish and revise. If you do

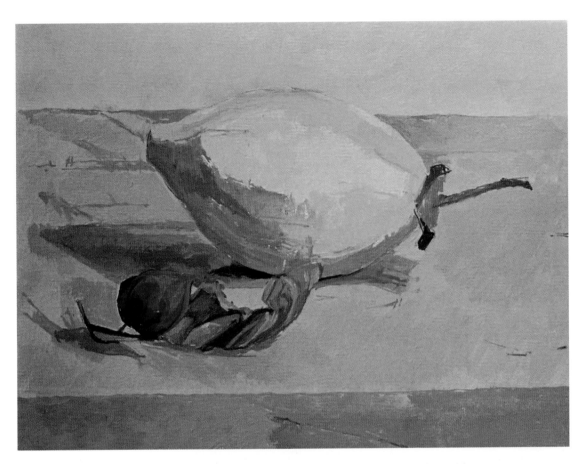

Autumn Still Life.

Squash.

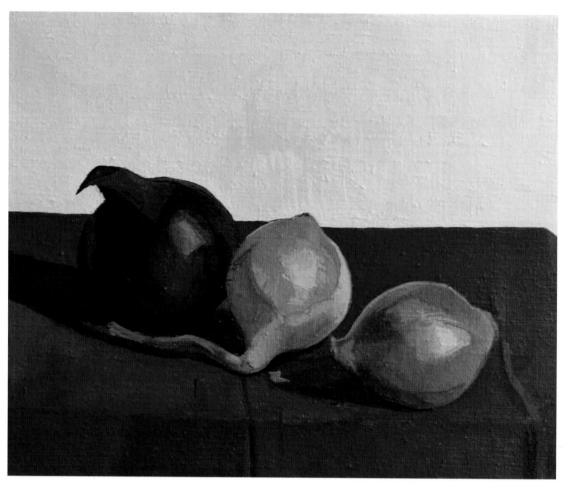

Three of a Kind.

analyse the process of the artist. Where do you think they started, what was their palette? Can you see any of the initial drawn lines, is all the canvas covered with the same level of attention, or are there areas of canvas that seem quite bare?

It is always useful to study the paintings of other artists. You can learn so much about other processes, such as the scale of marks and the direction of brushstrokes.

Vegetables

With their beautiful colour combinations – some subtle, others bright and saturated – their angular, well defined planes that move around each form, or the soft sheen of their skin as light touches them, vegetables are a challenging subject to paint. *Autumn Still Life*, *Squash* and *Three of a Kind* are examples of recent paintings inspired by a small number of vegetables. Painting a single form allows you to strip away all other compositional elements and to focus on the quintessence of the subject.

Squash was placed in a set-up where all the colours and tones echoed those seen in the squash itself. Thus the cool ochres of

the vegetable are repeated in the wooden surface and in the facets of the crumpled brown paper on which the squash partly rests. *Autumn Still Life* was also inspired by the close colour and tonal range of the objects and surrounding area. The orange of the Chinese lantern adds a touch of warmth to an overall cool palette.

The contrasting colours and scale of three onions inspired the painting *Three of a Kind*; the deep reds and mauves of the left onion were particularly exciting to paint as seen against the deep viridian of the drape. Vegetables, and in particular onions, have inspired some wonderful still life paintings. From the seventeenth-century still lifes of Cotan to the present day, onions as a subject have continued to be popular. Cézanne, Van Gogh and Uglow often painted them.

Exercise: *Still Life with Pumpkin and Gourds*

These particular vegetables had been in the studio for a little while, and one of the gourds had completely dried up. This wizened form contrasts wonderfully with the full and rounded forms of the small dark gourd and dried fig against the green

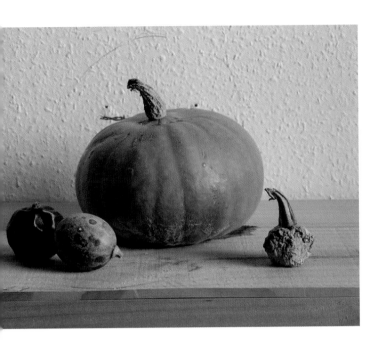

stalk, and the mid-point on the horizontal cuts through the 'shoulder' of the pumpkin. The eye level is set a little higher than the set-up, and the horizon line of the back of the surface is just under the mid-way point.

A grey wash was painted over the linen before drawing began. (Be sure that it is completely dry before beginning to sketch out the composition.) The overall tone was a mix of all the paint that was on the palette at the end of a day's painting: mixed together they created a cool grey, which was a perfect base for the range of colours in this composition. This tone wash subdues the white surface, so the lightest and darkest tones in the composition can be established in the early stages of the painting.

Use a dilute raw umber with either a rigger or small round brush to sketch the pumpkin and gourds on to the board or canvas. Once this is done, some of the larger patches of colour can be quickly blocked in as the drawing progresses.

Mix a generous amount of colour for the background, two or three tones for the surface, and the same for the pumpkin and gourds. It is best to paint areas of colour in simplified shapes in the same way that you began to lay down paint in the orchid painting.

A cool light tone has been worked over the background, while on the wooden surface, patches of light and mid-tone ochre have been broadly painted. Each of the gourds and pumpkin has been painted with two or three tones so that at this stage the lightest

pumpkin. It was the close range of the colour palette and the cool light falling on this group that brought these natural forms together.

Through drawing and observation of the still life, it was decided to place the larger form quite centrally in the canvas with the smaller forms to either side. The centre line that runs through the canvas on the vertical touches the right side of the

Above: Set-up for *Pumpkin with Gourds.*

Right: Establishing the composition and blocking in.

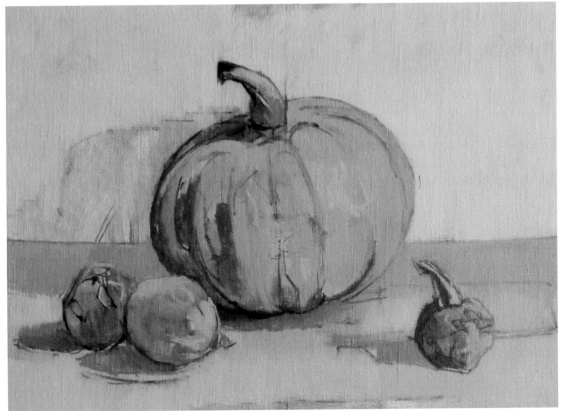

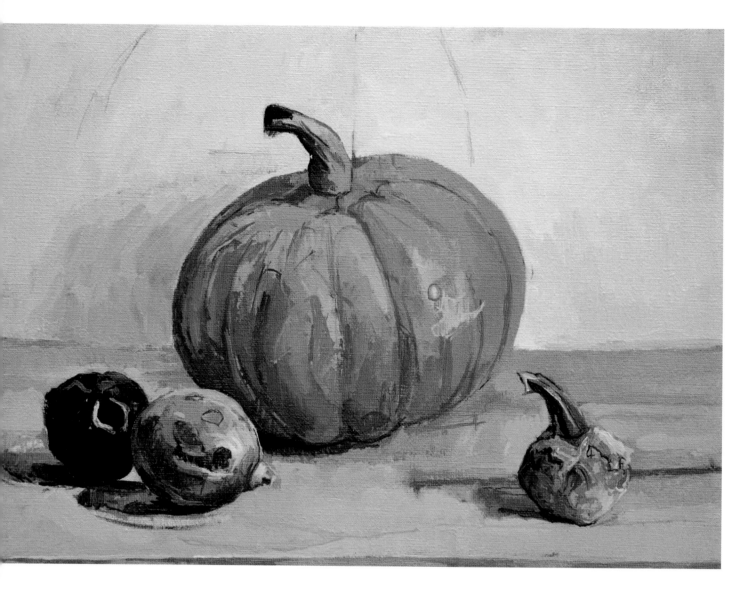

Closer analysis of tonal relationships.

to darkest and warmest to coolest relationships are established. A mid-tone is used for the pumpkin, and a darker shade was then used for blocking in the dark on the left as well as establishing shapes and contours over the surface. The shadow cast on the wall from the pumpkin is left for the moment, as it is similar to what is observed as the tone of the under-painting.

Mixed colour has been used to pick out any drawn elements, and shapes over the forms.

During the following session on the painting, it is important that the light/dark contrasts are put in. The darkest area of this still life is the fig on the left. This was added because it introduces a dark, rich, warm colour that contrasts with the cool light and mid tones of everything else. The only other dark sections are the shadows under the vegetables, on the left of the two stalks and around the left side of each form.

Mix a number of colours and shades on your palette so that you can begin to paint each of the smaller areas and facets of colour. As you progress, apply the paint in smaller and smaller patches to describe the subtle colour transitions over each object.

Over the wooden surface, the contours of the vegetables and the background smaller areas of colour mark the transition from light to dark or warm to cool. Make any further drawing with colour, as this will make the separate areas of paint come together more quickly. A line of an appropriate colour becomes a part of the overall form and gives a structured feel to each area.

The shadow on the wall is blocked in in small sections. It is not as dark in tone as one would expect, whereas the shadows cast on the wooden surface are really quite dark and rich in colour. Remember to double check the tonal relationships throughout the painting as a whole by regularly half-closing your eyes.

The edge of the wooden surface just appears along the bottom edge of the canvas. The colours here are darker in tone,

The light hitting the 'shoulder' of the pumpkin and gourd is one of the lighter areas, after the centre of the wooden surface. Avoid using pure white to show reflected light, but instead introduce some colour. Here, blue has been added to show cool light as it touches the surface of the vegetables.

The close-up (left) shows how the paint surface continues to build up. As each layer of paint used is slightly thicker than the previous one, the colour continues to become richer and the resulting colour saturation becomes more vibrant. Begin to use less turps and introduce linseed oil into the paint mix.

The side of the pumpkin and the gourd underneath, when seen close up, show how the planes of colour are used over the surface to create contour and form. Some areas remain larger and more broadly painted, while others are very small. Directional brushstrokes can be identified describing the roundness of the shape, and many lines of different colours can be seen moving over the entire surface. The pumpkin is a sculptural form, so continue using drawing and small facets to describe its volume; it is easy for larger things like this to become too flat.

As the colour builds, make sure that you don't lose the contrasting lights and darks. Sometimes the tonal contrast can be reduced as more paint is applied. Always check that the lights are light enough.

The painting as seen in the last stage has colour that is much brighter. Thicker paint has been used, and only oil has been

much warmer and saturated; this helps to move this area forwards, and creates space between the foreground and midground in the painting.

As the darker range of tones has been established early on during the painting, don't forget to do the same with the lights.

Above: A detail of the planes of colour and tone that describe the form.

Right: *Pumpkin with Gourds*.

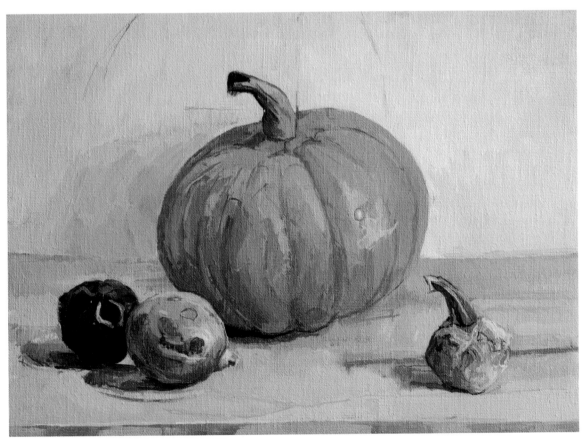

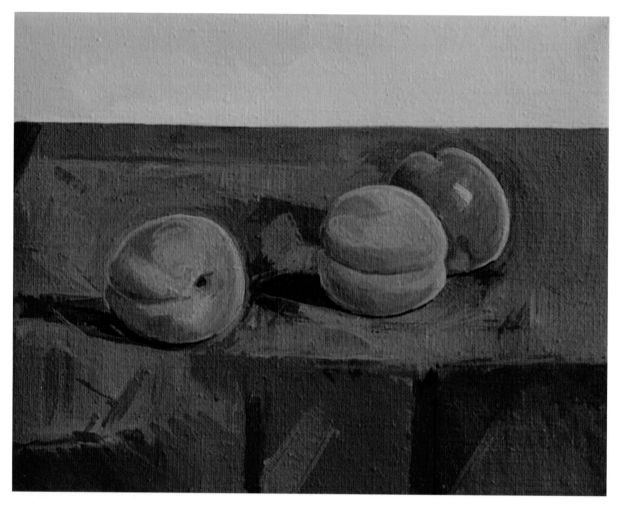

Apricots.

added to the paint at this time. Look out for any areas or patches where the paint seems to have sunk or appears too dull, and add more paint over the top.

Areas of the background were repainted to make the colour brighter and the lighter tones become cleaner, and the right side was made warmer.

The remaining touches were made to the areas of reflected light on the vegetables; the colours of the shadows underneath them were made a little richer, and the tone deepened. Any details such as markings on the skin or lines on the surface were added at the end. If possible allow the paint to dry so that the brushwork remains sharp and defined.

Fruits

Many of the greatest still life paintings have been inspired by fruit, whether placed in bowls or fruit baskets or in tabletop arrangements. When we think of Cézanne, we think of his paintings of tumbling apples; in the work of Uglow we think of pears, apples and oranges; and of Chardin, baskets of fleshy

peaches and strawberries. In the paintings of Caravaggio we see how the symbolism of different fruits is used to convey a different meaning.

The following paintings show how a small number of different fruits can be used in a painting; the composition is intentionally made very simple by keeping the number of objects to a minimum. Thus *Apricots* shows three fruits placed on a light blue surface (the complementary colour), while *Figs* is a study about the relationship of colour: the hues are very close to each other on the colour wheel, and when placed side by side the colours interact and seem to 'vibrate'. *Chinese Lanterns with Fig* was originally part of another larger composition, but this arrangement was painted independently of the other objects to make this small painting.

Exercise: *Quince Still Life*

The quintessential still life is a simple and harmonious composition of either a single fruit or a pair of fruits, and is a rewarding subject to paint. When painting one or two objects a composition can be reduced to its very essence. Traditionally when we

hear the words 'still life' we think of arrangements of fruit, and apples, pears and quince are beautiful subjects to paint again and again.

The colours and irregular shapes of quinces make them a well visited subject. The quinces painted here have a very sculptural feel about them, their irregular shapes making a series of well defined planes and facets moving around the fruits. The two painted in this still life, with their leaves still attached, have all sorts of imperfections on the surface, and a range of colours that appear both vivid yet subtle at the same time. The leaves make an interesting arc and help lead the eye around the composition.

The colour palette used for this painting is titanium white, cadmium lemon, cadmium yellow, raw sienna, burnt sienna, cadmium red, alizarin crimson, cobalt blue and French ultramarine, and raw umber which was used to draw with during the early stages.

Once the position of the fruits has been decided, sketch the composition on to the canvas using brush and paint. The illustration overleaf shows how a thinned mix of raw sienna is used to draw with. Raw sienna is transparent and is a good colour when sketching, and here, the warmer colour of the sienna is similar to the quince in tone, which makes it suitable for underpainting. Be sure that turps is used for thinning the paint at this stage, and not oil.

Once the composition has been established, begin to block in broadly painted areas of colour over the background and drape. It is important to do this before you begin to put in patches of colour on the fruit. This allows you to establish overall tone and colour values in the areas immediately surrounding the quinces. With the amount of white reduced, a closer tonal range will be achieved when painting the fruit.

Using a viewfinder to observe the still life before beginning to draw will help you to clearly see how the position of the subject relates to the rectangle of the viewfinder or canvas. The central point of the still life as seen at the centre of your viewfinder can be directly transferred to the canvas if you mark the centre before you begin.

Be sure to measure throughout the initial drawing in order to establish the scale and proportion of the quince. Check the width, height and size of each fruit against the other during the sketching out process. Any lines drawn 'internally' on the fruits show main 'junction' points of different plains and contours. These lines describe the edge of each facet moving around the fruit to help establish form and to give underlying structure to each fruit.

Next, establish the horizontal of the table edge so the subject will be placed within a pictorial space and structure. 'Guidelines' such as markings on the white cloth, creases and edges of shadows are placed on the white surface.

As you begin to paint the quinces, try to simplify how you

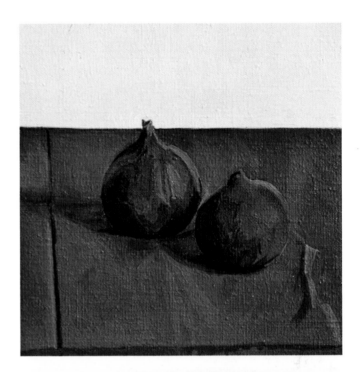

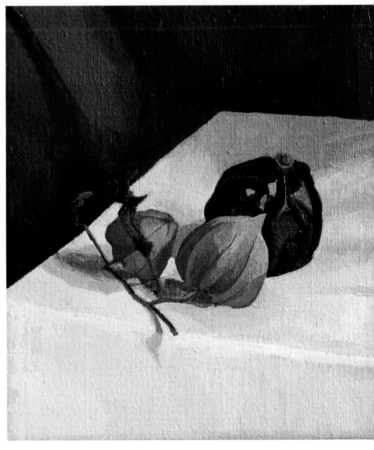

Top: *Figs*.
Above: *Chinese Lanterns with Fig*.

113

Left: Set-up of *Two Quinces*.

Below: Sketching the composition and blocking in the background and surface.

see the areas of colour moving over them. As you analyse the overall blocks of colour, identify the main light, mid-tone and dark contrasts.

By mixing a number of yellows – warm and cool, light and dark – large patches of colour can be laid down fairly quickly using a medium round brush. Move over the surface of the fruits concentrating only on the larger shapes to begin with; as you add each colour, take the area right up to the edge of the next. Like this you can paint out any remaining white of the canvas and establish the tonal relationship throughout the whole composition quite quickly. If the tones of the fruit are

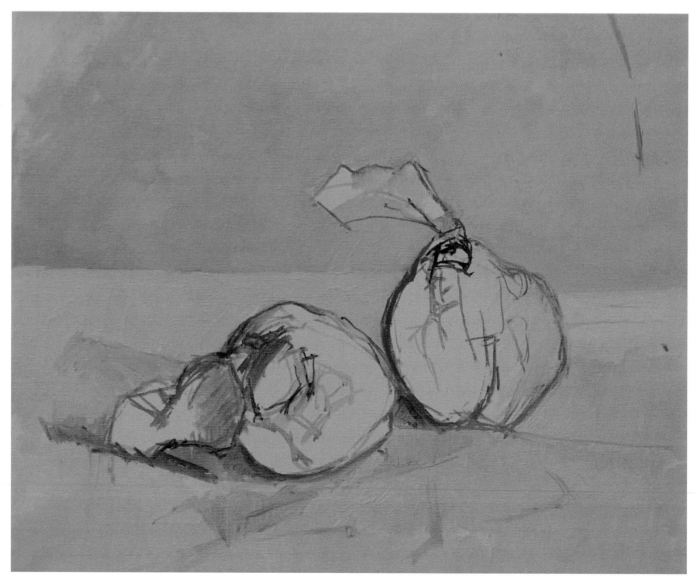

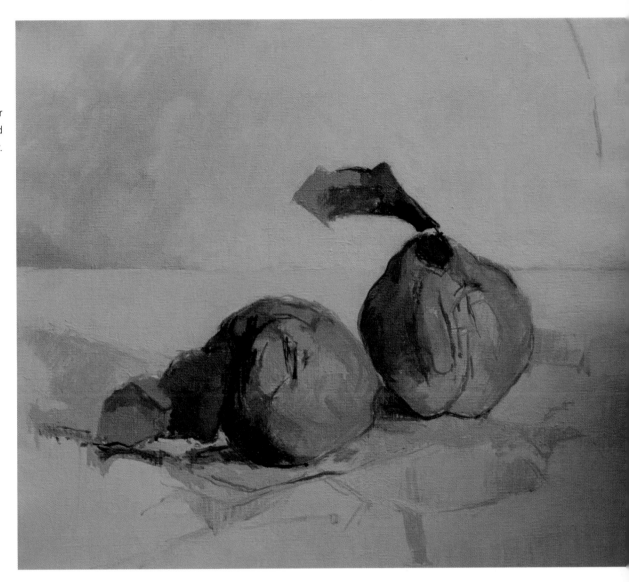

Blocking in the colour areas of the fruit, and drawing with colour.

painted when too much white of the canvas remains, the resulting tones are generally too light once all the canvas has been covered. This happens because any tone painted on to a white surface will appear to be darker than when the same colour is placed next to a darker tonal value.

Continue to paint areas of colour and tone as simplified patches of light and dark, warm and cool, without letting the image become overly complex. There is time to look at more subtle details later on. Always concentrate on form before worrying about detail!

The paint mix at this stage still has a small amount of turps added. The paint should be fluid, but thick enough to be opaque once it is applied to the canvas.

By now there will be a number of mixed colours on your palette, so use these for any further drawing when establishing lines, structures or junctions within the form. The illustration overleaf shows a detail of one of the quinces, and it is clear how the lines on the fruit and the cloth are drawn with observed

colour. Lines of various shades of yellow, ochre and green delineate and show how the planes move around the form, creating an edge to each colour plane. This same method is used when painting all other parts of the canvas.

Once the base colours and tonal relationships of the fruit have been established, return to the background and surface on which the quinces are resting. As you begin to analyse smaller and more detailed transitions of colour, tone and temperature change, and to add more paint to the surface, use paint that is slightly thicker in consistency. Mix a small amount of linseed oil into your paint, which will increase the flow without desaturating the colour.

When painting a background surface, drapery or folds around your objects, continue to lay down paint in small areas, patches or blocks of colour next to one other, rather than painting one larger area of flat colour or tone. Smaller areas will enable you to describe the changing colours and forms running over each surface of the painting. The folds and creases along

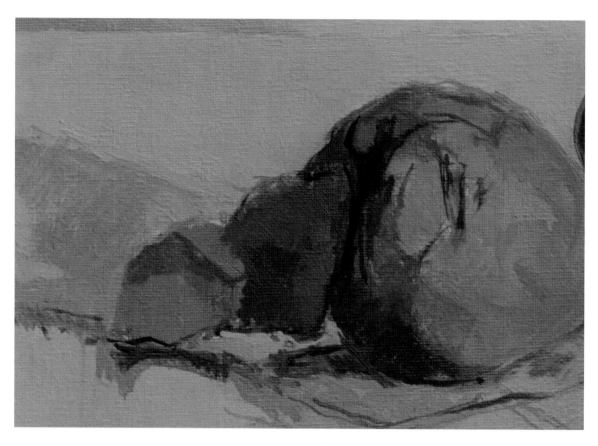

Detail of the paint surface, the direction of marks and drawing with paint.

the edge of the table are now painted in more strongly to create space between the foreground and subject.

The illustration on page 115 shows how a section of the tabletop underneath the quince has been described using small patches of colour to show the subtle changes of temperature. Any folds or edges within the cloth are painted with lines of mixed colour.

When observing the background, check for any subtle temperature changes. In this painting the right side of the wall appears lighter and cooler, and the left slightly darker and warmer. Continue to lay down paint that is thicker than the previous layer, and vary the direction of your brushstrokes so that the surface marks have an energy and painterly quality to them.

In the same way describe small shapes and facets moving around the fruits, but now focusing on the more detailed changes of colour and tone and the temperature of the colours. During these final stages of the painting continue to draw, and to re-establish any points where two or three planes meet and move away from each other.

As you paint, try to make each brushstroke describe as much about shape and contour as possible. Think about the direction of the form, and apply the paint in the same way. Some of the paint layers on the painting will not be of the same thickness, but it doesn't matter if in some areas the paint is thicker or thinner than in others. This makes for a more exciting and 'painterly' surface.

Some of the final touches of paint, such as a fleck of light or a line running along a leaf, can be made with a quick and fluid stroke. Try not to let all your brushstrokes be of the same speed or weight, or to hold the same amount of paint.

Because your painting will have developed over a number of sessions its appearance may begin to change, as some pigments dry more quickly than others. The oil in the paint can sink into the canvas, resulting in some areas appearing flat or dull. If this happens, mix a little more oil into the paint mixture and lay down fresh paint over the top of the dull area. Alternatively wait for the painting to dry, and then either oil out the surface (gently rubbing a mixture of linseed oil and thinners into the paint surface with a lint-free cloth) or varnish it. For either process wait at least six months and then try a sample area to test for any colour lifting. A mixture of retouching varnish diluted with a small amount of turps may be used as a temporary varnish or to act as a protective surface should your picture go into an exhibition.

As the painting nears completion, be careful not to overwork the paint surface. Avoid blending colours together, and keep areas of colour 'separate' as this will make them appear richer and more saturated. Do not add too much white into a mix as this will desaturate any colour.

Make sure that the darker colours in your painting are dark enough. It is easy to make the lighter tones too light by adding too much white overall, but if you can make the darker passages

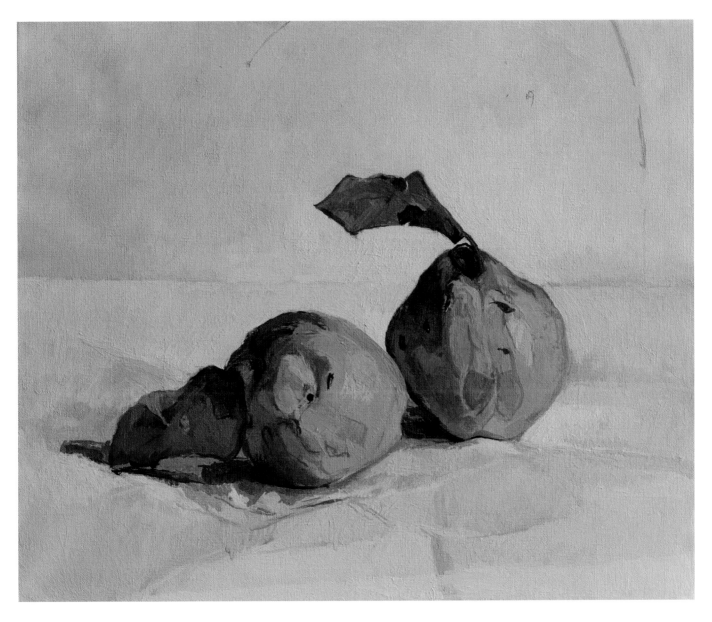

Two Quinces.

darker this will make the lights 'come alive'. During the last session on this painting the shadows on the quince and leaf were made darker and richer. Remember that a hint of the complementary colour is present in the shadow of an object, and shadows will help to connect the objects to the surface and give them a feeling of weight and solidity; without them the objects may appear to float – so make sure that the still life sits on the surface.

Look at how the colours in the still life objects are reflected throughout the composition. Thus the vivid yellows and ochres of the fruit are reflected on the sheet against their base, and the cool blue of the drape is seen as a patch of reflected light on the quince. A bright colour placed against a subtle one will be seen as a reflected colour to some degree.

The patches of colour on the leaves were now intensified, and these areas of paint are kept fluid and sketchy to describe the surface. The darks of the fruit were also made darker, and doing this allowed the warmer lights on the right-hand side to become richer and more saturated in colour.

The final touches of paint describe any marking, scar or line on the skin of the fruit.

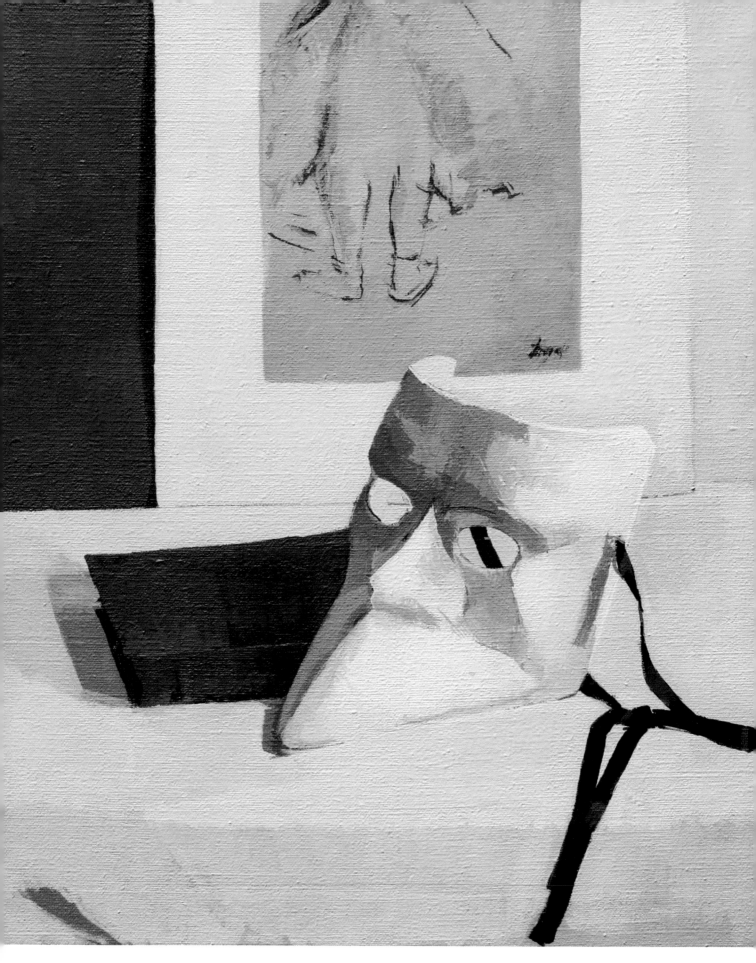

Mask with Degas.

THE ALTERNATIVE STILL LIFE

For most of the painting exercises so far the subject matter has focused on natural forms in the shape of flowers, fruit and vegetables, and often the majority of still life paintings we see are based on these subjects. This chapter will begin to introduce alternative and more ambitious subject matter – the traditional and not so traditional. You may find that you are beginning to introduce almost anything into your still life pieces. The historical background in Chapter 1, and your own personal exploration into still life, will have made you increasingly aware of the wide range of possibilities when it comes to selecting objects for your next still life composition. Thus alongside the more usual pots, jars and vases, still life can include skulls, musical instruments, books and casts. In your own study of still life painting, what is the most unusual subject matter that you have come across so far?

To demonstrate that most things could be considered as a still life subject we see quite a different theme painted by Craigie Aitchison in his two paintings *Liquorice Allsorts Still Life*, 1980 and *Italian Easter Egg*, 1994. Using cakes and sweets in still life makes an excellent subject matter, particularly in the variety of shapes and colours available to choose from.

The human skull is used symbolically in a group of still life called *Vanitas*, a type of still life painting popular in northern Europe during the sixteenth and seventeenth centuries and most commonly found in Flanders and the Netherlands.

The *Vanitas* theme overlapped with the motif of *Memento Mori* so that the image of a skull alongside other subjects such as musical instruments, candles, books and rotting fruits came to symbolize the transience of life, the fact of ageing and the inevitability of death. One notable Dutch painter of the *Vanitas* theme is Pieter Claesz (c. 1597–1660) whose painting *Vanitas* of 1625 illustrates a typical interpretation of this theme showing a skull placed on a pile of books next to a candle.

Look at other paintings to see how modern artists have used the skull in their still life arrangements. Euan Uglow used a skull in a few of his still life works, but in quite a different manner to the more traditional treatment. Look up 'Skull' in the works of 1952 and 1994–7.

Throughout art history you will be able to find still life works depicting all sorts of different things, some quite unexpected, pushing the boundaries of what we would expect still life to be. Some of the most unusual in this genre are the macabre still lifes by the French painter Theodore Géricault (1791–1824). Géricault bridged Classicism and Romanticism, and showed a startlingly new approach with his loose and painterly style that prefigured the subsequent artistic developments of the nineteenth century.

During his preparation for his monumental painting *Raft of the Medusa* (Louvre, Paris), Géricault produced a phenomenal number of studies, and amongst this vast body of work is a small number of astonishing still life paintings of dissected limbs and severed heads. These fragments were intended to give the artist information about decay, all of which would inform his painting. Despite their rather grisly subject, these paintings have a pictorial beauty about them – the artist's act of observation in front of a subject of unbearable reality.

To Delacroix these paintings were 'truly sublime' and 'the best argument for beauty as it ought to be understood…'[10] To him they demonstrated the power of art to be able to transfigure what was odious and monstrous in nature.[11]

Another truly remarkable painting, although not strictly a still life, is Zurbaran's *Agnus Dei* (The Prado, Madrid), a stark yet beautiful image of the sacrificial lamb placed on a slab, as if on an altar. Here the subject is presented to us as if it were a still life, beautifully observed and with a finely executed attention to detail. The bound lamb is shown against an intense black void, heightening its sense of isolation and vulnerability.

Throughout his career the Spanish painter Goya painted only a few still life pieces. He uses the medium of still life to express emotion, to show his moral outrage at the senseless butchery that was taking place during the Spanish civil war. In his still life *Catch of Golden Bream* (Museum of Fine Arts, Houston), fish are piled up like the dead in his *Disasters of War* series. Here Goya demonstrates a beauty in his fluid paint handling, his loose painterly approach reminiscent of that of Géricault.

Using casts of sculpture and other sculptural pieces also

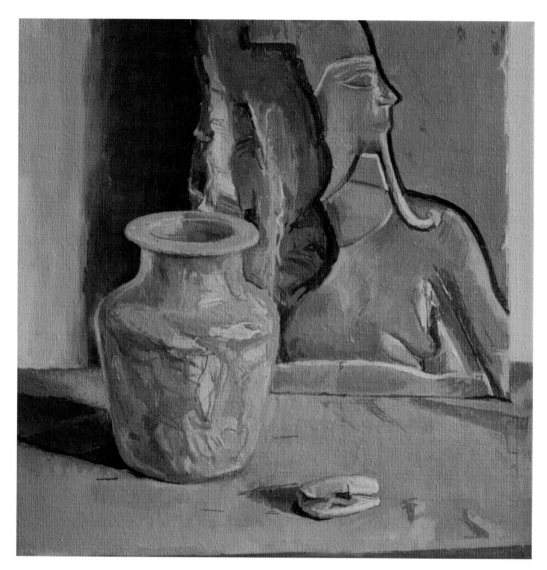

Still Life with Hatshepsut Relief.

makes a wonderful and quite unique subject matter. Casts are used in still life paintings either with other objects, or on their own. *Still Life with Hatshepsut Relief* (above) shows how sculpture has been used in a recent painting. The carved relief is seen as a backdrop, and its Egyptian theme links together the other objects in this still life.

Many artists have included casts in their work. Chardin painted two still life paintings which included casts, in a series called *Still Life with Attributes of the Arts*, one of which is found in the Hermitage, St Petersburg. In one version there is a cast head placed with books and a rolled canvas, in the second a cast of a full figure sitting amongst illustrations, an artist's palette, brushes and propped-up portfolios of work, amongst other objects.

Uglow painted both cast heads and a torso as a unique subject, whilst Cézanne, like Chardin, included cast figures in more complex arrangements; his *Still Life with Plaster Cast* (c. 1894) can be seen in the Courtauld Gallery in Somerset House, London.

Painting the Alternative Still Life

Several subjects will be selected for the following exercises, and you will need to set up a still life within each suggested theme. It may be difficult to source the exact objects each time, so see what is available to you. Charity shops and antique sales are wonderful places to pick up unexpected objects, any of which can be used in still life painting.

In this section some paintings are shown stage by stage, from start to finish, demonstrating each step of the painting process. Other paintings are discussed 'in progress' and as yet unfinished pieces, to show how a variety of subject matter can be placed in a composition and painted.

The following paintings will show how cakes and sweets, casts, a skull, books, a candlestick and a musical instrument can be placed in a still life piece. The palette used is the extended or Impressionist palette – titanium white, cadmium lemon, cadmium yellow, alizarin crimson, cadmium red, cobalt blue

Still life set-up showing pencil marks made on the drape, used for measuring and scale.

through the painting, and also consider the distance around each object: it is the negative shapes in a painting that can make a more interesting and dynamic composition.

The cakes selected for the painting illustrated on p. 00 [ref=Fig. 161] were chosen for their bright colours and simple geometric shapes. The intention was to place the bright pink cake at the very front of the picture plane, positioned right on the edge of the table, using the vivid pink of the icing to lead the eye into the picture. The yellow cake was then placed in the mid-ground, its brown markings leading the viewer to the other cakes behind it. The brightest colour moves forwards in the pictorial space, and the eye is then led round the other objects. When setting up a still life, try to think about how your eye will move through the composition: where does it start, and how does it move over each object in turn?

Before beginning to draw on the canvas, do some measuring to help work out a scale in the painting. *In Still Life of Cakes* the height of the pink cake was used to establish a scale through the whole piece; this was then used to double check both scale and drawing during the entire painting process. It will help to put a mark on the drape to show where the bottom edge of the canvas is.

The illustration below shows this first stage of measuring in

and French ultramarine. In *Two Cast Heads* raw sienna was introduced, and for *Still Life with Violin and Candles* burnt sienna was added to this palette.

Exercise: *Still Life of Cakes*

Using cakes and sweets as a subject may seem fun and rather frivolous, but the array of shapes and colours that they offer gives us a great opportunity to create something that can be joyous and light-hearted, as well as giving an interesting range of shapes and colour relationships to paint.

A still life of cakes can be as colourful or muted, or as simple or complicated as you wish. You may select one cake or several, but find a pleasing and harmonious composition to investigate in relation to the picture plane. The bright artificial colours and block shapes provide an ideal opportunity to focus on structure and depth, as the cakes themselves are simple in form. Consider the composition through a viewfinder to examine the placing within the rectangle or square of the canvas. You may wish to have a lot of space around the still life, or perhaps to make the composition fill the painting surface. Using a viewfinder enables you to establish this relationship quickly.

A series of thumbnail sketches can be made in a sketchbook to help you select the composition that you will paint. Try to place your objects in a set-up that creates depth and space

Sketching out the composition of cakes using dilute unbleached titanium white and a rigger brush.

Beginning to block in the main tone areas and the brighter colours of the cakes.

unbleached titanium paint to draw the initial sketch. A fine rigger brush when used with this wash will make a fluid and loose drawing to establish the overall placing of the still life within the rectangle, the precise centre point allowing you to place careful measurement marks as needed.

When selecting a suitable colour for sketching with paint, choose something quite neutral. The unbleached titanium wash in this instance was useful for our sketching out as it is close in tone and colour to the muted surrounding colours and overall key of the painting. A thin wash of raw umber is also a useful pigment to draw with.

We all have our favourite pigments for this purpose, so use what works best for you – but avoid too vivid a colour as you may then spend all your time trying to get rid of the underlying coloured drawing, rather than it being helpful to you, as it can disturb the overall hue of the painting.

Once you are satisfied with your drawing on to canvas, and with the placing and balance of the composition, the following stage will focus on establishing the main tonal values and colour range. As you do this, translate what you see as areas of flat colour. In the illustration left, the tones of the large areas of the drape around the cakes, the wall behind, and the dark of the cloth have been quickly painted in. Examine the contrasts of dark and light, bright and subtle, warm and cool.

Light, mid and dark tones of each colour were mixed on the palette at the beginning so that this initial blocking in could be done quite rapidly. A thin layer of paint 'scumbled' over the surface will break the intensity of any white ground showing, and this will help you to judge the correct tonal values of the objects against the background. Make the paint layer thick enough to be opaque, while avoiding making the surface too flat or perfect.

As you block in the areas of simplified colour in your painting, try to lay down the paint so that you feel a sense of movement and energy in the brushwork. As the layers of paint slowly build up, over time the oils will begin to give rich and luminous colours.

When mixing during the early stages in particular, mix a large enough quantity of paint to avoid needing to remix and match colours too often. Any remaining mix can always be placed to the edge of the palette and added to later.

As you work, note the direction of light and how it falls on to the still life, and begin to analyse the warm and cool contrasts throughout the composition. As you build up the tones, ask yourself if they lean towards a warm or a cooler temperature.

During this stage, be careful that you don't become too detailed when translating the tones you see into paint. Continue to simplify throughout, only observing the most important changes in tone, temperature and colour.

Once the shades of the surrounding areas have been painted, the next step is to introduce the areas of brightest colour, which

the painting and of establishing the place of each object. Thus it can be seen that the scale of the height of the pink cake measures four times into the width of the canvas, while marks on the vertical indicate that this measurement fitted in five times. These points may be plotted on the canvas to guide you in your drawing.

Alternatively, if using a viewfinder, it may be helpful to mark the centre of the canvas. To do this, make a mark at the halfway point on both the height and width of the surface, and place a cross in the middle. You can then relate this point to the centre of the viewfinder, and you will then be able to see how the outer edge of the canvas relates to the objects and the space around them.

Once you have decided on the composition, sketch it on to your chosen surface. Use a thin wash of either raw umber or an

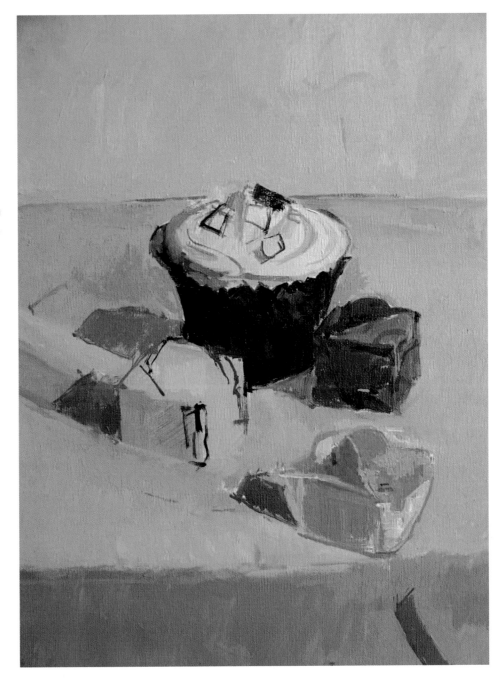

Establishing the tonal range by adding the darkest tonal values.

in this example would be the pink and yellow of the cakes in the foreground. The intensity and richness of each colour can now be judged against all the other tones you have established.

When observing the object, if you have an obvious light and shade, mix both tones on the palette and block in the areas of tone as simple shapes; in the illustration opposite you can see how the yellow and pink squares have been added. Putting in the light and dark passages creates form and volume from the outset.

To complete the overall tonal range of the painting you will now need to establish the darkest tones. In this example this would be the earth colours of the two cakes in the background.

By this stage most of the canvas has probably now been covered. If there are still large amounts of white or underpainting showing and you find this intrusive, try to cover these areas fairly soon.

As the painting progresses, the drawing in some areas may need to be changed or revised. To do this, mix an appropriate colour for the area you will be drawing into, and use this to re-establish any key positions or to fine tune the shape or scale of an object.

The shadows in the still life are very important, indicating the direction of light; they create depth in your work, and also help to anchor the objects that you are painting on the surface they

are sitting on. Moreover the dark shadows we see in the illustration opposite are very important to the harmony of the composition: the cupcake furthest back is centrally placed, but the other cakes are positioned further to the right side of the canvas and without the dark shadows the composition would feel slightly unbalanced and 'off centre'. These shadows on the left are therefore an important part in the balance and weight, centralizing the arrangement on the canvas. The initial measurements therefore took them into consideration.

As the paint surface slowly builds up, begin to look at the areas that were painted first to see how the paint now looks on the canvas. Does the paint appear to be quite flat and dull, or the darks lifeless? If this is the case you will need to add more paint over the top, making sure that it is thicker in consistency.

Above: Revising and changing, using colour to draw.

Right: Before the final session.

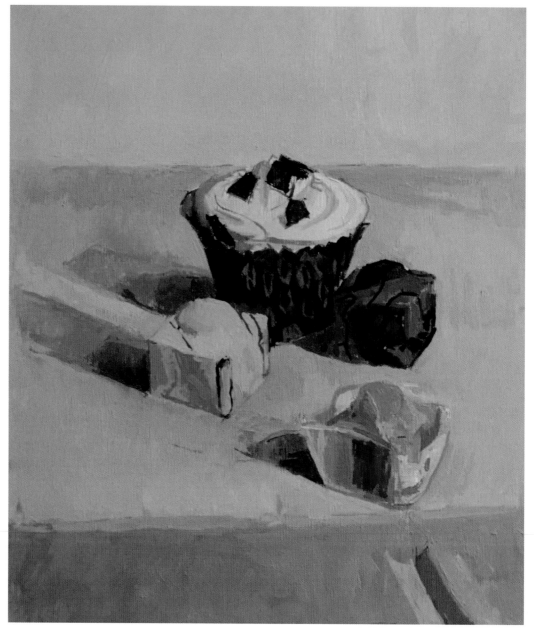

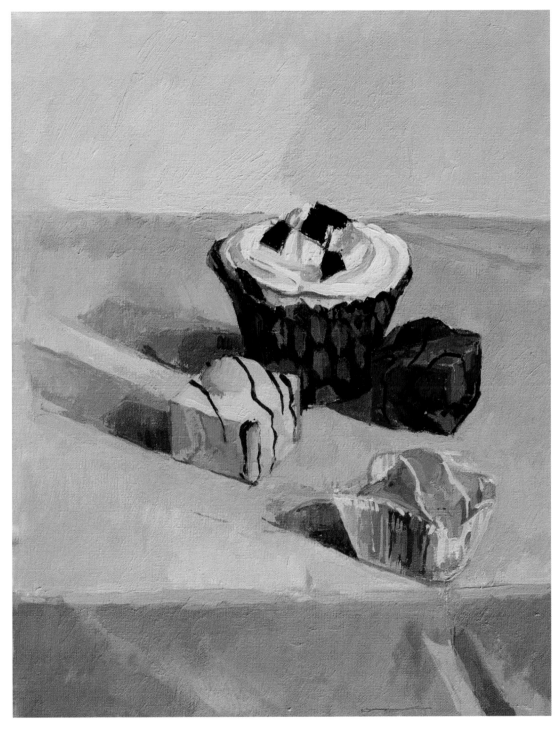

Still Life of Cakes.

If you haven't already begun to add a small amount of linseed oil into your mix, consider doing this now, and reduce the amount of thinners.

Over time continue to focus more on the smaller changes of temperature within each colour area, and to refine the tonal relationships, examining the 'in-between' tones. Be sure to avoid blending or softening any of the edges of these patches of colour; it is these small planes and facets moving around our objects that help to describe the surface, contour and form.

If the cakes have any surface pattern, use this to help describe the contour. Pre-mix the colours and begin to put this in, without becoming too detailed or fussy. Try to use the minimum of marks as you work, and continue to draw with colour. You can see how the lines that represent the icing have been used in the painting, and a cool mauve was then used to draw the round swirls of the icing on the top of the central cake to establish volume.

Before starting to paint in the final session, take some time to

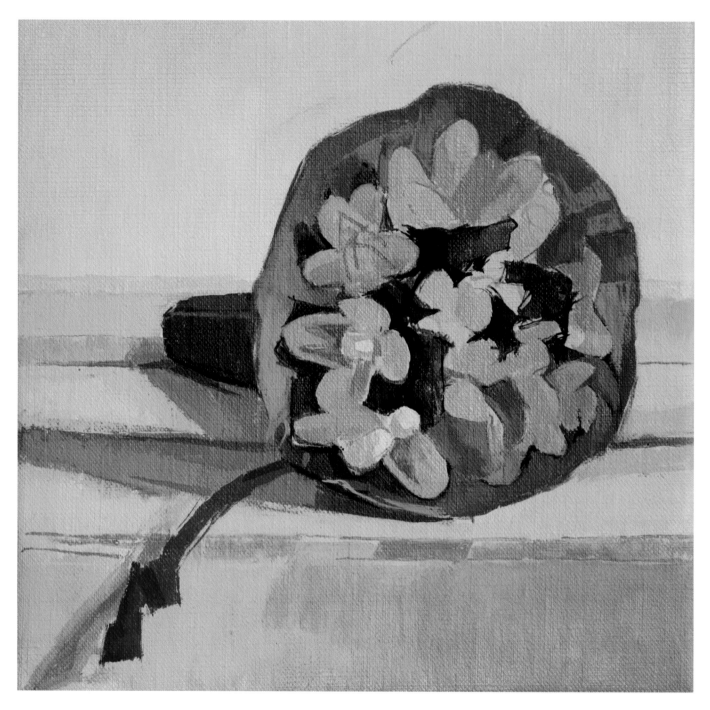

sit and look at the work you have done so far, and decide what you are going to concentrate on. Be careful not to overwork the painting, but keep the colours fresh and clean. As you study the still life, look at the tones throughout the painting: are the darks dark enough? Does the still life look as if it is sitting on the surface? Are the lighter areas bright enough? Do you need to enhance any colours that appear flat, or draw some more to define form?

In the last session on this small cake still life, a few areas were darkened to add weight to the overall balance of the piece; this was mainly on the lower part of the cloth on the left. In the opposite corner, at top left, the light colour was brightened a little as the colour had sunk and become dull.

Further work was needed on the paper cups of the two cakes, to create contour and depth, and on the white paper around the pink cake; also a deep 'grey' was needed in the shadow on the left side, while the lighter areas were painted a crisp light with the bright pink glowing through the paper. The small brown cake was made a little lighter in tone and its hue warmer to separate it from the dark tones to the left of it; this also helps to move it forwards in space.

The final step was to paint the white lines of icing over the

Opposite: *Italian Sweets*.

small cubes, and to lay down more paint on the larger cake to describe its swirls and decoration.

Exercise: *Italian Sweets*

This small bouquet of 'flowers' made from sugared almonds, with their vibrant colours and simplified shapes, makes an appealing and unique subject to paint. The pinks and reds of the Italian sweets against the complimentary colour of their green tissue wrapping stand out boldly against the calm, subdued palette of the surrounding area.

When working out the composition for this piece it was decided to place the sweets intentionally off centre, with the white inside of the left-hand 'flower' placed directly in the middle of the canvas. The red ribbon serves to counterbalance the overall composition.

By showing this painting in progress you can see how the intricacy and detail of the arrangement has been simplified. The painting was photographed after four sessions, by which time there had been a great deal of redrawing and revision. The darker areas of negative shapes were helpful to simplify and delineate the sweet petal shapes. This same technique has been used to establish and refine the flower shapes, by placing a lighter green around the edge of the wrapping. Over the sweets and on the dark green stem moving away from us, colours have been used to draw over areas of similar hue.

Casts and Sculpture

Casts create a wonderful opportunity to study the palette of coloured greys that can be seen in stone or plaster; they also give us some fabulous shapes and contours to work from. Casts of sculptural pieces can be difficult to find, particularly older ones, but keep a look-out in antique markets and junk shops: you'll be surprised at what occasionally turns up.

Once you have found a pleasing composition to work with, it will then be helpful to make either a reductive drawing or a painted study using black, white and grey; this is particularly useful to study the tonal values throughout the composition. As most casts are light in tone with subtle shifts of colour over the surface, it is all too easy to make the tones throughout the whole painting too pale.

If you have made drawings of sculpture in museums you will have noticed just how dark shadows can be when artificial or directed lights have been used. If you are painting your cast

Set-up for *Two Cast Heads*.

using natural light, which is more diffused, still note how dark any shadows cast will be. These shadows will be an important part of the composition, so be sure to leave enough space around the objects for them.

Once drawings or tone studies have been made, begin to sketch with paint on to the canvas to establish the placing of everything. Whether you are painting one sculpture or two, or

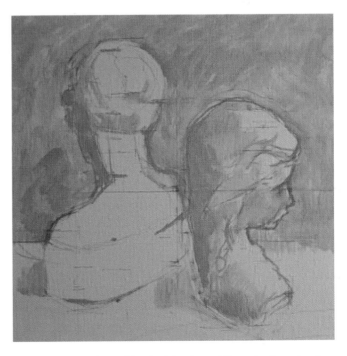

Sketching out using unbleached titanium white and a rigger brush.

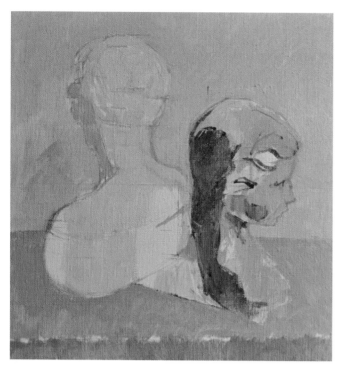

Beginning to block in the shadow and establish the contrasting warm and cool tones of each head.

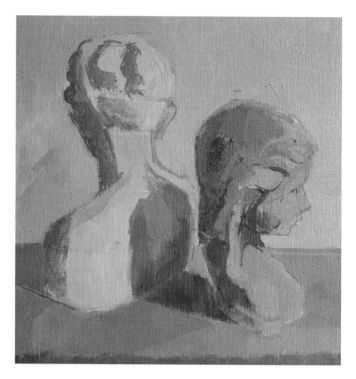

Establishing the darks.

have added something else with your cast, make sure that you place everything carefully within the square or rectangle.

Exercise: *Two Cast Heads*

The illustration on page 127 shows the first stage of sketching out *Two Cast Heads*. The two heads were carefully measured, and each measurement marked on the canvas. A square surface was selected, as the composition fitted well into this proportion. Find the central point of your drawing, and then mark this point on your canvas because you will find it helpful as a reference point when transferring your drawing.

Using a viewfinder, the centre of the composition was shown to be the turn of the far shoulder of the left cast just next to the small sliver of negative shape.

When the two heads were placed together, of particular interest were the curves and negative shape created when the casts were turned away from each other. The casts are greatly contrasting in colour and tone, one being pale and cool while the other is much darker and warmer in hue.

A thin wash of unbleached titanium paint was used for the underlying sketch, as this pigment is close to the colour of the sculptures and sympathetic to the palette as a whole. The background was quickly painted in with a thin wash of the unbleached titanium, as were the darker areas of shadow on the casts.

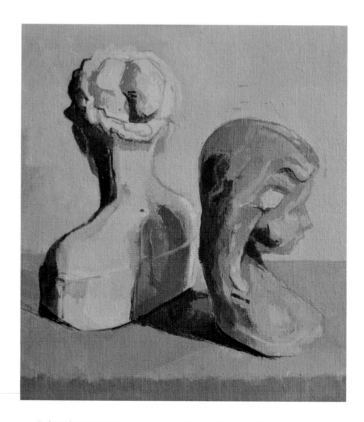

Colour becomes more saturated by building up the paint layers.

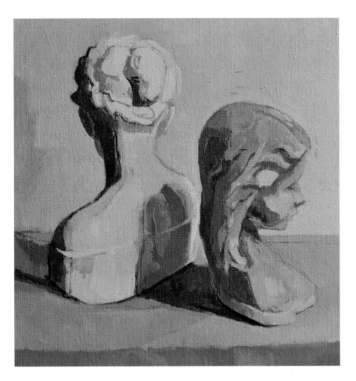

Accentuating the colour and tone.

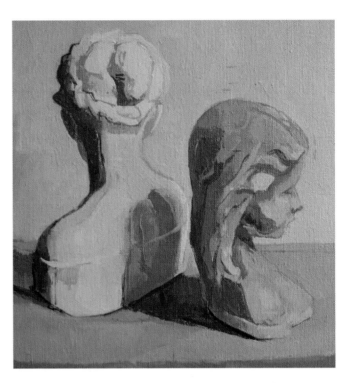

The final session: intensifying the darks and
building up the colour.

Once you are happy with the placing of everything on the
canvas, establish the larger areas of tone and colour. In this
example the background was quickly blocked in using a mix of
unbleached titanium with a little rose madder and ultramarine
added. A dark and light shade of the warm ochre on the right-
hand cast was painted next, and you can see how these areas
have been simplified, letting the edges between each patch of
colour remain. Any further drawing made during this painting
should be done with colour, as on the right head, where the
dark ochre delineates the contour of the hair.

The contrasting pale cool colour of the left cast was the next
to be painted, followed by the dark of the surface drape – this is
shown in the illustration above left. The colours seen in any of
these areas are slightly enhanced, the blue tinge in the warm
ochre against the cool blues and mauves in the light cast. When
mixing colours focusing on temperature contrast, remember to
select the appropriate colour on the palette to make a warmer
or cooler hue.

The next step is to establish the darker areas that run
throughout the painting to give weight to the composition
and to connect the objects. The central shadow is important in
both linking the casts and also in leading the eye around the
composition.

As you continue to add more paint to your subject, remember
also to pay attention to the paint surface around it. If the paint
has sunk at all into the surface, put down more layers, adding a
little linseed oil into the paint, as well as a small amount of tur-

pentine. Begin to analyse the more subtle changes between
colours and tone in these surrounding areas.

In the picture there is an interesting passage of simultaneous
contrast between the dark rich warm section on the back of the
right head and the cool shadow on the back of the left cast. In
the cool of this shadow there is a hint of warm reflected light.

During each stage of the painting continue to observe con-
trasts in tone and temperature to create exciting and dynamic
passages in the painting, from dark to light and warm to cool,
sitting next to each other on the canvas.

If you have not yet introduced any medium into the paint
mix, begin to do this now: this will increase the flow of the
paint, and it also stops the colour becoming desaturated. The
colours will then remain more luminous, and the paint consis-
tency becomes gradually thicker with each layer. With each
session continue to spend time mixing a range of colours on the
palette before you begin, making enough of each mix to last
throughout the sitting.

As the painting progresses, continue to focus on the warm
and cool passages. In the illustration above right, the cooler
green on the right of the background moves through to the
darker warm on the left. On the surface some areas appear
slightly more blue, pink or ochre. Areas of colour on both the
objects and the surrounding area are still painted in small sep-
arate patches, and not blended with other areas.

Casts offer us a beautifully delicate range of colour and tonal
transitions, yet the darks can be very dark and sharply delin-

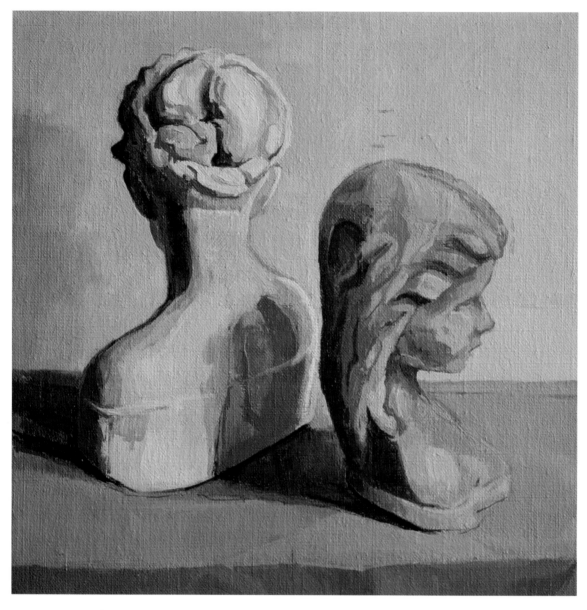

Left: *Two Cast Heads*.

Opposite: *Vanitas*.

eated. Check that the dark-to-light contrast is great enough, as the darks are often much darker than we first think, particularly when seen against the subtle lights of the plaster or stone.

During the final session on this painting, time was taken to accentuate the dark passages and dark colours in the shadows. Finer details, such as the curves and shapes in the hair of both heads, were now looked at more closely. The transition from light to dark is often quite sudden, resulting in a sharp line between two tones; this happens on the left head on the neck and passages in the hair.

Exercise: *Still Life with Skull* or *Vanitas*

This painting originally began as an analytical study of a hum-an skull, but after drawing the skull, ideas of adding other objects began to emerge, resulting in the piece suggesting a *Vanitas* theme.

This unfinished painting demonstrates how objects can be grouped together within a particular theme. The apple, also associated with *Vanitas* subjects, was placed on the edge of the tabletop and soon began to rot and shrivel up. The image in the background is a sketch from a detail of Jacques-Louis David's 1794 painting of *The Death of Bara* (Musée Calvert, Avignon).

This painting remains sketchy and fluid, with measurement marks that are clearly visible over the entire surface. You can also see how parts of the drawing have been established using lines of different colours throughout the composition. The line around the back of the skull re-defines its shape, while planes and facets around the front are placed using a mix of line and patches of colour. The edge of each area of tone and colour remains clean and sharp: nothing is blended. Mixing an in-

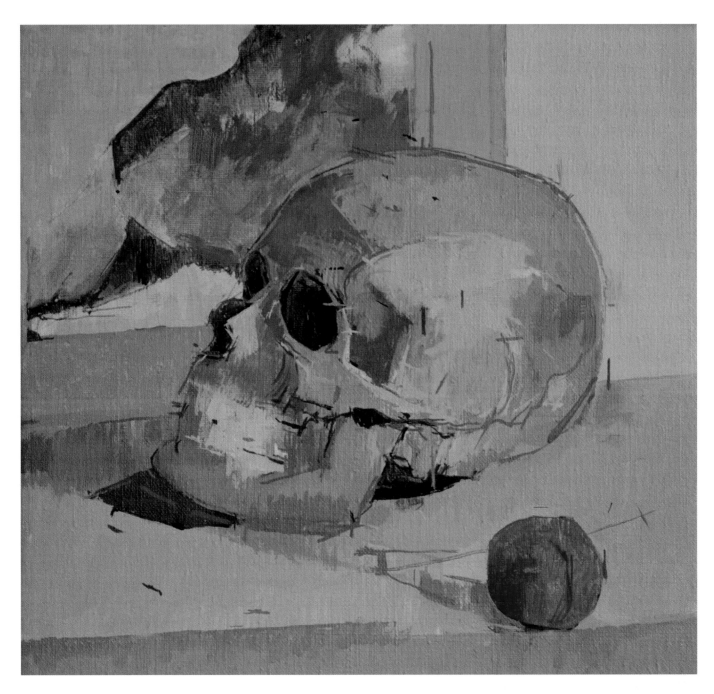

between shade and then placing it adjoining two areas and over dry paint, creates a subtle transition from one tone to another. The edges of each patch of colour describe the contour and volume of the skull.

Musical Instruments

Musical instruments have inspired many artists over the centuries, their sensuous and rhythmic shapes providing painters with a challenging and fascinating subject matter. Instruments appear frequently in *Vanitas/Memento Mori* theme pieces. Caravaggio painted many fine instruments, featuring in paintings such as *Lute Player* (1596–7): here a selection of musical instruments including a violin and a recorder, besides a bow and some music, is placed on an elaborately detailed tablecloth. The foreshortened viewpoint of the lute being played creates depth between the objects placed on the table and the figure seated behind it. In *Victorious Cupid* (c. 1602–3), in Berlin's Gemaldegallerie, instruments are piled to the left of a rather jubilant-looking cupid. A violin and a lute, seen from a foreshortened viewpoint and supremely drawn, rest at the feet of the cupid.

In Holbein's *The Ambassadors*, painted in 1533 and found in

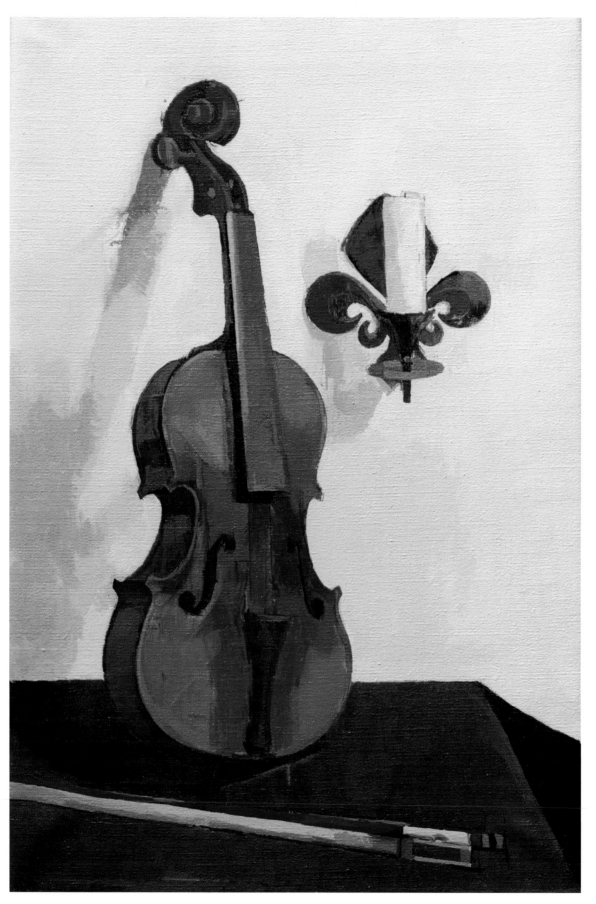

Still Life with Violin.

the National Gallery, London, an array of objects is displayed between two men who are symbolic of the two religious factions dividing the country at the time. In the foreground is an overlarge and distorted skull, but when viewed from a particular angle a perfectly foreshortened skull can be seen: it is a reminder of our mortality, and the broken string of the lute continues this theme, which runs throughout the painting.

Exercise: *Still Life with Violin and Candles*

A *Memento Mori* theme is suggested in this still life painting, as depicted in the illustration (right). The old violin in the composition is facing the wall so we don't see its broken strings and missing bridge; the one remaining visible peg suggests its dilapidated state. One of the candles, another *Vanitas* symbol, is removed from its holder and cast on to the tabletop. The strong shapes and warm rich tones of the violin contrast beautifully with the delicate candlestick and the subtle palette used for the candles and surrounding area.

When you have found a pleasing composition with the instrument and the other objects you are going to paint, take great care during the initial sketching out as the complexity of the shapes may take some time to resolve. During the first sitting, carefully measure and set the position of each object. Remember how useful it is to record where horizontals and verticals connect several points along a line, and then to use these to check the placing of the objects in your drawing.

Set-up for *Still Life with Violin and Candles.*

Mark the centre of the canvas, and look at the still life through a viewfinder to find the centre of the picture. This point can then be related to the centre mark on the canvas surface. In this painting, the central point is on the top of the instrument, the small curve just below the neck. This was marked on the canvas, and could be used to check that all other parts of the composition were correctly placed in relation to it.

As when sketching out other paintings, use a fine round or

Establishing the composition and blocking in the main tones.

Establishing the warm and cool colours.

rigger brush with diluted paint to establish the overall composition. Continue to measure and to use horizontals and verticals during this process to double check the relationships and scale.

In the illustration on page 133 (bottom), a horizontal line connects the top of the glass candlestick with the highest part of the curve of the violin, which is just off the edge of the picture, as viewed here. Because of the subtle diagonals of the slightly foreshortened violin, it will be helpful to use horizontal lines to check positions against other parts of the composition throughout the duration of the piece. Also the vertical of the candlestick is an important element compositionally, as all the other lines are angled to some degree.

The next step is to begin to block in the largest areas of tone. It is clear in the illustration above that the background and surface were painted quickly so that the majority of the white primer was obliterated. During this first session on the picture the light-to-dark and warm-to-cool relationships will be the main focus.

As the darkest and warmest area, the body of the violin was next to be established. The complexity of the shape meant that this had to be drawn a few times, each time fine tuning the contour and shape. A general colour for the wood was mixed, and this was used to refine and correct the drawing.

During the following stage it is important to double check the drawing, making sure that anything that needs altering is done fairly soon to avoid any major redrawing later on. Continue to measure throughout, as well as checking horizontals and verticals from time to time. There will always be an element of revision during any painting, but the complexity of shape and proportion when working on a subject such as this requires much revision early on.

Use mixed colour for any further drawing or redrawing, or when identifying a plane or contour. Up until now most of the drawing has focused on the violin, but during this stage make sure that any other elements in the painting are established so that you have an overall feel of how the composition is working in terms of weight, form and harmony.

The candlestick and candles in the foreground were next to be drawn in, paying close attention to the proportion of the negative shapes around them, making sure they are placed correctly in relation to the table edge, and the neck and scroll of the instrument.

There is always an element of 'building up the surface' at this stage. Try to lay down a layer of paint over any remaining white so that you can begin to consider the tonal values throughout the whole painting. When building up the paint surface, use paint that is slightly thicker in consistency; it will still need to be thinned slightly with turpentine, but don't add as much as you did in the first stage when the paint needed to be more fluid.

The next step in this still life is to establish the darker areas,

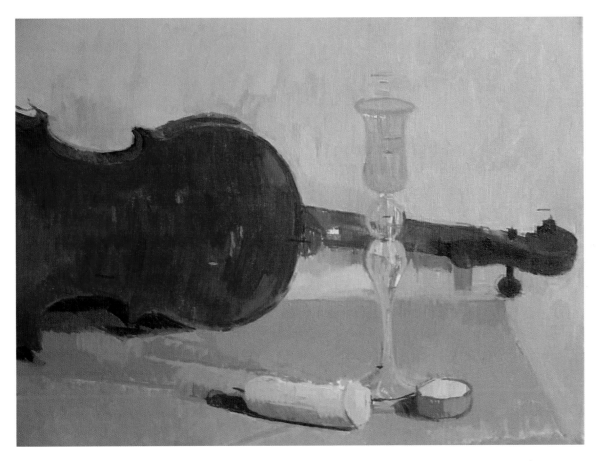

More paint being added over the back of the violin, candles and scroll.

and to accentuate any darks already painted that may appear to have 'sunk' by layering more paint on the surface. The dark of the back of the scroll was added, and also the darker triangles of tone on the surface leading towards the violin.

Areas of colour over the background and surface are now exaggerated slightly. As the paint becomes thicker and more opaque, the colours will appear more saturated. Looking at the background, it is possible to see distinct areas of colour: one with a touch of ochre may appear warmer, while another with a hint of green is cooler. Begin to look at these colour transitions moving over the surface. The different tone of the background as seen through the glass of the candlestick was painted in, and more colour was added on the surface drape. The longer you analyse your still life, the more colours you will begin to see. On the surface hints of blue, ochre and sienna could be distinguished in quite separate areas over the fabric.

As the painting progresses, each of the paint layers will become thicker and by this time should be opaque as one patch of colour is laid down next to another. As the paint surface builds up, colour saturation will increase, and the temperature of colours will become more contrasting. The paint in the background continues to build, and the cools becoming stronger under the cool light coming in from the right.

As your eyes become more accustomed to the subtlety of the colour changes, you will begin to identify more colours. Against

the warm oranges of the violin simultaneous contrast occurs, and the complementary colour blue is clearly visible in the cloth immediately next to the wood. The complementary pair is seen as one colour enhances the other.

As the colour builds over the surface of the violin remember to think about the direction of brushstrokes to describe form. The brushstrokes follow the curvature of the body of the violin and describe its contour and volume.

A number of colours were mixed for the violin, and these were then used for any revision of shape and for drawing the curves of the instrument. These are very difficult shapes to master, with both the symmetry of the two sides and the slight foreshortening. If you are having difficulty achieving the shapes, turn your canvas and look at your drawing from different angles. Sometimes a mistake in drawing can be seen more clearly when looking at the painting upside down! Use an appropriate colour for any redraw.

Much time is spent on the darker areas of the painting during this stage. The dark underneath the violin not only serves to add weight, but also to anchor it on the surface. This shadow also helps to describe the subtle foreshortening of the instrument, making it appear to move forwards a little. The shadow by the candle adds gravity, and continues the diagonal of the line leading towards the violin.

Smaller areas of colour are next to be established, such as the

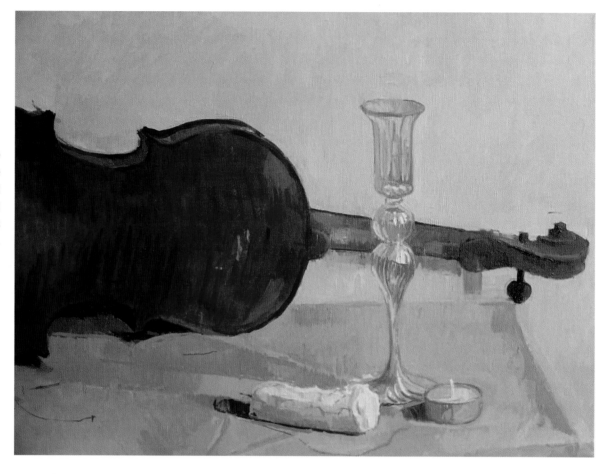

Drawing the edges of the violin and candlestick, and adding flecks of light.

lighter colour on the top edge of the violin and patches of colour moving around the scroll. The detail of the peg was added next, and then a touch of colour for the wax left behind in the candlestick.

With each session you will focus on smaller and smaller shifts of tone and colour over and around the objects and surfaces, building these transitions carefully to create form, depth and contour.

A part of the drawing had to be changed slightly over the top section of the violin. This was done with a mix of raw and burnt sienna with a touch of ultramarine. The outline of this part of the instrument was raised a little higher.

Up to this point, the candlestick and candles hadn't been given much attention. The darker lines on the candlestick were the first to be established and painting these gave an opportunity to double-check and add any further drawing that was needed.

The flecks of light on the glass are the last things to be painted. With a light tone, the contour of the glass is indicated, the direction of the brushstrokes following the curvature of the shape of the stem.

Darker tones were used to place the base and stem of the candlestick, while the areas seen through the glass were next to be painted. A dark line is depicted along the length of the left side

of the stem and the wall colour as seen through the glass seems to be slightly darker and warmer.

Some of the areas of colour on the violin needed to be a little more saturated, as the first layers of paint had sunk. This tends to happen with the darker colours in particular, so increase the amount of linseed oil with each progressive layer. Over the back of the scroll patches of burnt sienna with a touch of cadmium red were added to make the colour brighter.

As a number of areas in the painting have become darker, check the relationship of other tones against them: thus if the tonal contrast of light to dark has increased, check that other darks, for example the shadows, are now dark enough.

During the later stages of the painting continue to lay down areas of paint over the background and surface on which the objects stand. Colours can look quite different as paint begins to settle, sink in or dry, so continue to reassess and evaluate the relationship of colours and tones from beginning to end. As you are painting, also continue to use the edges of each patch of colour to describe any drawn element, such as creases and folds on the cloth.

The majority of work during the final session on this painting was mostly concerned with the detailed areas of the candlestick, candles and the edges of the violin. A warm ochre was used to delineate the shapes around the instrument, and to

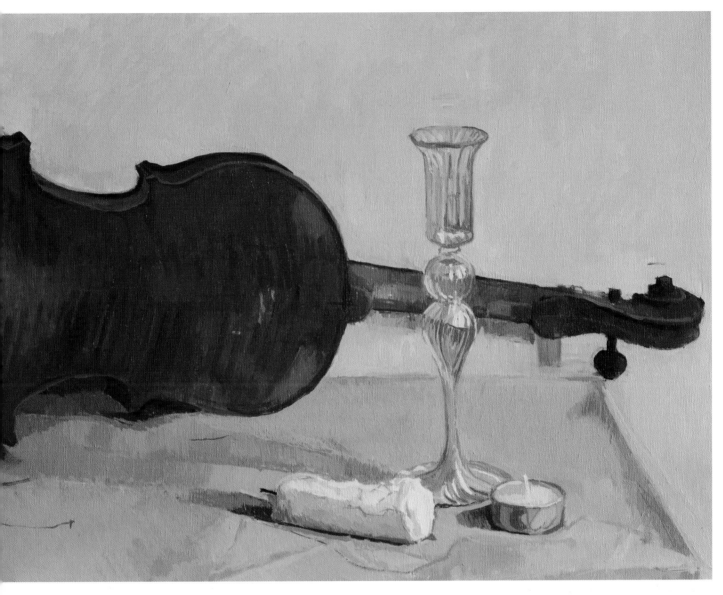

Still Life with Violin and Candles.

make the drawing sharper. The top edge of the violin was also darkened a little more.

The shadow to the left of the candle was made darker, while on the candle itself an area of cool ochre was placed along the side. On the right-hand candle more colour was added to the metal case, and the lights and darks were made more contrasting. Colours being picked up are reflected colours from the surface, and on the left side a lighter patch is seen as the other candle is reflected on the metal.

The final touch was saved for the top of the glass candlestick. During the previous session the lines on the glass had become too dominant, and layering a small amount of the background colour between these makes the tonal range closer and softens the overall drawing. One or two more flecks of reflected light on the stick complete the painting.

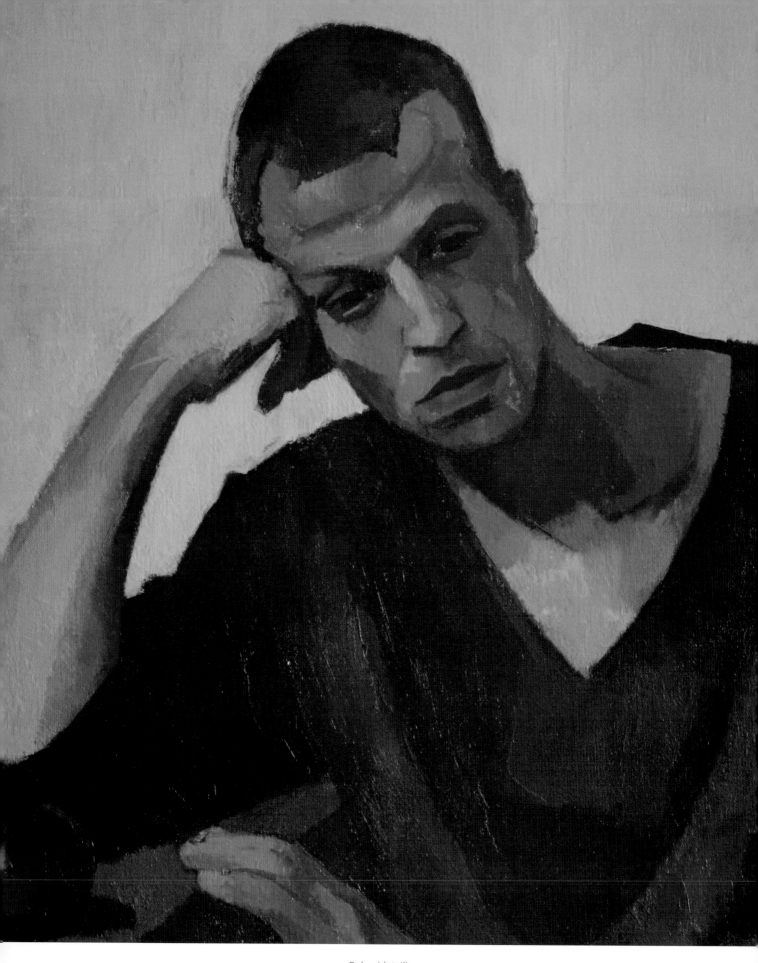

Dylan (detail).

STILL LIFE PAINTING WITHIN THE GENRE OF PORTRAITURE

During this book so far our focus has been on the 'independent still life' for each of the painting exercises in Chapters 6 and 7. This genre has allowed us to concentrate on the pictorial elements of composition, design, form, tone and colour, and in exploring how the placing and depiction of a small selection of objects can begin to suggest a narrative in our work.

In Chapter 1 we examined how the earliest still life arrangements were used in figure compositions and provided a role that could be either symbolic, narrative or used purely as a decorative element. In the religious paintings of Caravaggio, for example *Supper at Emmaus* (in the National Gallery, London), there are the most sumptuous tabletop still life arrangements, while Velasquez incorporated exquisitely observed still lifes in his figure compositions, such as in *Old Woman Cooking Eggs* (National Gallery of Scotland, Edinburgh), and amazing textures and surfaces such as can be seen in *The Water Seller* (Wellington Museum, London).

This final chapter returns to this idea, and looks at how elements of still life may be used in a contemporary portrait painting. To this end, a selection of paintings and painters has been identified, in particular works from the nineteenth and twentieth centuries which demonstrate how artists have incorporated objects and still life into their portrait works.

Painting Modern Life

Artists in the nineteenth century began to paint everyday life around them. Instead of the more formal 'posed portrait', painters became more interested in observing the immediate world around them, and this gave them more opportunities to place still life objects or arrangements with the figure, enabling the picture to become a more personal or biographical account of the person portrayed.

The French painter Edgar Degas (1834–1917) worked on portraits throughout his career. His main concern was an exploration of gesture and expression that enhanced the psycho-logical accuracy of the sitter; hence he constructed his portraits of people in their typical positions and familiar surroundings.

Degas painted *L'Absinthe* in 1896 (now in the Musée d'Orsay, Paris). This painting is much more than simply a portrait of two figures seated in a bar, but is a brilliant illustration of modern Parisian life. The two figures are placed in the upper right section of the canvas; they appear lost in thought, and the cool palette adds to their air of detachment.

In the composition the tabletops are placed on strong diagonals that run towards the figures, their glasses and a carafe in front of them. In the foreground there are various objects placed right at the front of the picture plane, but these are very rapidly sketched in, so it is not clear as to what exactly they are: their purpose is merely to lead the eye into the composition. Thus from the foreground the eye follows the diagonal of the tables to the glasses and carafe, thereby connecting us to the figures.

Degas' portrait of Diego Martelli of 1879, now in the National Gallery of Scotland, Edinburgh, depicts the Italian art critic sitting amid his books and papers. Martelli was a great admirer of his friend Degas' paintings, and this portrait conveys the sitter's lively personality through a characteristic attitude and a rather striking yet unconventional composition. The objects painted around the figure all portray the disarray of his everyday life, with piles of papers on his desk, and books, inkwell and slippers on the floor, which all add to the atmosphere. The angles and high viewpoint cleverly lead the onlooker through the pictorial space.

In the later portrait *Hélène Rouart in her Father's Study* (National Gallery, London) c. 1886, Degas has chosen to paint someone he knew well, and has therefore been able to paint a portrait containing many personal family associations. Degas and the sitter's father, Henri Rouart, had been lifelong friends. Rouart was a discerning art collector, and there are many references to his collection in this portrait, in particular three Egyptian statues in a case behind Hélène, as well as a Chinese wall hanging, a Millet drawing and a Corot seascape.

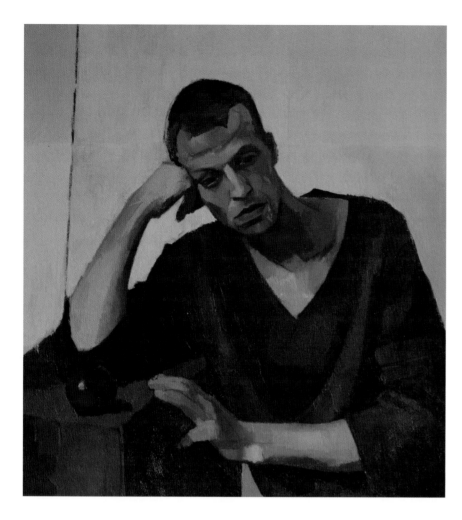

Left: *Portrait of Dylan*.
Opposite: Detail of apple still life.

Early Twentieth-Century British Painting

As French painters were concerned with the portrayal of modern life, from brothels to dance rehearsals, painters in London were also showing scenes of modern-day living, be it the man-made environment and industrialization, transport or theatre scenes. The Camden Town group depicted scenes of modern-day London, two of its members being Harold Gilman (1876–1919) and Walter Sickert (1860–1942).

Harold Gilman's *Mrs Mounter at the Breakfast Table*, of 1917, in the London Tate, shows the artist's housekeeper seated at her table. In the foreground Gilman uses a sophisticated composition to draw the viewer into the pictorial space: a collection of crockery, teacups and saucers, and a plate, a jug and a teapot; the edge of the picture cuts a plate in half. It is as if we are sitting opposite Mrs Mounter herself, at her table and in her space. There is a wonderful feeling of presence in this portrait, the elderly woman seeming austere and displaying a powerful intensity.

Also in the London Tate is one of Walter Sickert's best known works, *Ennui*, of 1914 – he painted at least four versions of it. This compelling image captures a mood of emotional strain and

world weariness, inspired by the work of writers such as Baudelaire and Flaubert. The objects in the room, the furniture and its decoration, reflect the social status of the couple depicted. In the foreground a glass and a box of matches sit on the table, to the right a carafe and a glass, amongst other things, are arranged on the fireplace mantelpiece, and on the left, completing the triangle, is a glass dome containing birds. It is as if the painter has theatrically staged the composition to create an atmosphere of isolation and melancholy.

Using a similar composition format to Harold Gilman, the Danish painter Vilhelm Hammershoi (1864–1916) portrayed his wife Ida in *Portrait of Ida Hammershoi* (1907). She is seated at the table, lost in thought, her head turned away from the viewer, teaspoon in hand, stirring the contents of her teacup. She could be seated across the table from the onlooker.

Between the late 1910s to the mid 1920s, Gwen John painted a series of portraits of a young woman: known as *The Convalescent*, the composition is of a girl sitting in a chair reading, depicted with a palette of beautifully muted dark and sombre tones. In each version of the painting is the same arrangement of a brown teapot and a pink cup and saucer on the table next to the seated girl: placed diagonally across the table, these

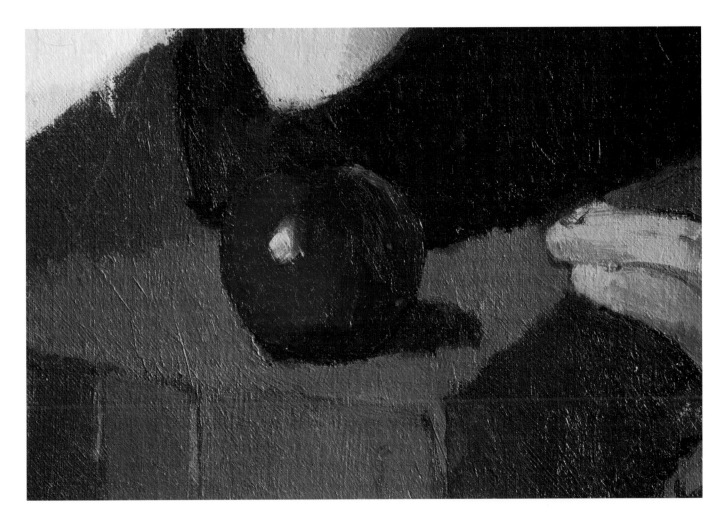

objects lead the eye towards the sitter. They are painted very delicately, simple dots of white depicting the reflected light on the surface of the china. The only other dash of colour is the red cover of the book, which echoes the red of the girl's lips. The white cloth next to the book serves to accentuate the colour.

Still Life in Portraiture
Portrait of Dylan

This painting, made while a student, was the first time that I had placed a still life element in a portrait. The figure is obviously the main focus of the painting, but when starting this work it was felt that something else – a simple object – needed to be placed on the surface on which the sitter is leaning. The apple was the required size, and its rich dark red against the complementary green of the drape gave the colour the 'note' needed to lead the eye into the pictorial space against the dark tonality of the model. Placed in the front of the picture plane, it helps to lead the eye around the composition: the viewer begins at the head,

moves down the arm to the 'still life' element, then to the hand in the foreground resting on the table edge, and back up towards the head.

The still life element was introduced for purely pictorial reasons, rather than as a narrative or symbolic gesture.

In many of his portraits Caravaggio uses fruit to introduce either a narrative or a symbolic reference. In his *Self Portrait as Bacchus* (1593–4), in the Galleria Borghese in Rome, he portrays himself as a rather sickly Bacchus clutching a bunch of grapes – executed with the usual exquisite attention to detail. He captures the fruits changing colour from ripe to overripe, with reds, siennas and ochres.

The two yellow plums in the foreground of the painting are placed next to the rich dark complementary mauve of the grapes. Whatever the symbolism Caravaggio wished to imply, it also serves the purpose of leading you into the pictorial space, the bright yellows jumping forwards against the rich darks around the figure and the fruit. The ripe fruit on the table contrasts with the overripe fruit that the figure is clutching.

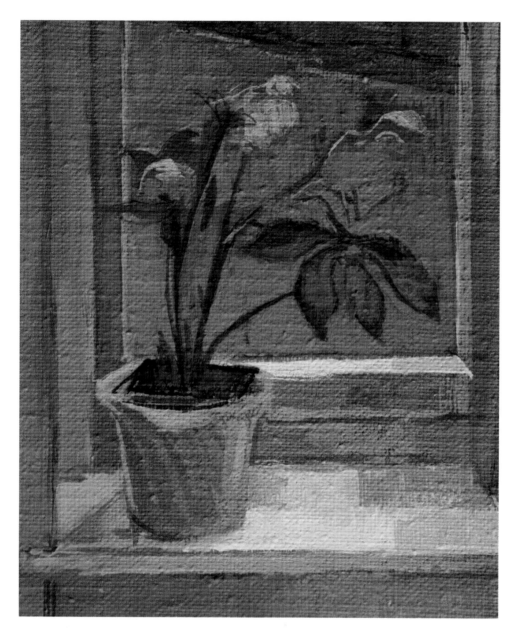

Opposite: *Aileen by the Window.*

Left: Detail of still life on the window-ledge.

Portrait of Aileen by the Window

This portrait of a woman seated by a window reading is influenced by the beautifully quiet images of a figure reading by Gwen John. The model, an avid reader and enthusiastic gardener, wanted to be portrayed whilst reading, and depicting her seated in front of the window looking out on to her garden with her favourite plant on the window ledge seemed an appropriate theme. The book she has selected is one of her favourite titles.

Painting someone while they are engaged in the activity that typifies them makes for an interesting subject: a painter painting, a musician playing. In this way the painter Hans Holbein the Younger portrays the astronomer Nikolaus Kratzer,

(1528) sitting amidst all the tools of his trade. Portraying someone in an interior allows the artist to experiment with different objects in a certain space. Using the space around the figure allows an artist to give the viewer a lot of information about them, using 'still life' objects to tell a story or to create a narrative.

Four African Heads

Working from cast figures and heads has always been a particular interest of mine. A number of sculptures, including the ones in this composition, have been placed in a variety of still life paintings over the years. Uglow, Picasso, Matisse and

Four African Heads drawing.

Cézanne are just a few of the artists who have used casts of figures or heads in their still life arrangements.

The contrasting tonal values of these sculptured heads suggested an interesting composition, with their bold shapes and flowing lines. An African theme connects the four female heads and inspired the idea for this portrait drawing. The heads in the illustration opposite are a plaster cast of the Benin head of Queen Idia, a wooden sculpture from Ghana, and a small but recognizable profile of Queen Nefertiti of Egypt.

The shape of the model's profile against the series of curves of the Benin head was of particular interest when setting up this composition, and the scale and proportion of the negative space between the two heads was important right from the start of this piece of work.

Painting a head in profile is a subject I have returned to many times. A profile portrait has a great intimacy in feel, and it is the elegance of the continuous line that makes this angle so appealing. The illustration above] shows one of these portraits, and it is the wonderful shape and line of this model's profile that I wanted to capture again alongside the sculptural pieces. Inspiration is drawn from the beautiful wall reliefs of Ancient Egypt, and the portraits of Piero della Francesca and Alesso Baldovinetti.

The original plan was eventually to paint this portrait on a rectangular canvas, but this idea changed once drawing was under way. This demonstrates how important drawing is during the setting-up process. When measuring, it was discovered that the length of the Benin head was equal to that of the profile, so the

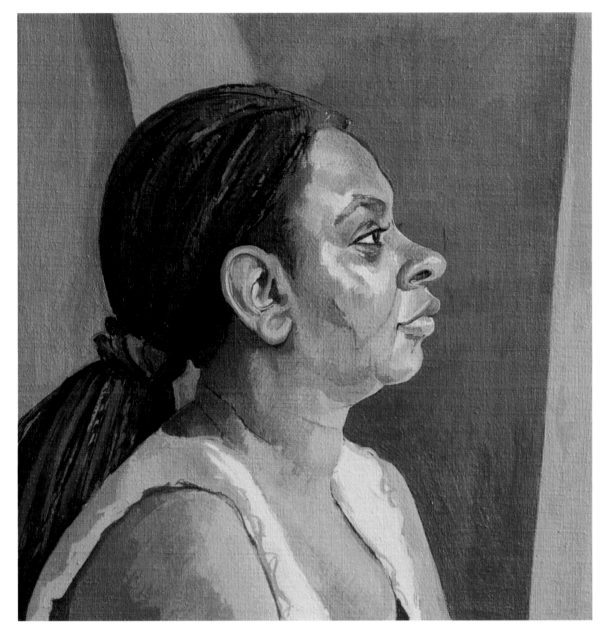

A profile of *Sonia*.

sculpture was placed so that the top of the curve lined up with the top of the model's head. This composition fits well into a square format, and the two profiles create an interesting negative space.

Exercise: Drawing a Portrait with a Still Life Arrangement

This exercise brings together portraiture and still life in a drawing, before beginning to approach this subject with oil paints. To help you decide on the composition, make a number of sketches in your sketchbook. Once the relationship

of all the various elements has been finalized, make a sustained drawing of the model and the still life elements. It is up to you which drawing technique you choose: your sustained drawing could be a measured drawing using either sight scale or comparative scale, or you may prefer to use the reductive method for a tone drawing.

When painting a figure with a still life set-up, try to think about a connection between the person and the objects you are choosing. You may portray someone with an instrument they play, or an artist with a piece of their artwork; an avid reader could be placed next to a pile of books, or perhaps something quite simple could be enough, such as a cup and saucer, a teapot, a piece of fruit or a vase of flowers. The objects chosen can be biographical or symbolic, or they might identify hobbies.

You may have a willing sitter or a theme in mind, or perhaps your starting point will be the still life.

When bringing together a model and a still life set-up in an interior, a fair amount of preparation will be needed. Experiment with the placing of all these different elements within the work space, making sure there is enough room to place all your materials and your easel, and very importantly so you can stand back from both your painting and the subject. The way the light illuminates the figure and still life can make a big impact, and can give a very different atmosphere to the painting, so it is important to experiment with different light directions and sources before you begin.

Do you wish to draw the full figure with the still life in an interior, or do you want to concentrate on the head and shoulders with the objects nearby, or something in between? In making a series of drawings you will get a feel of how your subjects relate to each other on paper, and the final decision as to which you choose to develop further can be quite instinctive.

The space around each element of the drawing is important to the overall harmony of the piece. Using negative spaces around and between your figure and the objects will be important to the success of the resulting composition. It is advisable to experiment with the distance between the figure and the objects: for example, should the gap be less, or would the composition seem more comfortable if the negative space were greater?

Self-Portraiture and Still Life Painting

Artists have portrayed themselves using self-portraiture throughout history, often showing themselves with a variety of objects to suggest a narrative or to give some biographical detail. As the artist is always present, painting a self-portrait with a still life set-up is ideal as there is no waiting around for models to arrive, or persuading someone to come and sit for you!

Inspirations for Self-Portraiture

LUCIAN FREUD (BRITISH, 1922–2011)

Lucian Freud's *Interior with Hand Mirror* (self-portrait) of 1967 (in a private collection) is a small painting where the artist is reflected in a small hand mirror wedged in a window frame. The self-portrait is very small in the overall painting. It is a stark yet effectively simple composition, as the small oval frame of the mirror is set against the strong horizontals and verticals of the window frame.

This is a unique way of representing a self-portrait in a painting, and demonstrates that the reflection can be just as effective in small scale as in a larger, more dominant scale as seen in self-portraits by artists such as Rembrandt. With this in mind, experiment in the setting-up of your own 'self-portrait with still life': will your portrait be dominant within the picture space, or do you wish the observer to catch just a glimpse of the artist at work?

FRIDA KAHLO

The Mexican painter Frida Kahlo (1907–54) painted some of the most powerful self-portraits of the twentieth century. The artist was severely injured in an accident in her youth, and her life-long exploration into self-portraiture began as she was convalescing. Her portraits include objects, vegetation, animals, costume and texts, and all are greatly symbolic in her paintings.

Kahlo painted numerous still lifes throughout her career, and they are of particular interest in the bridging of self-portraiture and still life painting. She used the subject of still life as a form of indirect self-portraiture that allowed her to project her innermost feelings through the use of symbols and objects. The fruits and vegetables that she chose to paint – for example *Fruits of the Earth* (1938, in the Banco National de Mexico) and *The Bride Frightened of Seeing Life* (1943, the Vergel Foundation, Cuernavaca) – all show native Mexican produce. Such still life paintings as these also allude to the cycle of life, as many of the fleshy fruits are purposely made to resemble body parts.

VAN GOGH AND GAUGUIN – PORTRAITS WITHOUT PEOPLE

Two interesting paintings to look at are Van Gogh's chair paintings. Van Gogh (1853–90) found a solution to the problem of his shortage of models by making an empty chair personify its owner, making it a 'portrait' of the absent sitter. These two works have a unique place in the history of both portraiture and still life painting, the artist being represented by their belongings on their individual chairs.

The first painting Van Gogh describes as a 'self-portrait' in that it depicts a yellow wooden chair with the painter's pipe and tobacco pouch on the wickerwork seat. The second painting is the artist Gauguin's chair (1848–1903), more crafted and decorated than Van Gogh's simple chair, with a lighted candle in a holder and two contemporary novels. In each painting it is as if the artist himself is present.

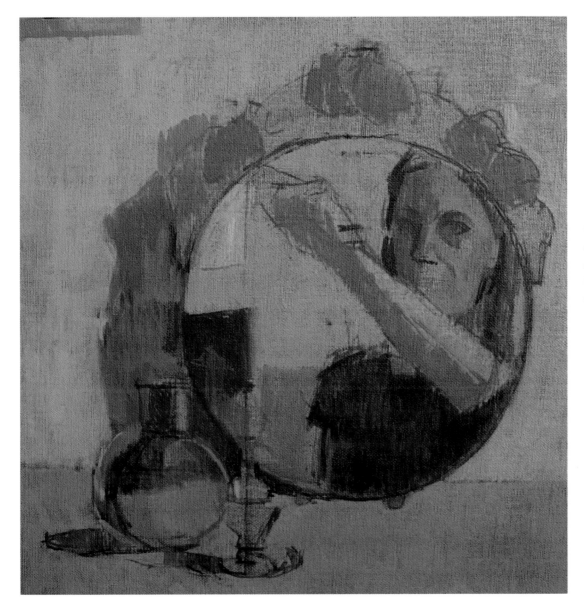

Establishing the drawing with paint and beginning to block in the main areas of colour.

Exercise: *Still Life with Artist*

Begin to select objects that could be used in your still life. You will, of course, need a mirror. The scale of the mirror, and hence the scale of the reflected portrait in your composition, is important: do you want the portrait to be dominant, or do you want to give greater importance to your still-life arrangement, with a more subtle and smaller scale self-portrait?

Look at a selection of artists' self-portraits and note when objects have been included, and how they have been used: is this in a decorative manner, or do they give further biographical information about the artist?

Take time to select the position of the mirror, and of any objects being used in this painting. The small round mirror in the illustration above is placed at a slight angle so that the figure and the two small bottles in the foreground are all

reflected – and the mirror with its carved flowers over the top is as much a still life object as both the small pewter and glass perfume bottles.

The reflection in the mirror shows the artist at work, caught in the act of observation. The portrait is small in scale and is depicted just within the edge of the mirror, the artist with her arm raised towards the canvas. The two bottles are reflected on the left side of the mirror. The three reflective surfaces in this painting are all contrasting, namely the flat surface of the mirror, the curved pewter bottle with its distorted reflections, and the brightly coloured yet transparent glass perfume bottle with its gold touches glinting with flecks of light.

In preparation for the painting it is important to spend time making a sustained drawing before you begin to work, as this will help you to gain a greater understanding of the arrangement, proportion, scale and tonal relationships.

Focusing on the head.

Once you have found a pleasing composition with a mirror and a few still life objects, begin to sketch on to your canvas. In this painting the scale of the still life arrangement, including the mirror, fills the square proportions of the linen canvas board, the surface being used for this piece. The board has been primed with rabbit skin glue rather than white gesso primer, so that the tone of the natural linen remains. It is more helpful to have this as a base when establishing skin tones and the darker elements of the reflection in the mirror.

The mirror is placed off centre, with a small amount of space between it and the edge of the board. A wide band of shadow by the mirror, with the two bottles positioned on the left, serves to balance the composition. The depth of the carved flower detail at the top of the frame fits into the length of the mirror five times. It may be helpful to establish the central point of the mirror so that you can see how your reflection relates to this.

A fine rigger brush is used with diluted raw umber for sketching on to the canvas. Once you are happy with the drawing, begin to block in the largest areas of tone as you did for the paintings in the previous two chapters. Put down opaque paint in colour patches over the surface, simplifying the amount of information that you see. With the amount of detail in the still life arrangement and the reflected portrait together it

would be very easy to do too much, too soon. Treat the head in exactly the same way that you have painted any still life, as shapes and patches of colour and tone. Concentrate on the shapes that give the head or face its underlying structure, and don't worry about details or getting a likeness.

The background tone is the first to be established as areas of subtle patches of warm and cool light. The surface cloth is next to be painted. The shapes as seen in the reflection are simplified and painted as simple blocks of tone.

The colour of the background wall (behind the artist) is much brighter and warmer than the background of the wall next to the mirror. Once the wall tone has been painted, the next step is to paint the darker tones of the figure with shadows next to the mirror and to the left of the bottles.

The area immediately around the mirror has a number of contrasting colour passages, so mix a number of shades for these. The right-hand side is a little warmer, while on the left side of the painting the wall appears to be cooler. A hint of blue is suggested on the edge of the dark shadow to the left of the mirror, making a more subtle transition from the dark shadow to light on the wall. More paint is then layered over the cloth in small areas to suggest subtle transitions from blue to mauve, pink and ochre. Directly under the mirror more blue is added to make the surface brighter.

A lot of earlier paint had sunk, so further paint layers were needed to build up the paint surface, although no oil has yet been added. The wall to the left side of the mirror has touches of pink and blue, whereas on the right side nearer to the window it has slightly more yellow and is warmer. Use mixed colour to establish or re-establish any drawing as you proceed.

Once the surrounding area and still life have progressed, begin to spend some time establishing the self-portrait. As this is reflected and appears to be 'distant' within the painting, try to avoid making the head or face too detailed. The key is to keep this really simple so that the viewer's attention focuses on the still life first and perhaps only later sees the reflected face. Areas of light and dark are blocked in over the figure and background. Simplify the facial structures to small facets, just as you have painted everything else: don't panic because it is a face and so begin applying paint in a different way. Add more colour as you work, and if necessary start to add linseed oil into the paint.

As the previous session had concentrated mostly on the painting of the portrait, the background and the areas surrounding the mirror, it is time to work on the small still life arrangement in the front of the picture space, and its reflection.

This still life is full of reflections as the transparent glass is reflected in the pewter, which is then reflected in the mirror. The subtle shifts of tone of an object or a surface when seen against its reflection is one of the interesting yet challenging aspects of painting reflective surfaces. You can see how the wall reflected in the mirror is a darker and warmer tone when compared to the

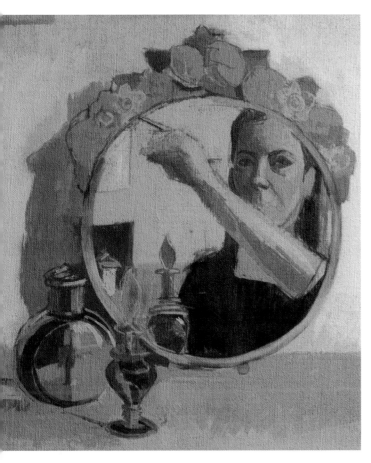

Looking at the still life and establishing the reflections.

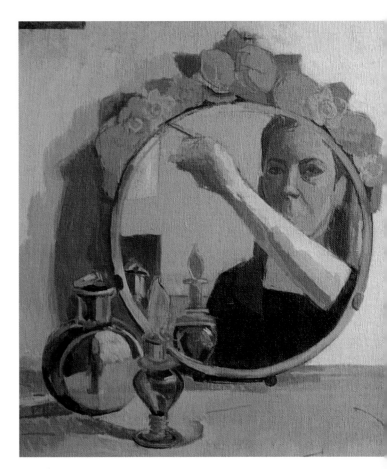

Building up the paint surface.

wall immediately around the mirror. The same can be said for the cloth reflected in the pewter surface: it is warmer in tone and slightly richer in colour.

Spatially this is a difficult subject to tackle. As you focus on your reflection this appears to move forwards in relation to everything else, but in fact this area is the most distant from you as you work. Next is the mirror itself, positioned in the mid-ground, and the still life is right in the front of the picture plane. The bottles reflected in the mirror appear to be further forward than your reflected image, and so on. The key is to make sure that the tonal relationships work with one another, and that nothing 'jumps' forwards in space by being too bright.

As you draw the objects placed in front of the mirror don't worry about their reflections yet. Carefully measure and check their scale in relation to each other, and once this is done, use the horizontals and verticals to help you establish the relationship of the objects themselves to their reflections. Simplify the shapes of colour of the reflected images, being careful that nothing is too detailed.

The two bottles here are surprisingly dark in tone and rich in colour. The colour at this stage is exaggerated slightly to make them stand to the front of the pictorial space. Look carefully at the direction of the ellipses moving around the bottles. In reality we are looking down on the two bottles so we see the ellipse moving around one way, but in the reflection we see how the arc is moving in the opposite direction.

The colours on the faded carved flowers on the top of the mirror are next to be painted: they need to be kept rather subtle and delicate, and although in one or two places the colour is a little richer, this area as a whole needs to recede and not to jump forwards. The colours used are within the same tonal range, so that nothing stands out too much. The shapes of colour are kept rather loose and fluid, hinting at flower shapes rather than drawing them too precisely, as this could make them become too dominant.

As you begin to focus on the smaller elements in the picture, identify any areas that need more paint, or perhaps where a shadow or dark area needs to be accentuated further.

The large shadow to the left of the mirror needed to be made darker and with a little more warmth. The bottles in the foreground needed more detailed passages and richer colour in order to move them forwards towards the viewer. Small areas of dark are added to the bottles and to the shadows underneath them. These are important because they help to link the objects and aid the eye moving around the pictorial space.

Next pay attention to any details that up to now haven't been

worked on. The small stand underneath the mirror is now addressed, as this helps to give it weight and to connect it to the surface. In the top left of the painting there is a suggestion of a picture frame: this contains the eye in the composition – without it the eye runs out of the picture space.

Using different shades, various lines, shapes and markings on the drape are drawn in.

Final touches to the two bottles included darkening the arc moving around the left side of the pewter, and making the patch of reflected light as bright as possible without it moving too far forwards in space.

A little more colour was placed over the flowers on the mirror as coloured lines to describe the forms, but keeping them very subtle. More paint was added to the right side of the mirror to make it a little brighter, and more colour was then added to the bottles and reflections.

Consider whether you need to do anything further to the portrait or reflection.

The final touches to be added are the glints of reflected light on the glass bottle and the hints of the gold design. A very pale mix of yellow ochre was used for the highlights, and the number of brushstrokes is kept to a minimum so that the surface doesn't become too fussy or tight. A fine round or rigger brush is ideal for this purpose.

This has been the most challenging painting to bring together as there are so many separate elements to think of when making them work as a whole. If the painting takes you longer than usual, don't worry: you are thinking of many complex things pictorially. Persevere, and work a little at a time: as long as your still life element isn't perishable you can take as long as you need.

You may find it easier to paint from a model directly in front of you with a still life to begin with. When you feel more comfortable with this, begin to work on a self-portrait with still life arrangement. The advantage is that you, the artist, are always present. Once you have set up a position for everything, try to work on the painting at the same time of day so that the lighting is as close as possible to the previous day you painted.

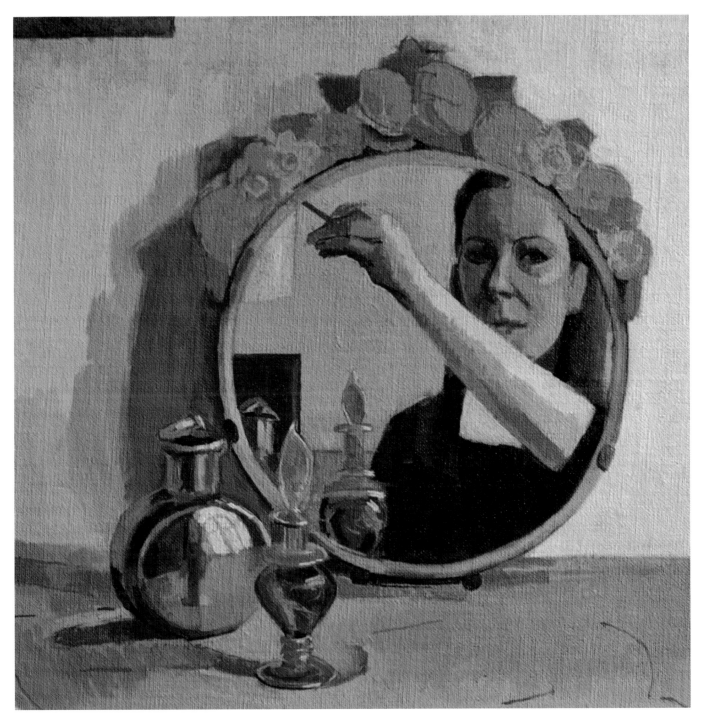

Still Life with Artist.

REFERENCES

1 *Still Life: Still Life Painting in the Early Modern Period* Taschen 2009 p. 25. Norbert Schneider (*The Growth of the Antwerp Market & European Economy*), Louvain 1963, S.D. Skaskin et al).

2 *Caravaggio* Howard Hibbard, London 1983 p.83.

3 *Zurbaran* Jonathan Brown, Thames & Hudson 1975 p.78.

4 *Caravaggio* Howard Hibbard, London 1983 p.17.

5 Craigie Aitchison, *Out of the Ordinary* Andrew Lambirth, Royal Academy of Arts 2003, p.14.

6 Euan Uglow *Ideas 1952–91* Browse & Darby, London 1991, p.1.

7 *Colour Art & Science*, Bourriau & Lamb, Cambridge University Press, 1995 p. 6.

8 *The History of Colour in Art* David Bomford from *Colour Art and Science*, Bourriau & Lamb, Cambridge University Press 1995, p.24.

9 *A Treatise on the Color System of Johannes Itten based on his book The Art of Color*, Faber Birren, Van Nostrand Reinhold Company 1970, p.30.

10 *Gericault: His life & work*, Lorenz E.A. Eitner, Orbis Publishing Ltd, London 1983 p.184.

11 *Gericault: His life & work*, Lorenz E.A. Eitner, Orbis Publishing Ltd, London 1983 p.184 (Battissier, *op. cit.* p.42)

BIBLIOGRAPHY

Birren, Faber, *A Treatise on the Color System of Johannes Itten based on his book The Art of Color* (Van Nostrand Reinhold Company, 1970).

Brown, Jonathan, *Zurbaran* (Thames & Hudson, 1975).

Browse & Darby, *Euan Uglow: Ideas 1952–1991* (Browse & Darby, London, 1991).

Campbell, Colin, James, Merlin, Reed, Patricia, Schwartz, Sanford, *The Art of William Nicholson* (Royal Academy of Arts, London, 2004).

Coldwell, Paul, *Morandi's Legacy: Influences on British Art* (Philip Wilson Publishers, 2006).

Dexter, Emma & Barson, Tanya, *Frida Kahlo* (Tate, 2005).

Eitner, Lorenz, *E.A. Gericault: His life and work* (Orbis Publishing Ltd, London, 1983).

Harris, Enriqueta, *Velazquez* (Phaidon 1982).

James, TGH, *Egyptian Painting* (British Museum Publishing, 1985).

Jenkins, David Fraser & Stephens, Chris, *Gwen John and Augustus John* (Tate Publishing, 2004).

Lamb, Trevor & Bourriau, Janine, *Colour Art and Science* (Cambridge University Press, 1995).

Lambert, Gilles, *Caravaggio* (Taschen, 2000).

Lampert, Catherine, *Euan Uglow: The Complete Paintings* (Yale University Press New Haven and London, 2007).

Lambirth, Andrew, *Craigie Aitchison: Out of the Ordinary* (Royal Academy of Arts, London, 2003).

Rediscovering Pompeii (L'erma di Bretschneider, 1992).

Roberts, Keith, *Degas* (Phaidon Press Ltd, London, 1994).

Royal Academy of Arts, *The Golden Age of Spanish Painting* (The Hillingdon Press, Uxbridge, 1976).

Schneider, Norbert, *Still Life: Still Life Painting in the Early Modern Period* (Taschen, 2009).

Seymour, Pip, *The Artist's Handbook: A complete professional guide to materials and techniques* (Arcturus Publishing Limited, 2003).

Upstone, Robert, *Modern Painters: The Camden Town Group* (Tate, 2008).

Wheeler, Mortimer, *Roman Art and Architecture* (Thames & Hudson, 1970).

LIST OF ART SUPPLIERS

Atlantis Art Materials & Art Supplies www.atlantis.co.uk
Dick Blick www.dickblick.com
Eckersley's Art & Craft www.eckersleys.com.au
Great Art – Art Supplies www.greatart.co.uk

Jacksons Art Supplies www.jacksonsart.com
L. Cornelissen & Son www.cornelissen.com
Russell & Chapple, London www.russellandchapple.co.uk
Winsor & Newton www.winsornewton.com

COLLECTIONS AND GALLERIES

Below is a list of the artists mentioned throughout the book and where to find examples of their work. There are full listings of where to find each artist's work worldwide online.

Key to collections:
BM = British Museum, London
MOMA = Museum of Modern Art New York
NG = National Gallery London
NGS = National Galleries of Scotland, Edinburgh

Aitchison, Craigie: Marlborough Fine Art London, NGS, Tate London

Auerbach, Frank: Marlborough Fine Art London, Tate London

Barbari de', Jacopo: Alte Pinakothek Munich, BM, NG

Campin, Robert: The Hermitage, NG, The Prado

Caravaggio, Michelangelo: Merisi da Gemaldegalerie Berlin, NG, Pinacoteca Ambrosiana Milan

Cezanne, Paul: Courtauld Institute London, Art Institute of Chicago, The Hermitage

Chardin, Jean Simeon Baptiste: Musée du Louvre, Metropolitan Museum of Art New York

Claaesz, Pieter: National Gallery of Art Washington DC, Rijksmuseum Amsterdam

Cotan, Juan Sanchez: Museo del Prado Madrid, San Diego Museum of Art

Cranach the Elder, Lucas: Hermitage Museum, NG, National Gallery of Art Washington DC

Degas, Edgar: NGS, Musée D'Orsay Paris, NG

Delacroix, Eugene: Fitzwilliam Museum Cambridge, Musée du Louvre

Dine, Jim: BM, MOMA

Durer, Albrecht: Kunsthistorisches Museum Vienna, NG, NGS

El Greco, Domenikos Theotokopoulos: Metropolitan Museum of Art, NYC, NGS

Freud, Lucian: National Gallery of Australia Canberra, Pallant House Gallery Chichester UK, Tate London

Gericault, Theodore: Musées Royaux des Beaux-Arts Brussels, Musee du Louvre, Musee Fabre Montpellier

Gijsbrechts, Cornelius Norbertus: Musées Royaux des Beaux-Arts, Brussels

Gilman, Harold: Manchester City Art Gallery UK, Tate London

Giocometti, Alberto: MOMA, Tate London

Goya, Francisco: Musée du Louvre, NG, Prado Madrid

Hammershoi, Vilhelm: New Carlsberg Glyptotek, Copenhagen, NG, Tate London

Holbein (the younger), Hans: Frick Collection NYC, NG, Thyssesn-Bornemisza Museum Madrid

Hoogstraten van, Samuel: Courtauld Institute of Art London, NG, Rijksmuseum Amsterdam

John, Gwen: Metropolitan Museum of Art, NYC, Tate, York City Art Gallery UK

Kahlo, Frida: MOMA, Museo Dolores Olmedo Mexico City

Matisse, Henri: Hermitage Museum, Matisse Museum Nice France, MOMA

Memling, Hans: NG, Sint-Jan Hospital Museum Bruges, Belgium

Monet, Claude: L'Orangerie Paris, Musée Marmottan Monet Paris

Morandi, Giorgio Estorick Collection of Modern Italian Art London, Tate

Nicholson, William: Courtauld Institute of Art London, NGS, Tate

Picasso, Pablo: Musée National Picasso Paris, MOMA, Museo Picasso, Barcelona Spain

Sickert, Walter: MOMA, NGS, Tate

Seurat, Georges: Art Institute of Chicago, Musée d'Orsay Paris, NG

Titian, Vecellio: Fitzwilliam Museum Cambridge, Hermitage Museum, Musée du Louvre, NG

Uglow, Euan: Browse & Darby London, Marlborough Fine Art London, Tate

Van Eyck, Jan: Musée du Louvre, NG, The Prado, The State Museums of Berlin

Van Gogh, Vincent: Van Gogh Museum Amsterdam, Musée d'Orsay Paris, Metropolitan Museum of Art NYC, NG

Velazquez, Diego: NG, NGS, Wellington Museum London, The Prado

Weyden van der, Rogier: Musées Royaux des Beaux-Arts Brussels, Musée du Louvre, NG

Zurbaran de, Francisco: Museo de las Bellas Artes, Seville Spain, NG, The Prado

INDEX